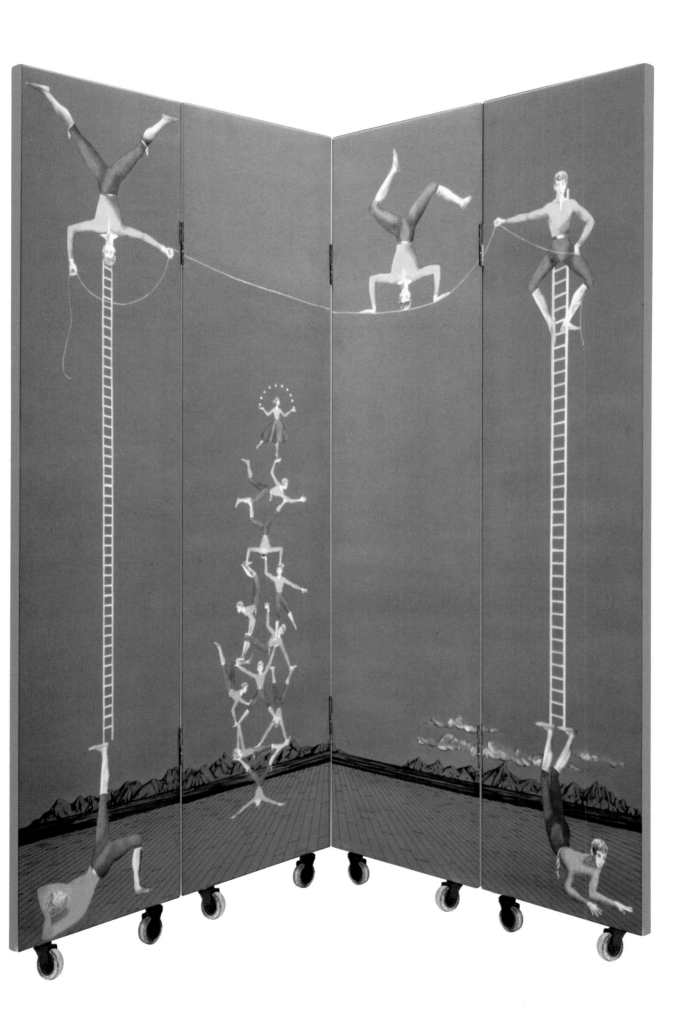

p.1
Acrobati (Acrobats)
screen
1952
Lithograph on wood
with painting by hand
140 × 135 cm

Piero Fornasetti
as a young man
1930s

*I am a stickler
for detail
who loves
uncertainty.*

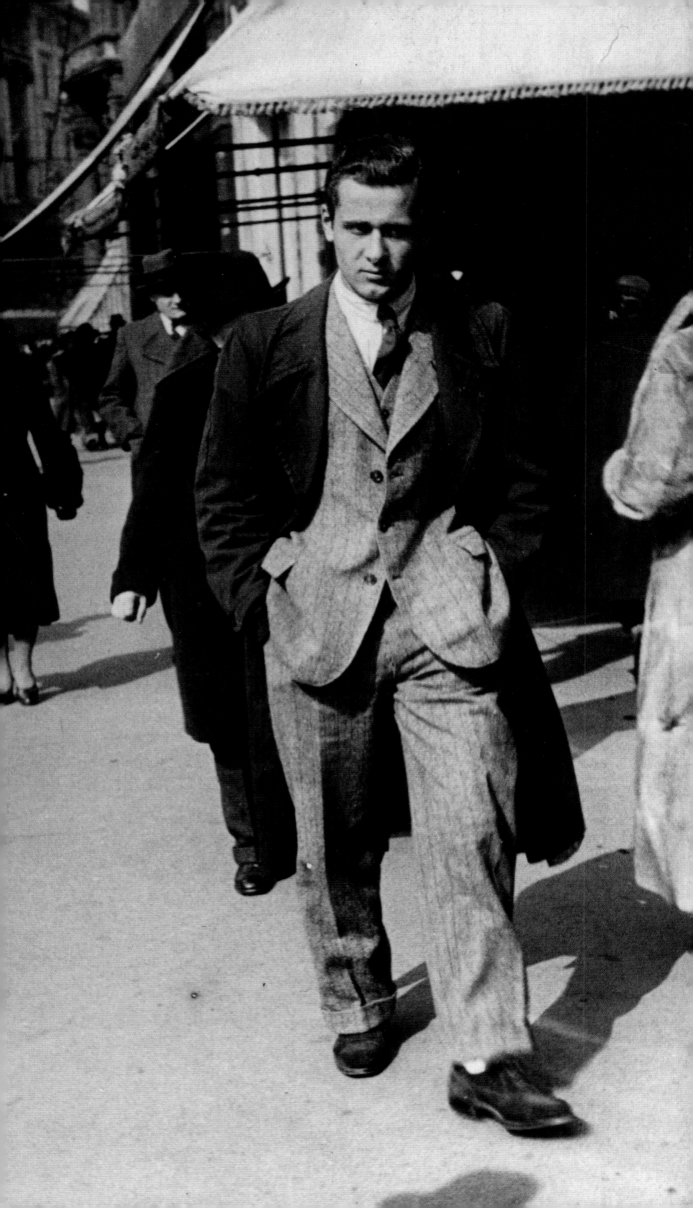

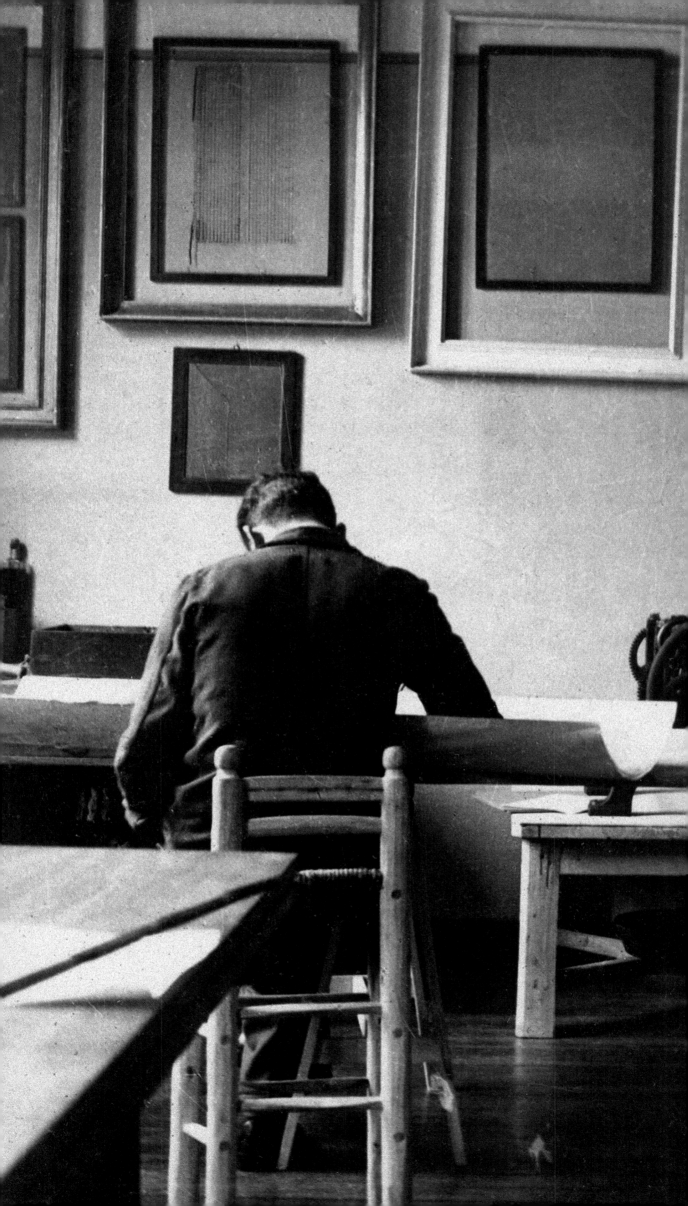

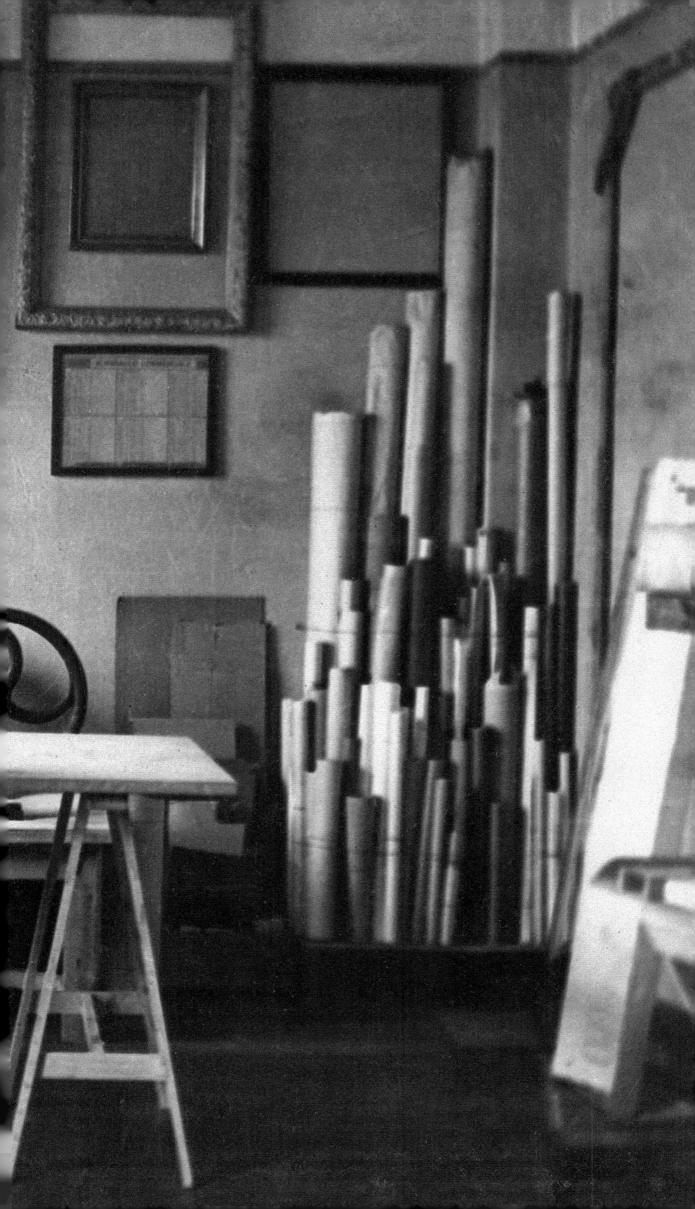

*Now we say:
modernity is born dead,
reasoning is futile,
salvation is in the form.
Fine discoveries.
Salvation is
in the imagination:
if I were
a government minister
I would set up
a hundred Schools
of Imagination in Italy.*

p.5-6
Piero Fornasetti's
studio
1948

Piero Fornasetti
1948
Photograph by
Irving Penn

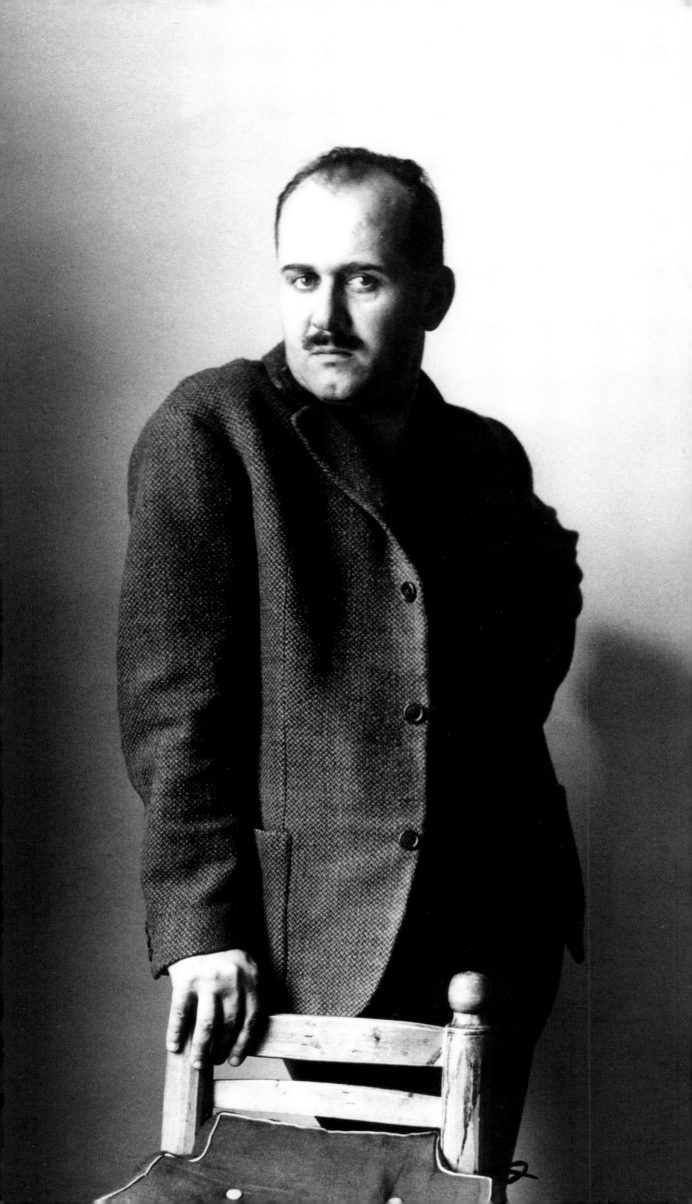

*I have gathered
thousands of documents
on the so-called
decorative arts;
it is essential to find,
to collect things together
so that at the right
moment I can find
an aesthetic reference
to use for my creations,
and it gives me
a sense of tranquillity,
another satisfaction of
the 'collector'.*

Autoritratto (Self- portrait)
Late 1930s
Oil on panel
54 × 80 cm

*The objects that
I have designed
over forty
years, even if
their decoration
overflows with
imagination,
nevertheless have
extremely simple
and clear forms.*

Piero Fornasetti
with his *Greca* bicycle
1982

p. 11
Piero Fornasetti
with the *Braccio con moneta*
(Arm with coin) tray
mid-1950s

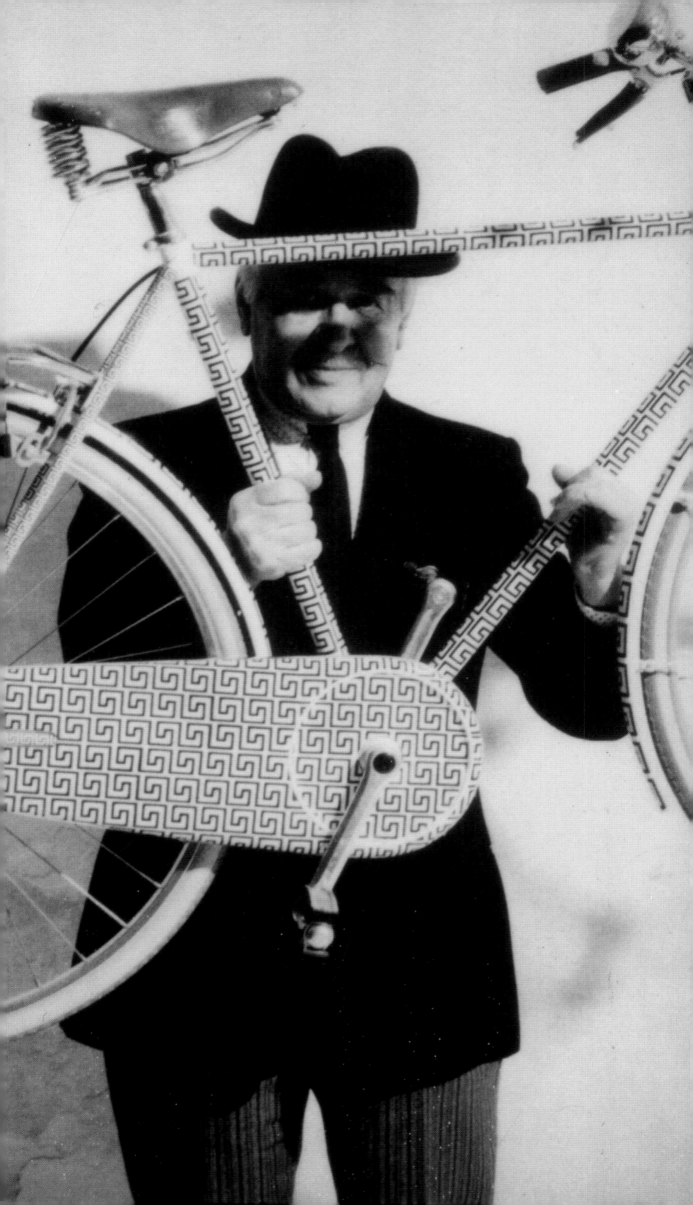

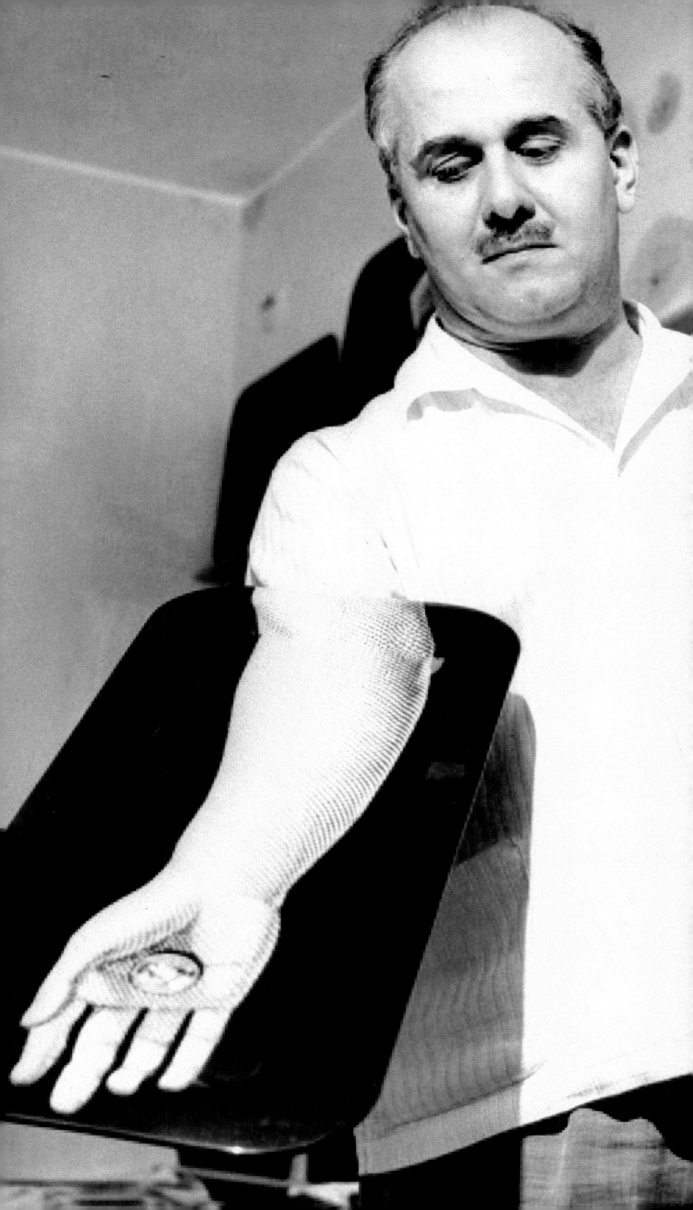

PIERO FORNASETTI

PRACTICAL MADNESS

Edited by
Patrick Mauriès

RIZZOLI
NEW YORK

New York · Paris · London · Milan

THE POWER
OF THE IMAGINATION

In the autumn of 2013, the centenary of Fornasetti's birth was marked by a remarkable retrospective exhibition at the Triennale Design Museum in Milan, paying homage to one of the city's most brilliant and inventive children. Today visitors to this exhibition at the Musée des Arts décoratifs will be captivated by the freedom and diversity of such a rich body of work, and one which escapes categorization. At an institution such as Les Arts Décoratifs, where heritage and design meet, Piero Fornasetti finds a rare resonance: his sources and his own culture are deeply rooted in the history of the decorative arts and architecture, his unquantifiable corpus defies all definition by design's strictest rules, yet adheres to the subtlest of relations to it. In 1987, in conversation with Shara Wasserman, he revealed his personal ideas, taking on designers on their own territory, and genially pointing out their contradictions: 'Design such as I understand it is supposed to favour the production of high quality objects at low prices. That's not entirely the case: the design is high quality, yes, but the result is expensive. Reserved for an elite. That's bad.'

This sense of limitless creativity – neglected for so long – was acknowledged early on by Gio Ponti, and later by Ettore Sottsass and Andrea Branzi, each one recognizing in Fornasetti an originality and standing of the first rank in the history of Italian and European design and decorative arts. Many young contemporary designers will respond to the spirit of Fornasetti, the visionary nature of his thought processes, his method and his use of an infinite repertoire of visual sources; he was employing reproduction, collage and repetition as elements of his art long before Pop Art and the creative process of Andy Warhol.

Invited by Olivier Gabet, director of the museums, to adapt the Milan exhibition to the scale of the Nave at the Arts Décoratifs, Barnaba Fornasetti has given it the full scope it deserves, bringing together for the first time in Paris hundreds of paintings, drawings, furniture and objects, tracing almost fifty years of a protean artist, reader, tireless draughtsman and impenitent teaser – so many keys that bring him close to the world of the decorative arts. We would like to thank Barnaba Fornasetti most warmly for his authoritative participation in the project, as he continues the Fornasetti adventure today, always diversifying and enriching his father's work. We are also delighted to have this opportunity to collaborate with the Triennale Design Museum, hoping that there will be more to come in the years ahead.

This exhibition was made possible thanks to the generosity of a number of sponsors, all united by art and design, and by their enthusiasm for the chance to bring together this unique artist and this emblematic place for the first time. Thanks to the indispensable financial support of the house of Valentino, Yoox, the Fondazione Vittoriano Bitossi, Cole & Son, and United Parfums, this journey to the heart of one of the most fertile imaginations of the twentieth century has been made possible: Piero Fornasetti's 'practical madness'.

Bruno Roger, President of the Arts décoratifs
David Caméo, General director

LIVES OF FORNASETTI

'People, tell your story'
Alberto Savinio

Ever since Giorgio Vasari's *Lives of the Artists*, this literary exercise of collecting 'lives' has been one of the great legacies of Italian art. In 1942 Alberto Savinio added his contribution to the tradition with his *Narrate, Uomini, la vostra storia* (later appearing in French as *Hommes, racontez-vous* and in English as *Operatic Lives*). In it he combines lives as diverse and rich as those of Nostradamus, Stradivarius, Guillaume Apollinaire, Isadora Duncan and Jules Verne. None takes his place more rightfully among these than Giuseppe Verdi, 'compositeur fleuve', composer of endless invention, the 'oak-man' to whom Savinio attributes a singular nature: 'Eminent minds, those rich in thought, are occasionally unaware of Bach, of Mozart, of Wagner; but they are stopped in their tracks, surprised and fascinated, by the madness of the world: by the madness of Giuseppe Verdi.' This sort of singularity is entirely shared by Piero Fornasetti: a madness for images, for objects, for an immediately identifiable world, and the steady gaze, looking to infinity, of a woman as enigmatic as the Mona Lisa, the melancholy eyes and plump lips of Lina Cavalieri, a late nineteenth-century opera singer and, after her own fashion, courtesan, contemporary of Eleonora Duse and Gabriele d'Annunzio… Decorating and illuminating several hundred of Fornasetti's works, however, including but not limited to plates, the face of this great *fin de siècle* mistress threatened to eclipse the almost inexhaustible wealth of the Milanese designer's oeuvre, as happened to so many 'total artists' from the Italian Renaissance. He was a painter, draughtsman, printer and engraver, decorator and designer of furniture and objects, illustrator and brilliant author whose talent for writing shines through in his penetrating aphorisms that remain too little known. One should add to this his rare human capacity to collaborate with other artists, without worrying that someone might poach his ideas or compete with him. Alberto Savinio himself was one such collaborator; another was his friend and contemporary Gio Ponti, an architect and designer similarly outside the norm, who went so far as to state: 'If ever my life as an architect were one day deserving of a book, the chapter that starts in 1950 could be called "The Fornasetti Passion".'

A universally curious and eclectic artist, Fornasetti had a spell in purgatory during the 1960s and '70s. The history of art and that of the decorative arts and design in particular have a certain propensity to favour the great periods, styles or schools, and are often uneasy about discussing singular artistic individuals, these tasty side-dishes, one might say, to artistic periods, these somewhat original, harder-to-find branches of well-organized family trees. For a long time Fornasetti's unquenchable imagination was misjudged and misunderstood: this extended to his capacity for absorbing the most varied influences, of Picasso, De Chirico and his Metaphysical art, Marinetti, his friendships with Ponti or Eugene Berman, his willingness to push the boundaries of what could be done, or his healthy scepticism for 'good taste' – something that is occasionally taken for a lack of taste altogether. This one-man world of art, this oak-man, as Savinio called Verdi, was never granted a retrospective in France. In fact, in November 1956 an exhibition entitled 'Objects and furniture decorated by Fornasetti' opened at the Bernheim-Jeune Gallery without

a single museum coming to honour his artistic prolixity. Piero had to put up with this. France was, for him, his second country, and Paris lay just as close to his heart as certain Italian cities – Milan, of course, but also Venice, Verona or Turin. In the spring of 1970, Fornasetti created the poster for an exhibition curated by François Mathey at the Arts décoratifs, 'Bolide design' (on car design), lending a sort of artistic direction to a selection of racing cars assembled by a committee that included Roger Tallon, Joe Colombo, Pio Manzu, Jean Tinguely, Robert Delpire and Victor Vasarely. Fornasetti, practical madness and a sense of the unexpected…

It is high time, and entirely natural, to pay homage to Piero Fornasetti at the Musée des Arts décoratifs, after the Victoria & Albert Museum in London devoted an exhibition to him in 1991, three years after his death. Since the 1980s his protean work has been more fairly reconsidered, work that the artist himself defined as 'pre-post-modern'. Fornasetti's eclecticism marries an encyclopaedic richness of visual and intellectual references with the kaleidoscopic effect of an artistic pantheon that combines Bodoni's characters, the collections devoted to Pompeii and Herculaneum by William Hamilton and the Baron d'Hancarville, the whimsies of Piranesi, and the building plans immortalized by Palladio in *I Quattro Libri dell'Architettura* (The Four Books of Architecture). Fornasetti likes to play with ancestral traditions, such as painting Renaissance-style wood inlay marquetry to depict the forlorn dereliction of urban architecture, or ancient cartography, erudite treatises on astrology of the sixteenth century, popular magic and fortune-telling. At a time when the mainstream is impressed by modernity, this all suggests a high degree of freedom and a real independence of tone. It is this Fornasetti spirit that has probably fascinated Vivienne Westwood, Philippe Starck or an entrepreneur as irrepressible as Sir Terence Conran since the 1980s. His Italian peers have managed to re-establish Fornasetti's singular, almost marginal position. Ettore Sottsass described him as 'a very sophisticated child, a magic child with charms that can transform the world into a place of fantastic memories, into a supermarket of postcards, stickers, games, puzzles, writings, photographs that come from faraway lands where everything is beautiful, silent, pleasant, noble and even a bit comic, a bit ridiculous, a bit erotic, a bit beguiling…'. Andrea Branzi has emphasized the character of the 'decorator', that has contributed to the difficulty of incorporating Fornasetti into the history of design, while his clearsighted vision of the evolution of decoration was as pertinent as that of, say, Mario Praz: '[in the eighteenth century] the only people who had uniform interiors were nouveau riche'.

For all these reasons, the work of Piero Fornasetti today deserves its place in the Nave of the Musée des Arts décoratifs. More than ever, the abundance of his work speaks to us of a terrifically contemporary and up-to-date eye; it is no-holds-barred, generous, even disarming when he brings tricks of scale jostling together between the monumental and Antonioni-style 'blow-up', when his wardrobes become Piranesian skyscrapers.

Without the flawless involvement of Barnaba Fornasetti, the challenge of this exhibition could not have been met. Since the early 1980s, he has taken on the task of reviving the house of Fornasetti and the durability of its position in contemporary design, as well as the continuity of the history of his family, but in his own way, a very delicate task that he has undertaken with admirable energy. I offer him my heartfelt gratitude.

Thanks to Barnaba and the trust that he was quick to lend to the museum, this story finally has the Parisian chapter it deserves. During our always warm and engaging discussions, he has been able elegantly and precisely to adapt the spirit of place needed for Piero's centenary exhibition that was organized in Milan in 2013 for the Triennale Design Museum under the leadership of its director, our friend Silvana Annicchiarico, whose support has been invaluable. With Barnaba, several important people were key to the success of this project, in particular Chiara Zanesi, Gabriele Ferrero, Yuki Tintori and Fulvio Marcello Zendrini, all friendly and efficient collaborators. They also enabled the exhibition's crucial sponsors to take their place. The house of Valentino, already linked to the Museum through the marvellous pioneering retrospective exhibition undertaken here by Pamela Golbin in 2008, under the Fornasettian title 'Themes and Variations', played a primary role with its generous contribution towards the exhibition. To this has been added the benevolent aid of the Yoox group which, thanks to Diamante Rosselli, was essential, as was the financial support of the Fondazione Vittoriano Bitossi, Cole & Son and United Parfums.

Finally, we must render unto Caesar the things that are Caesar's. In January 2014, Patrick Mauriès had the happy idea to send me the exhibition catalogue from the Triennale Design Museum, and to have me meet Barnaba in Milan several days later: the start of this adventure. For more than thirty years, Patrick has undoubtedly been the greatest connoisseur of Piero Fornasetti's work, and his 1991 book *Fornasetti: Designer of Dreams* was a milestone. It seemed an obvious choice to entrust him with the direction of this catalogue, on which he has spared neither his intelligence, his time nor his effort; his translations of Piero's aphorisms constitute a hitherto unpublished journey into the Fornasettian labyrinth, and his eye as editor emeritus has guided our every step, in concert with Barnaba's advice.

Against the dullness of the ordinary, Fornasetti's work takes us to a place of freedom and illusion, a consummate art of arrangement, 'imagining one has what one doesn't have', a healthy irony, and the jubilant exercise of discovering a process poles apart from romantic inspiration, for which the preferred principle was that of Curzio Malaparte, whom he met one day with Gio Ponti: 'the important thing is not knowing how to design, invent or write something, but knowing how to deduce; in other words, knowing how to draw from one thing, no matter what it is, a whole multitude of others… In the end, there is no such thing as invention, only deduction.'

Olivier Gabet, Director of the musées des Arts Décoratifs

MASKS AND THE FACE

Patrick Mauriès

Lovers of fine decoration from the last century may well have had the strange sensation of being followed around by the eyes of a placid yet polymorphous female face. During the 1950s and 1960s it was difficult to escape this woman's omnipresent gaze, whether looking out from the bottom of an ashtray, the surface of a plate, the lid of a matchbox, the side of an umbrella stand, the front of a chest of drawers or the pages of a magazine: Piero Fornasetti had turned the face into his motif of choice and lavished it on furniture and objects that were to become icons of their age.

As Fornasetti told me later, those eyes belonged to a turn-of-the-century opera singer, Lina Cavalieri, whose somewhat tortuous destiny and perfect features fascinated him (and also

23

touched the heart of painter Giovanni Boldini). In the 1980s it was those features, in their various guises, that would welcome you as you crossed the threshold of an improbably shambolic studio on the Via Brera in the centre of Milan. Here in this emporium, in which every nook and cranny was crammed with a hundred of his creations, the designer reigned supreme – although his reputation by now extended little further than his immediate surroundings in Milan. Always prepared to discuss his designs, and attended by a gracious housekeeper, he would wait for visitors with firm resolve: I use this expression advisedly, since he was never one to suffer gladly either intrusions or visits by people who had unfortunately simply lost their way as they wandered through the area, finding themselves at the door of this whimsical boutique out of mere curiosity. Ever suspicious, discriminating and ironic, Fornasetti's willingness to trust and confide would increase by measured degrees. His appearance suggested an essential paradox: there was a concern for form – in every sense of the word – expressed by a refined sense of elegance, codified and slightly out of date, in understated tweeds or cashmere, yet this was simultaneously enhanced (or countered) with a flamboyant waistcoat or tie, or perhaps an impertinent pocket handkerchief, showing not only particular care for his appearance, but also superb insolence in the face of conformity or the outwardly respectable.

As has been the case with so many designers whom I have found myself having to track down, either because they have retired, or because they have been forgotten (I am thinking of the 'interior portraitist' Alexander Serebriakov, or jewelry designer Line Vautrin), Fornasetti had a fair sense of his own worth, but came up against the obstinate refusal of the artistic authorities and institutions to recognize his importance anywhere except 'merely' in the decorative arts, relegated, as it were, to a lesser category. He never lost his acute awareness of the prejudice suffered by 'decoration', an essential mode of the human condition, as he saw it, and held to be no less an essential expression of it by Poe or Baudelaire.

Like so many artists considered secondary, Fornasetti found himself at odds with mainstream opinion very early on (he was expelled for insubordination from the art academy where he had been enrolled for only a few months); and like so many others, what mattered to him was to find his own way,

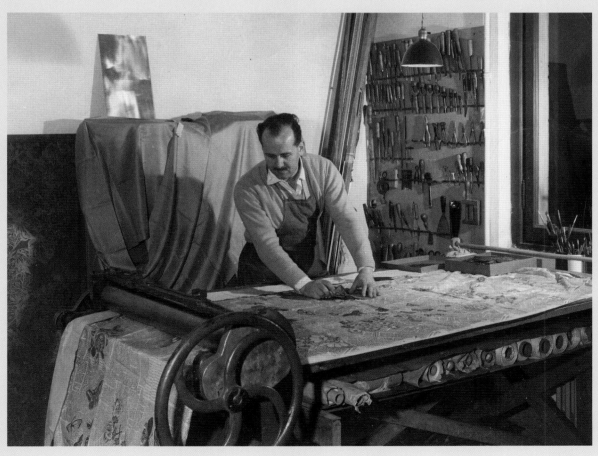

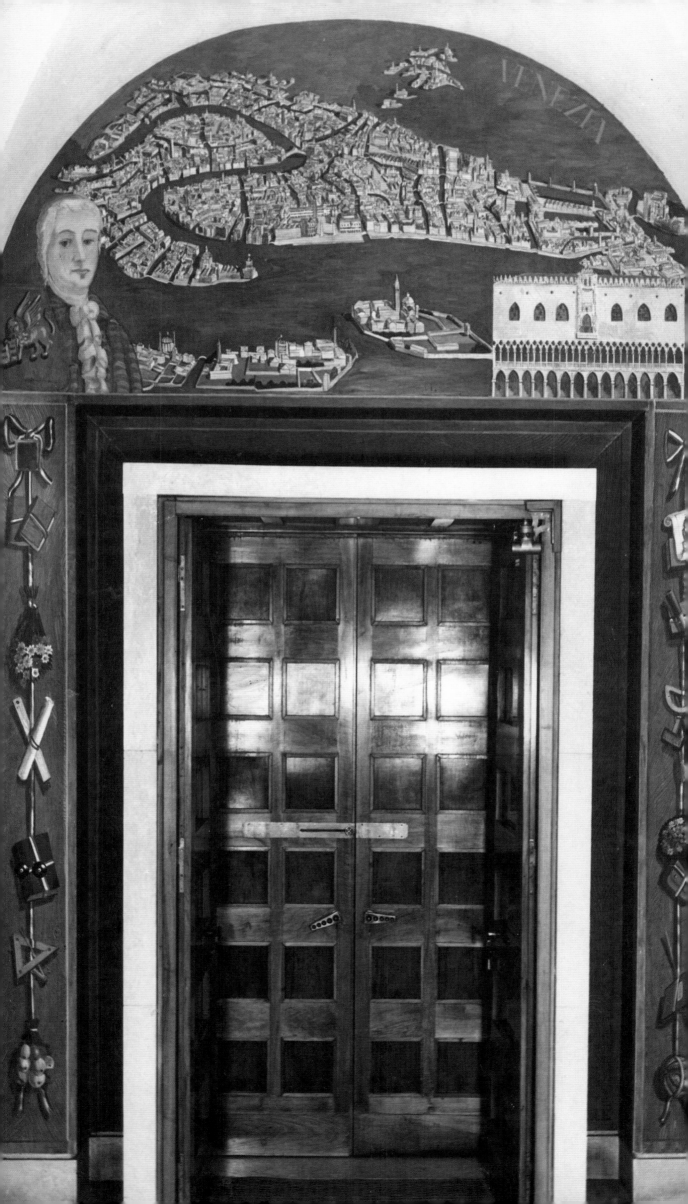

to follow his imagination, to experiment, albeit hesitantly, and to conjure up his own world.

Born in Milan in 1913, Fornasetti participated in his first Triennale when he was barely twenty years old, presenting a series of printed silk scarves, demonstrating that the importance of printing may be traced back to his earliest work. An artist of multiple talents, Fornasetti mastered glassmaking, ceramics, textile design, woodwork and papermaking; he was, however – again, like so many artists in different areas (René Gruau or Jean-Paul Goude, to name but two) – first and foremost a graphic artist for whom the line and the stroke – as one might call a 'light line' – were the essential modes of expression. It is what he would call, picking up the Italian artistic tradition since the Renaissance, 'disegno', which – far from referring to a single drawing – covers a whole vision of life, both aesthetic and ethical (as in the Zen practice of archery, the subject of a famous work by Eugen Herrigel that Fornasetti identified elsewhere as the fundamental influence on his vision of the world).

The corollary of this basic rigour was Fornasetti's definitive rejection of every sort of romantic pathos, of nineteenth-century *scapigliatura* such as the soft and sinuous forms of the Art Nouveau or Liberty style that was all the rage in Milan when he was growing up. His artistic approach was unmistakably influenced by the formalism pursued by certain artists to whom he was close in Italy in the 1930s. He was also eager to acknowledge a fundamental debt to two books: Carlo Carrà's *Giotto* and Roberto Longhi's *Piero della Francesca*. These books both show that the metaphysical experiment during the early decades of the twentieth century had its roots in a sort of 'primitivist' memory of Italian art, resonating with Quattrocento 'purism' and various expressions of a 'return to order' that were current in Europe at the time. The pure lines, dull chromaticism, restrained colour range, the taste for a certain monumentality, shallow spaces, the recourse to classicizing gestures and themes, along the lines of Picasso subject matter in the 1920s, all find an echo in the rarefied atmosphere one can identify in the frescoes that Fornasetti painted in 1942 at Palazzo Bo in Padua.

However, Fornasetti's work is delivered without a hint of dryness; in fact, this clarity and formal control were to him nothing more than the flipside or the medium of dream (his famous 'follia pratica': the desire to put 'reason' at the service of 'unreason').

The artist with whom Fornasetti had most in common in this sense, and in many others, was probably the impressive Alberto Savinio, Giorgio De Chirico's brother, another all-round talent, a friend of Fornasetti's, and for whom Fornasetti illustrated several books. Without question Fornasetti was an artist who could be defined within the tradition of the 'artist dilettante', as he would have identified Savinio: from Lucian to Montaigne, Stendhal, Nietzsche and himself, sharing, as he wrote, 'the company of the Great Amateurs: these men who have liberated themselves from sad necessities and resolved all of life's rationalities in the form of pleasure,' before adding an observation of particular interest here: 'these men who have "crossed" the depths. These are, moreover, the only ones, the truly "superior" men, the most spiritually "superior", because they are the "lightest": the most "enlightened"'.

Fornasetti never lost his first passion for typography, and all his life was a voracious consumer of paper, books and all and any newspapers. He also professed particular admiration for the work of Leo Longanesi, a man little known outside Italy, a great publisher, editor, painter, draughtsman, graphic designer and polemicist with whom Fornasetti shared a taste for disarming irony and critical distance, and whose publications he kept religiously, in complete series. (He could doubtless have shared Longanesi's own profession of faith: 'Even as a child, I was fascinated by almanacs, dream collections, card games, bottle labels, grandmother's embroidery, and all the things that are totally out of date today').

It was through the expedient of printed matter that the decisive moment of his career came about. Having seen a collection of Fornasetti's 'lunari', or almanacs, at the seventh Milan Triennale in 1940, Gio Ponti proposed a partnership that would change Italian and European design in the twentieth century. It would flower in the interior decoration of the big liners such as the *Conte Grande* (1950) and the *Andrea Doria* (1952), and again at the spectacular San Remo Casino, and in an example of 'total décor' at the Casa Lucano in 1951, with the iconic furniture that was a part of it (the 'Architettura' cabinet, the 'Palladiana' chest of drawers).

Only someone with such a cultivated and curious sense of the modern as Ponti could make room for a person whom – in the face of the triumph of the right angle and the concrete

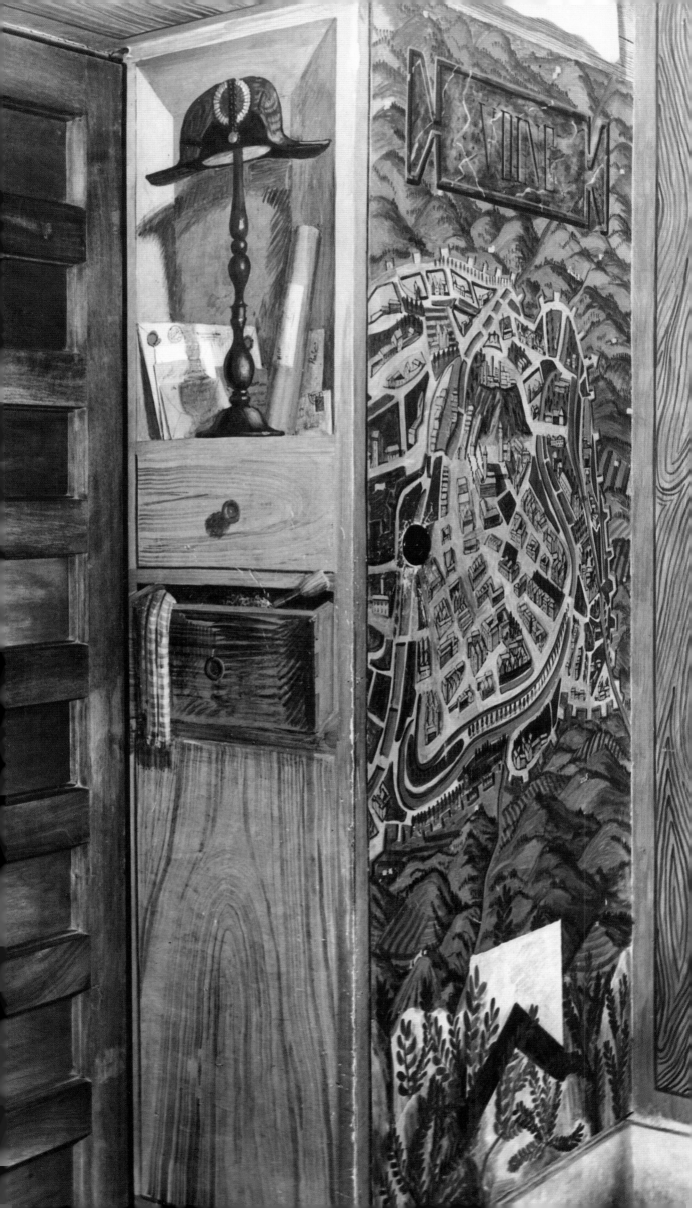

Preparatory sketch for the Zodiac Suite on the transatlantic liner *Andrea Doria*, 1951, tempera on paper, 37 × 45 cm

cage – he himself designated as a master of ornament. ('In this era of open contempt for decoration,' Ponti calmly asserted in 1962, 'Fornasetti gladly stands as a witness to its importance... He teaches us to read ornamentation in all its forms.') No one knew better than Fornasetti how to apply his graphic games to the furniture and surfaces Ponti created, playing with effects of scale and depth in a sort of jocular, outsize trompe l'oeil. Fornasetti took advantage of what he had learned in his magnum opus, a veritable architecture of illusion, made up of screens and practical items, transposed from one place to another, that he had thought up between 1955 and 1958 and christened *Stanza Metafisica*. One can see here how this game of motifs – applied motifs – manages to subvert one's sense of depth, seeking not so much to decorate or to impose a rhythm as to question the notion of depth itself, to register it as a false pretence, to provoke in the spectator a sense of dizziness and uncertainty.

The perfect osmosis between the two designers, and the exemplary works they created, had only one negative consequence for Fornasetti: they set a formula with which he would become stuck, reducing his role as a designer of furniture and interiors to the detriment of his other modes of expression – in the first place, his paintings, as the 2013 exhibition at the Triennale Design Museum revealed, but also drawing, book design, printing and production, and design for exhibitions and special events.

The variety of his stylistic registers and particular talents shows Fornasetti to belong to a wave of artistic taste in Europe between 1930 and 1960 that has yet to be fully understood. It was created by artistic as much as literary individuals whose common theme was to resist the formulaic doctrines of modernism, and to counterpoise a neo-baroque or neo-romantic imagination, while at the same time re-evaluating works and movements that had hitherto become neglected. These individuals, although often no more than informally linked by friendship and the occasional collaboration, shared certain predilections. One day someone should draw up a map of this imaginative aesthetic landscape featuring, among others, the Sitwells, Clough Williams-Ellis, Cecil Beaton and Rex Whistler in Britain, Christian Bérard, Emilio Terry, the Noailles and Charles de Beistegui in France, Fabrizio Clerici, Leonor Fini, Lila de Nobili and Eugene Berman (in his later years), in Italy... Fantasy architecture, games of

cards, saltimbanques and harlequins, ruins and obelisks are all
motifs that belonged in one way or another to most of these
figures, and indeed to Fornasetti. One has only to think, for
instance, of the frescoes Gino Severini painted for the Sitwells'
Castello Montegufoni, filled with pensive harlequins, and which
Fornasetti borrowed after 1924 before turning them into the key
motif for the Arlecchino cinema in 1949; or of Eugene Berman's
superb lithographs for *Viaggio in Italia*, a book designed, typeset
and published by Fornasetti in 1951. Although he may have culti-
vated a fierce desire for independence, and may have legitimately
asserted the singularity of his creation, we cannot imagine that
the inventor of the *Stanza Metafisica* – omnivorous reader that
he was, always in touch with the artistic events of his time – was
not aware of its links with this secret fraternity.

Somewhere amid the creative pattern of these artists'
motifs we should not forget the fundamental obsession with
trompe l'oeil that brings Fornasetti close to designers as diverse
as Martin Battersby, Pierre Roy or (once again) Berman. The
renewed interest in the genre in the 1930s, which has long been
considered no more than anecdotal, was manifested by a small
circle of artists, connoisseurs and collectors in both Europe and
the United States: gallerist Julian Levy, collector and critic James
Thrall Soby, and museum director Chick Austin, among others,
to whom we owe the re-evaluation of traditional nineteenth-
century American masters of illusion such as William Harnett
or John Peto, who in their turn influenced the work of artists
such as Joseph Cornell.

Visual tricks, imaginary stage and theatre settings, figures
borrowed from commedia dell'arte, fantasy landscapes, games,
tropes and allusions to literature and art: the loss of a reference
point and the blurring of identity are the driving forces behind
Fornasetti's art. Concealed one behind the other are his regular
stylistic approaches: his taste for series, which incidentally lends
him the status of a forerunner of one of the principal themes
of contemporary art. It is a procedure by which form seems to
arise out of itself in an endless game of features and deviations
– or variations – and which radically questions the fetishized
notions of signature, originality and uniqueness (which allows
Fornasetti to be positioned, from this angle at least, in the cat-
egory of the grand masters of process: from Roussel and Jarry
to Duchamp and Warhol).

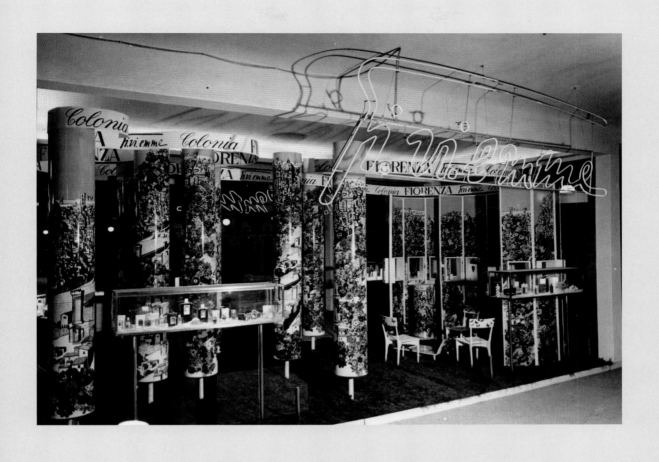

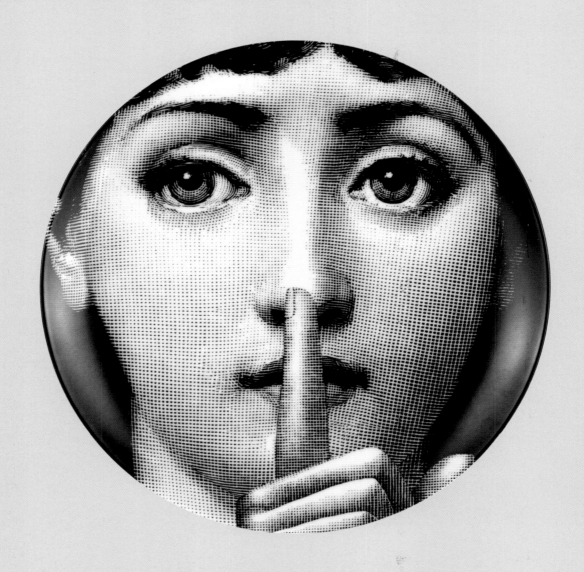

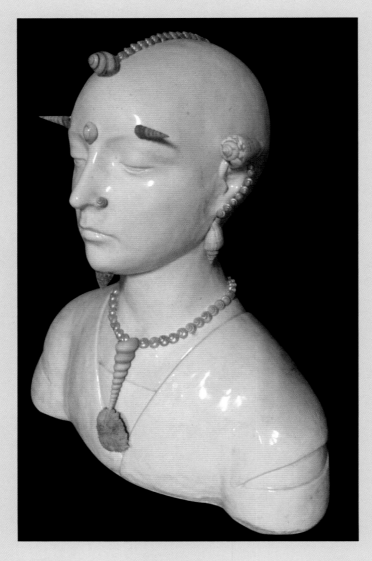

It may be said that he went so far as to lend a properly 'conceptual' dimension to his approach when he opened the Galleria dei Bibliofili in the 1970s. This was his response to the decline in popularity of his work and allowed him a way of continuing by other means. One need only look at the titles of exhibitions that he organized between 1977 and 1980 to recognize a certain continuity with the themes of his designs: 'Fruit Market', 'The Hand', 'The Sun', 'Owls, Grand Dukes and Co.', 'Behind the Screen', 'Fire and Flames'.

It should come as no surprise that the mask was the chosen theme of one of the gallery's last exhibitions, in April 1980. The mask that he most enjoyed playing with latterly was that of a strange character for whom the world could be represented in a single piece, whose reality was made up of finished objects that were arranged in close correspondence, both comparable and yet distinct from one another: cup-and-ball games and tableware sets; platters and corkscrews; lighters and umbrella stands; screens and ashtrays... The mask was that of the collector, behind which Fornasetti liked to hide and whose organized madness he worshipped. And this 'collector's collector' could be counted, as he once famously said in an interview, among those fanatics who collected orange wrappers, scientific retort stands, the capitals of ancient columns, razors, pencils, or objects in the form of a tortoise, or a duck (by a Mr Canard) and elephants (but only red ones), to name but a few of the things he had gathered around him. These were passions as extreme as Charles Fourier might have felt, and whose sense of secrecy Fornasetti enjoyed: a methodical spirit of obstinacy, long patience, the truly aesthetic search for the way something is made, a dedicated love of objects – and as for collections as a whole, the utter gratuity of these invisible works ultimately destined to be taken apart and dispersed... If one could conceive of such a person as an 'artist-philosopher', it seems to me legitimate to see in Fornasetti an 'artist-collector', a hybrid personality whose life's work sprang from this passion for nomenclature and constituted a unique, gigantic cabinet.

The easy-going face of Lina Cavalieri, the centrepiece of the collection, was turned into over 350 variations, printed on every kind of material; but more were certainly intended. A little sign in the Via Brera shop promised a gift of six plates

Tema e Variazioni (Theme and Variations) booklets, edited by Piero Fornasetti and Vanni Scheiwiller, 1964, offset print
Piero Fornasetti at the Brera shop, Milan, 1983

to anyone who could think up new ones. Fornasetti knew that his style wouldn't define an era, albeit one deeply marked by him, but that it was one created by a lover of mazes, dizzying tricks, trompe l'oeil and winks in the direction of a knowing spectator…

It was just this sort of conviction that brought me to the door of his studio to propose an idea for a book that would trace the course of this irregular journey. This suggestion from a passing stranger was received with the sort of circumspection one might expect; but after a series of meetings, endless discussions and stern inquisitions, and after which he had finally decided to give me his imprimatur, Fornasetti welcomed me one day with the look of a malicious conspirator. He told me to expect an unusual object, which did indeed appear a few days later, on the day before my return to Paris. It was a small heavy suitcase, which he handed over to me with strict orders to be discreet, and telling me to open it only when I was in a safe place.

When I did open it, with slight hesitation and trembling fingers, I found a single gigantic volume composed of reproductions and meticulously glued papers, in which he had cut and pasted the work of his life (this was the model and matrix for the slightly more modest volume on which we began work in 1987 and which contributed, I think, to his real stature). A final ironic twist, brought about by his unexpected demise during the course of a routine hospital stay on 15 October 1988, meant that he was prevented from holding in his hands the volume he so ardently wished for. At least he had been able to accomplish the most essential part: assembling the images, the objects and projects that had preoccupied him for so long, tracing (or drawing, once again) the thread of his life, compiling the complete and definitive set of themes and variations, with the care of a collector in his cabinet, in a final, fascinating paper monument.

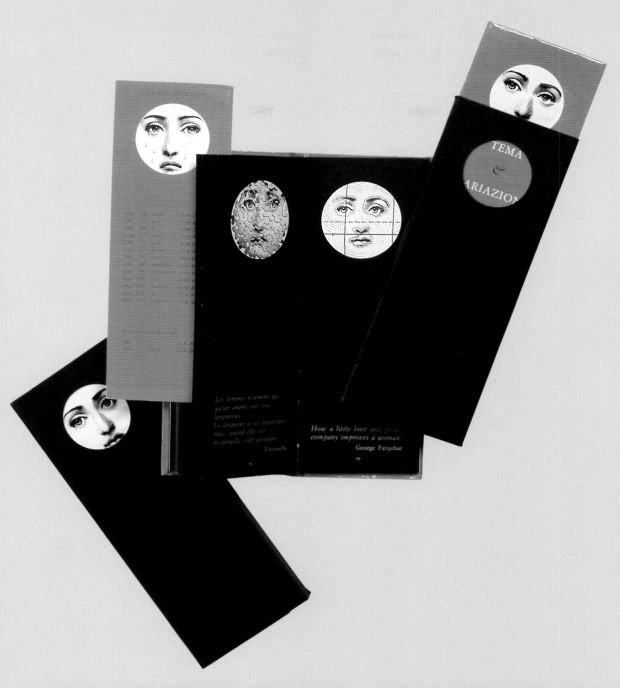

Les femmes n'aiment pas
qu'un amant soit très
langoureux.
La langueur a ses avantages,
mais, quand elle est
perpetuelle, elle assoupit
 Fontenelle

How a little love and good
company improves a woman.'
 George Farquhar
99

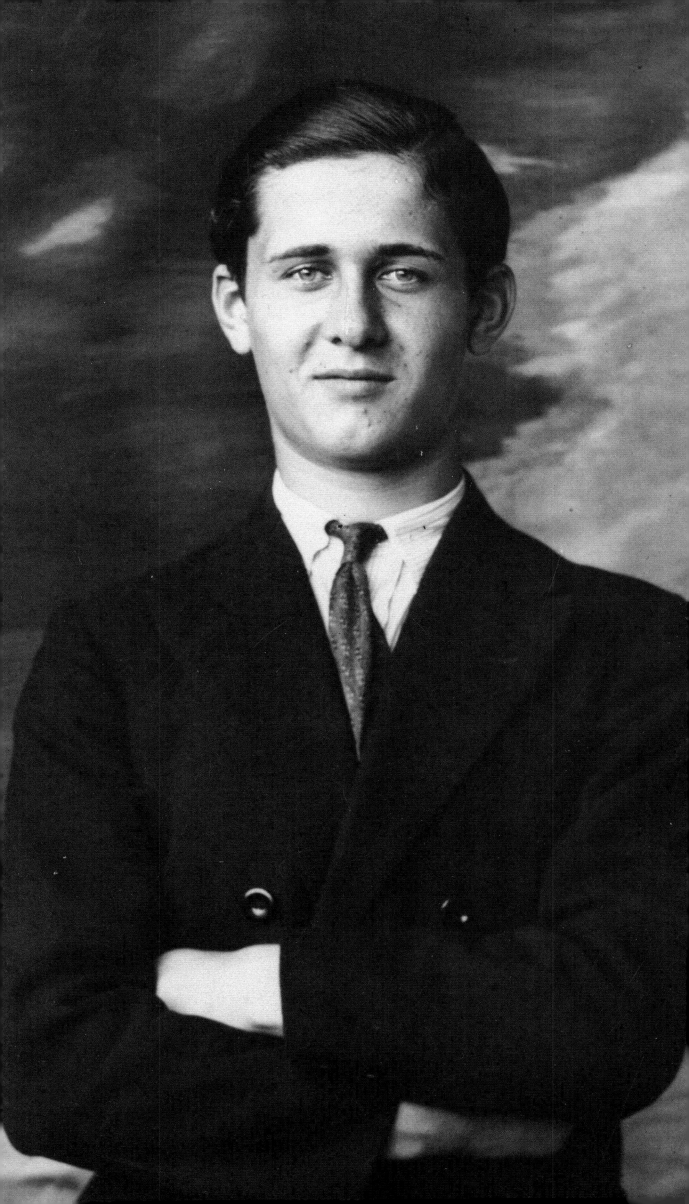

A LIFE'S THREAD

Ginevra Quadrio Curzio

'No one could see in that photo of me aged fourteen
what sort of person I would become...'
Piero Fornasetti[1]

There is a photograph of Piero Fornasetti aged only
fourteen that shows a solid, well behaved looking young man
wearing a tie and a waistcoat, arms folded across his chest,
who smiles slightly awkwardly yet without affectation at the
camera. The left side of his face – from the viewer's standpoint
– is more open and 'solar'; the right hand side, a little more
'lunar' and dreamy, melts into the background of an image
from a world of fantasy worthy of a Magritte painting.

1.
Fornasetti Archives, Milan

By looking carefully at the photograph of this fourteen-year-old, one can actually get a feeling for what the young man is going to become, or at least to spot the unmistakable link that connects his character with the cloud kingdom, the imagination. In reality, Piero Fornasetti knows exactly what he will or would like to become. But a biographer needs to proceed in an orderly fashion – so we should begin at the beginning.

Piero Fornasetti was born in November 1913 in Milan, the eldest son of a comfortable middle-class family. His father Pietro, a businessman from Lombardy, had broad intellectual aspirations, and an unbridled passion for singing. He loved to sing operatic arias in every register, from tenor to bass via baritone. He had a house built in the Citta Studi area on what were then the outskirts of the city, where he lived with his family and conducted his business importing typewriters (and later metal construction). The house, built around a courtyard that doubled as a garden for pleasure and for growing vegetables, consisted of business premises on the ground floor and the family home on the floors above. Pietro and his wife Martha Munch were not a typical couple: he, although Italian, was tall and blond, while she, German, was short and dark-haired. Years later, their son Piero said in an interview: 'Complete opposites, like everything I do. I'm simply destined to live with contrasts.'[2]

Pietro's taste for the arts and his encyclopedic aspirations did not prevent him from being an extremely authoritarian father: for him the future of his four children, Piero, Lina, Gigi and Marta, was never in doubt. He wanted them each to fulfil an element of his own ambitions. In recognition of his passion for singing, his eldest daughter was to be a piano teacher; his youngest son would write a famous opera in the mould of Aïda; as for the eldest, Piero, he would pursue his studies in accountancy in order to help his father manage his business.

In fact, Piero discovered at the age of ten – as family legend has it – that what he really enjoyed was not accountancy: 'I'll never forget my feeling one summer's morning when I was a child out by the lake, and for the first time my pen drew the outline of a leg, then a body, then a face. I was amazed, in heaven, dazzled by this miracle, and I am still astonished today when I see this image come bursting out all by itself from somewhere deep inside me onto the paper…'[3]

2.
'Gli allegri mobili
di architettura
di Piero Fornasetti',
Architektur und Wohnen,
4 December 1982.

3.
From the group exhibition
'Dell'incisione contemporanea'
with Piero Fornasetti,
Luciano Lattanzi, Dadi Orsi,
Romano, at the Galleria
dei Bibliofili, February 1983,
Milan, Archives Fornasetti.

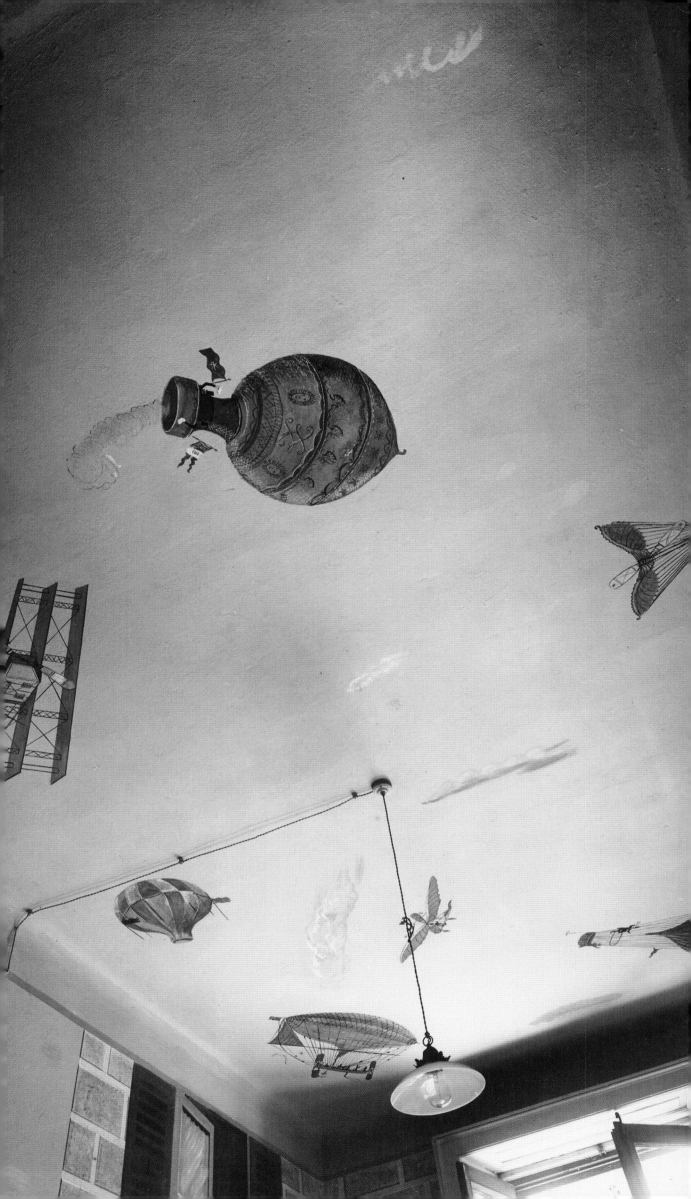

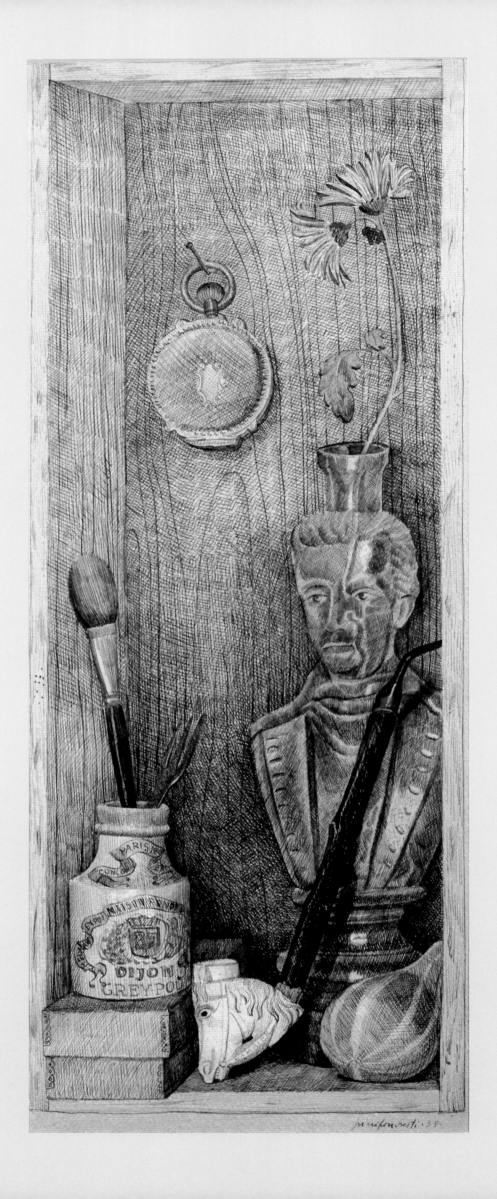

Natura morta in una nicchia (Still life in a niche), 1938, Indian ink on paper, 18.5 × 47.5 cm

As a child, Piero drew and painted constantly. He covered the walls of his room at home with trompe l'oeil decorations, as he would later: on his ceiling hot-air balloons and strange flying machines drifted through delicate clouds, while on the walls dreamy women appeared at painted windows, framed by classical columns, with other architectural elements and exotic birds. And here we come back more or less to our starting point, to a photograph taken in around 1929 when he was about sixteen, in which Piero is shown with his artistic creations – figurative compositions, apparently conventional and far from experimental, of landscapes, architectural views, still lives.

Another of Piero Fornasetti's character traits emerges from this photograph. In the portrait, his smile has vanished. His expression is sombre, perhaps even somewhat defiant… Stubborn, tenacious, Piero evidently appears to have decided to follow his own path, to think for himself without letting himself be led astray by anyone else. He succeeded, in fact, against his father's wishes, in enrolling at the Brera academy of fine arts. He may have been strong enough to resist his family, but he also refused to follow the course programme which he didn't like. Shortly after he enrolled he was expelled for insubordination. Self-taught by instinct, he couldn't accept that his lessons at the academy didn't extend to what his own research and reading had taught him was essential for the training of an artist: the study of the nude.

He registered for night classes at the Castello Sforza to study applied arts. There he discovered a passion for architecture, which he saw as the highest expression of drawing in the sense intended by artists from antiquity and the Renaissance. He continued to read and to collect books and journals obsessively, storing up information, continuing to broaden his knowledge, eagerly following events in Italy and the wider world. But his education basically consisted of personal exploration and experimentation. As he recalled in the 1980s, 'No one could teach me anything, in the ateliers I visited. I learned from books. I learned lithography, engraving. I learned all that before schools were started for teaching individual techniques.'[4] In the visual arts, and notably in painting, Europe was in the middle of the 'Return to order' – a wave of activity revisiting the tradition of classical art, as opposed to the avant-garde

4.
Sarah Wasserman, in conversation with Piero Fornasetti, in Patrick Mauriès, *Fornasetti. La follia pratica*, Turin, Allemandi, 1992, p. 283.

Rapanelli (Radishes), 1940s, oil on panel, 32 × 24 cm
Libri (Books) table, 1950s, lithograph on wood with painting by hand, 100 × 50 × 44 cm

movements that were all the rage, experimenting with a conception of art as a direct expression of the subject (which Fornasetti referred to dismissively as *scapigliatura*).[5] The Italian artists of the Novecento movement advocated faithful rendition, compositional rigour, colour as a way of lending dimension to the figure.[6] It was here that Fornasetti had encounters that would prove decisive for him: 'I was lucky enough,' he said, 'to be interested in culture when the Novecento happened, and to meet some of the "movement's" followers, whose ideas I espoused: painting should be tonal (like that of Giotto, Masaccio, Piero della Francesca, and as it has been inherited by Carrà, Sironi and Soffici) and in architecture, one should only be rational.'[7]

The bronze stele commemorating the Italian campaign in Abyssinia that Fornasetti exhibited in 1936 at the Milan Triennale, his decorative project for the palace of Italian civilization in Rome (not completed) and his frescoes in 1942 for the Palazzo Bo in Padua were evidence of his rediscovery of classical art, an approach he had in common with the Novecento painters.

At the beginning of the 1930s, the workshop in a building on the Via Bazzini that Fornasetti's father had put at his disposal had a printing press. Fornasetti tried out every technique of gravure and printing: lithography, engraving, drypoint, monotype. His assiduous practice of all these techniques quickly gave him the necessary skills, both as an accomplished engraver and printer. He collaborated with the greatest artists of his time, printing artists' books and lithographs for them, thereby making his living. The Stamperia d'Arte Piero Fornasetti produced work by Fabrizio Clerici, Carlo Carrà, Massimo Campigli, Eugene Berman, Giorgio De Chirico, Orfeo Tamburi, Marino Marini and Lucio Fontana.

The evolution of Piero Fornasetti's talents was decisively marked by one other encounter during these fruitful years, namely with architect Gio Ponti. Fornasetti attracted his attention with his presentation of a series of scarves at the fifth Triennale (Ponti was its director). The scarves were printed with an innovative technique that produced original effects. Within the space of a few years, a sort of creative symbiosis between Ponti and Fornasetti emerged, from which sprang numerous ideas and designs: almanacs, a decorative scheme for the EUR building, covers for *Domus* and *Stile* magazines, edited by Ponti,

5.
'Rumpled', 'unrestrained', a reference to a literary and artistic movement from the end of the nineteenth century in Lombardy.

6.
The Italian Novecento movement was launched by Margherita Sarfatti, close collaborator with Mussolini. Created in Milan in 1922, its members included artists such as Achille Funi, Mario Sironi, Ubaldo Oppi and Carlo Carrà among many others.

7.
Nicoletta Berta, 'Piero Fornasetti : una vita per la bellezza ripetibile', meeting with the Italian designer when he was invited for a month to the gallery Spazioarte de Mendrisio, *Il Mendrisiotto*, 12 July 1983.

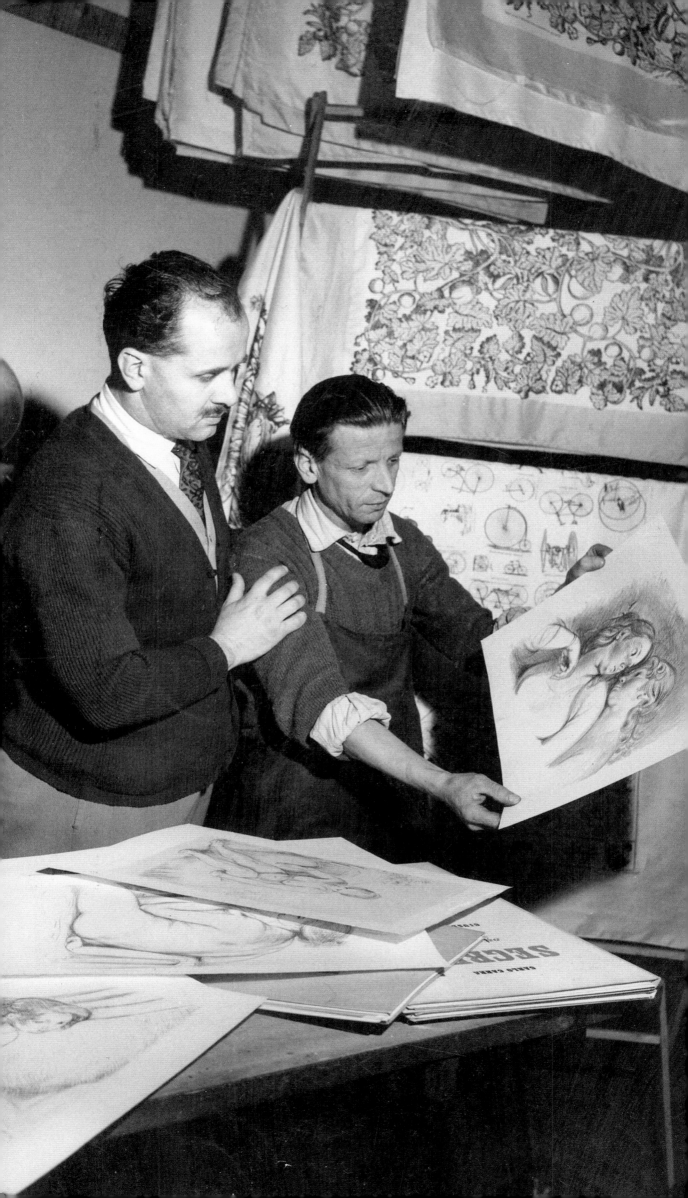

the *Architettura* trumeau bar cabinet exhibited at the ninth Triennale in 1951 and which stands today as the emblem of their partnership, many items of furniture, the decoration of the Casino at San Remo (1950), the interior decoration of the Casa Lucano (1951), the cabins and first-class salons of the transatlantic liner *Andrea Doria* (1952).

His meeting with Gio Ponti gave Fornasetti the reassurance that he could bypass the limitations of painting, strong in the conviction that once the laws of drawing had been assimilated, everything 'will then be possible: inventing ideas, exhibiting, making architecture, advertising, acquiring organization, method'.[8] He was equally encouraged not to confine the privilege of his painting activity to traditional media such as canvas and paper, but to extend it to any material, surface, or object.

During the war Fornasetti stayed in Milan. He was commissioned to decorate the officers' mess at the barracks on the Piazza Sant'Ambrogio with fruit and marine still lives. He was briefly arrested in 1943 and left for Switzerland, where he continued his artistic activity. He produced printed silk scarves for a local textile factory and designed the sets, costumes, announcement and poster for a 1945 production in Geneva of Albert Camus's *Caligula* by Giorgio Strehler under the pseudonym Georges Firmy. While interned in a camp at Deitingen near Geneva, he used himself as a model, for want of alternatives, in a series of pen drawings. They were published in a collection entitled *Autoritratto* (Self-Portrait) in 1966, with an epigram by Leonardo da Vinci: 'The mirror, the mirror above all, is your master.'

On his return to Milan in 1946, Fornasetti prepared – in the words of his artist friend Fabrizio Clerici – 'to fill the universe with scarves and the stationers with calendars'.[9] But he didn't stop there. After the war, Fornasetti continued his researches into graphic art, producing posters, advertisements, logos, both for himself and on commission. He decorated the Dulciora patisserie and the Arlecchino cinema in Milan, in partnership with architects Mario Righini and Roberto Menghi, as well as with artists such as Lucio Fontana. He refitted a shop on the Via Montenapoleone with Clerici, Campigli, Sassu and Manzù. He created all sorts of fashion accessories that didn't go out of fashion. He was awarded the Neiman Marcus prize

8.
Interview with Marzia Schiano, no date, Milan, Archives Fornasetti.

9.
Fabrizio Clerici, 'Piero Fornasetti: His Almanachs', *Graphis*, vol. 3, no 20, 1947, p. 266–270

Poster for a production of Albert Camus's play *Caligula* directed by Giorgio Strehler under the pseudonym Georges Firmy, Geneva 1945. Print on paper, 1945

with Ferragamo, Roberta di Camerino and Valentino. He organized an exhibition at the Musée des arts décoratifs in Paris in 1970, 'Bolide design', on the car as an aesthetic object. He designed sets for theatre productions as well as for exhibitions of his own work and Italian design for American and European department stores.

Throughout the world, Fornasetti was hailed as synonymous with 'Italian style'. His shop on the Via Brera was a sanctuary, where he reigned, according to his friend Miro Silvera, 'as Jupiter seated on Olympus, an imperial Jupiter whose head emerges from behind a malachite-green writing desk, while the telephone receiver transmits mysteries and figures to him long distance.'[10]

It is a short step from here, however, to a memory Philippe Starck recounts of a visit he made when he was very young during the 1970s with friends to Fornasetti's shop, where he understood nothing of this muddle of ashtrays, plastic and porcelain objects, screens, plates, waistcoats, ties, obelisks and architectural decorations.[11] At a time when rational function reigned supreme, Fornasetti's work was catalogued as kitsch; economic and administrative difficulties forced him radically to reduce his workshop staff and only to carry out work to order. As a response to these constraints, he created the Galleria dei Bibliofili, a way of continuing to stay in Milan and to participate in the city's cultural life (a vital necessity for him): 'I'm continuing to draw and to make sketches for new things.... But what interests me right now is another side of my business. Organizing stimulating exhibitions, looking for new talents to be discovered among the young and emphasizing certain unknown aspects of painters who are already recognized.'[12] Numerous exhibitions, both on single themes, and group shows by artists gathered from far and wide, were put on during this time: 'The Hand', which brought together two thousand objects from every period; 'The Sun', with more than one thousand drawings, photographs, sculptures, ceramics and poems; 'Owls, Grand Dukes and Co.' from ancient Greece to the present day; 'What is Design?' with definitions by Gio Ponti, Gae Aulenti, Marco Zanuso and Ettore Sottsass; and a show entitled 'Bon appetit', with tables decorated according to inspirations by different artists, that impressed many visitors. Fornasetti's work began to be rediscovered during the

10.
Miro Silvera, 'Fornasetti allegorico', 1985, Milan, Archives Fornasetti.

11.
Brigitte Fitoussi, *Piero Fornasetti. Conversation entre Philippe Starck et Barnaba Fornasetti*, Paris, Assouline, 2005.

12.
Nicoletta Pallini, « Mobili e oggetti anni 50 », 15 October 1983, text for the Mercanteinfiera at the Palazzo ducale, Parma.

THÉATRE DE LA COMÉDIE

LABYRINTHE PRÉSENTE LA

COMPAGNIE DES MASQUES

DIRIGÉE PAR CLAUDE MARITZ

ET GEORGES FIRMY DANS

CALIGULA

TRAGÉDIE D'ALBERT CAMUS

PREMIÈRE: 27 JUIN 1945, A 20 H. 30 ★ FORMES: 29-30 JUIN 1945, A 20 H. 30
MATINÉE POPULAIRE A PRIX REDUIT 1er JUILLET 1945, A 14 HEURES 45

LOCATION OUVERTE A «LA COMÉDIE» DÈS LE 18 JUIN 1945 ★ PRIX DES
PLACES : DE FR. 1.50 A 7.- ★ (DROIT DES PAUVRES COMPRIS) TÉL. 4 05 00

Imprimeries Populaires, rue de Lausanne 27, Genève

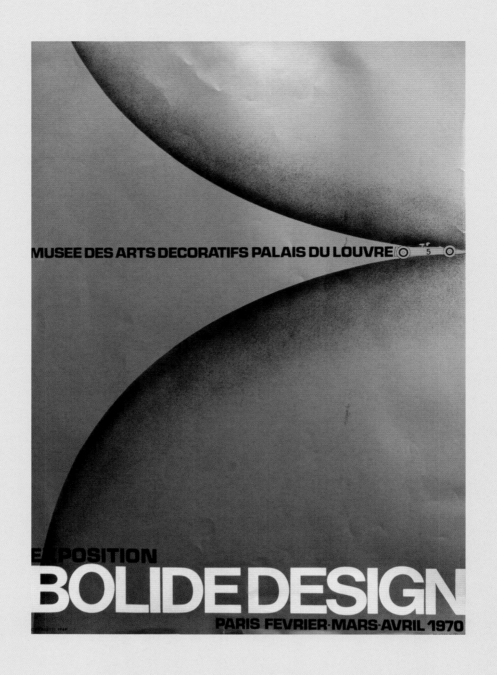

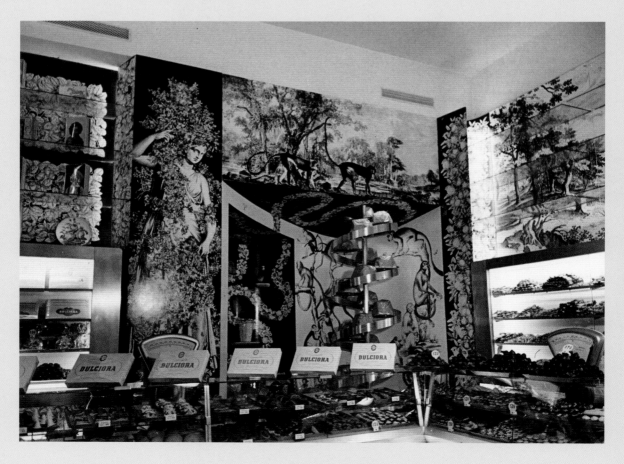

1980s, despite the ideological debate raging between form/
function and ornament, notably thanks to the opening of the
gallery Themes and Variations in London, under the initiative
of Liliane Fawcett and Giuliana Medda. In 1987 Piero began his
collaboration with Patrick Mauriès on the first full monograph
of his work, with an introduction by Ettore Sottsass.

After years apart, Piero's son Barnaba re-established his
relationship with his father and came to Milan to help with his
business. It was the beginning of a partnership that allowed
Barnaba to understand his father's work in depth and to carry
it on, safeguarding its spirit while launching it into the world
of contemporary design.

Piero Fornasetti died in Milan in 1988 during the course
of a minor medical intervention.

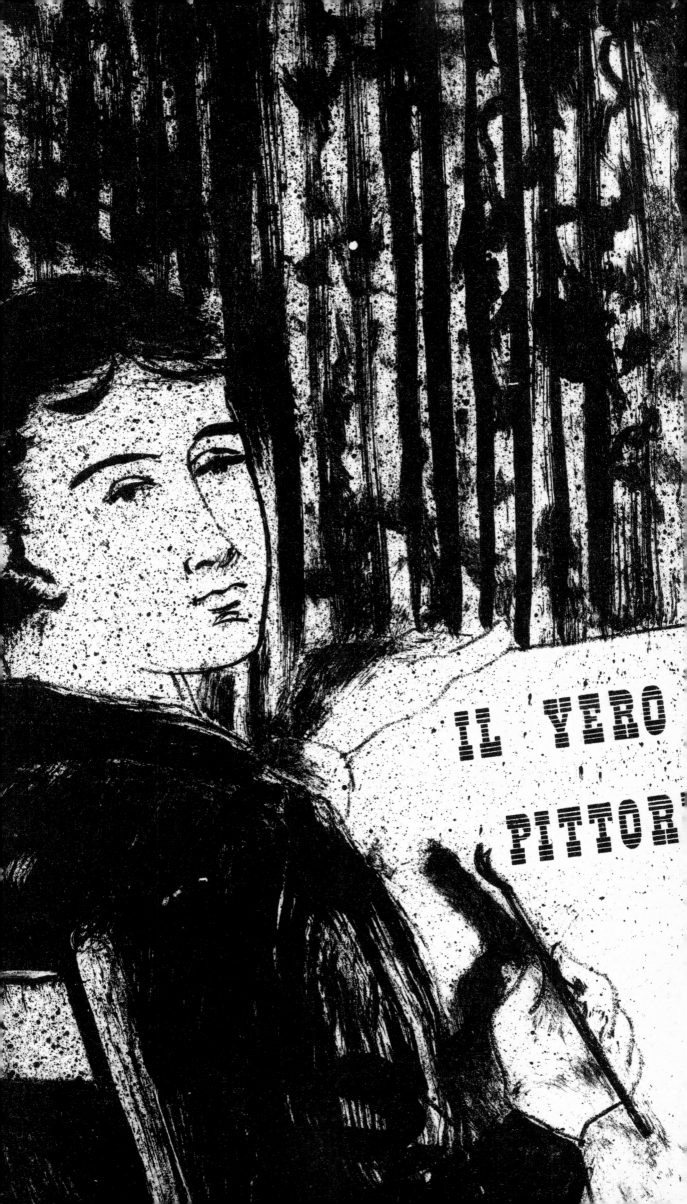

IL VERO PITTORE

One of twelve drawings
made for the calendar *Il vero pittore*
(The true painter)
1948
Mixed technique on paper
25 × 36 cm

Il vero pittore, the true painter, is the title that
Piero Fornasetti gave to the almanac that he
sent to his friends for 1948 and for which
he used a variety of techniques, demonstrat-
ing his many skills, to show his mastery of
his trade. Despite his anti-authority attitude
that led to his being expelled from the Brera
Academy of Fine Arts, he never renounced
the importance of his artistic training and his
work as a painter. 'I had the luck,' he said, 'to
involve myself in culture just as the Novecento
group arrived,' a movement that espoused the
'return to order' and a figurative approach,
and in whose circles Fornasetti moved in the
1930s, primarily with Carlo Carrà, but also
Ubaldo Oppi, Achille Funi and Mario Sironi.
It gave him the opportunity 'to associate
myself with their ideas, in particular that of
tonal painting (as done by Giotto, Masaccio or
Piero della Francesca)…' Although eclipsed
by his decorative work, his painting cannot
be dissociated from it: to adapt a well-known
phrase, the first is a continuation of the second
by other means.

53

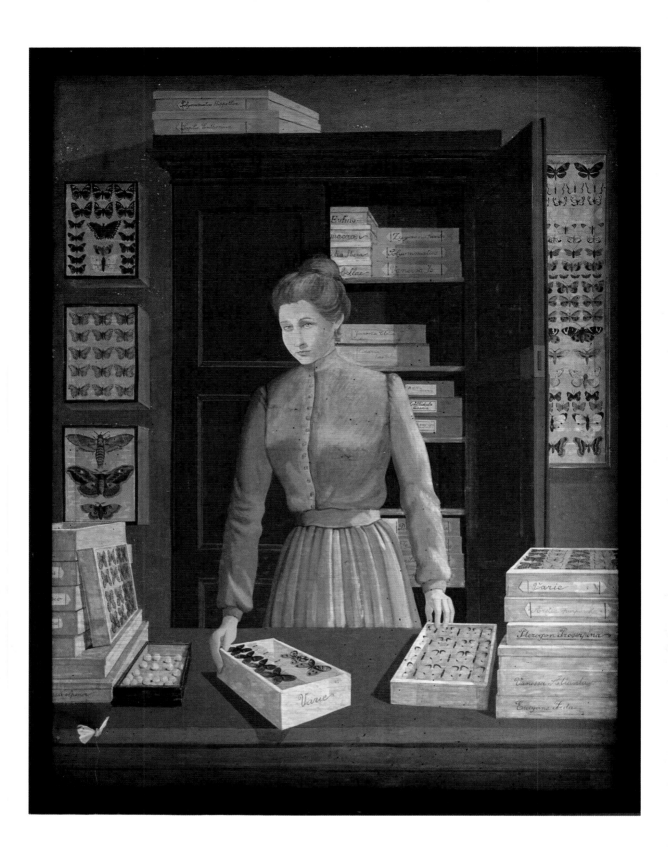

La venditrice di farfalle
(The Butterfly Seller)
1938
Tempera on panel
150 × 120 cm

Il vero pittore
(The true painter) calendar
1948
Mixed technique on paper
25 × 36 cm

AGOSTO

1	D	s. Pietro in V.
2	L	s. Alfonso de' Lig.
3	M	Invenz. s. Stefano
4	M	s. Domenico c.
5	G	s. Virginio
6	V	s. Sisto II papa
7	S	s. Gaetano Thiene
8	D	s. Erminia verg.
9	L	ss. Fermo e Rustico
10	M	s. Lorenzo martire
11	M	s. Radegonda
12	G	s. Chiara vergine
13	V	s. Ippolito martire
14	S	s. Alfredo
15	D	Assunz. di M. V.
16	L	s. Rocco conf.
17	M	s. Emilia Bicchieri
18	M	s. Elena imperat.ce
19	G	s. Giacinto conf.
20	V	s. Bernardo abate
21	S	s. Privato martire
22	D	s. Timoteo
23	L	s. Filippo B.
24	M	s. Bartolomeo ap.
25	M	s. Lodovico re
26	G	s. Alessandro mart.
27	V	s. Genesio m.
28	S	s. Agostino vesc.
29	D	s. Sabina
30	L	s. Rosa da Lima
31	M	s. Abbondio v.

GIUGNO

1	M	s. Crescenzio
2	M	s. Erasmo vescovo
3	G	s. Clotilde verg.
4	V	s. Quirino
5	S	s. Bonifacio
6	D	s. Eustorgio v.
7	L	s. Roberto abate
8	M	s. Medardo
9	M	s. Primo martire
10	G	s. Diana vergine
11	V	s. Barnaba ap.
12	S	s. Onofrio anacor.
13	D	s. Antonio da P.
14	L	s. Eliseo profeta
15	M	s. Vito martire
16	M	s. Aureliano
17	G	s. Ranieri conf.
18	V	s. Marina verg.
19	S	ss. Gervasio e Prot.
20	D	s. Silverio papa
21	L	s. Luigi Gonzaga
22	M	s. Paolino vescovo
23	M	s. Lanfranco
24	G	s. Giovanni Batt.
25	V	s. Eligio vescovo
26	S	s. Rodolfo mart.
27	D	s. Ladislao re
28	L	s. Attilio
29	M	ss. Pietro e Paolo
30	M	s. Lucina verg. e m.

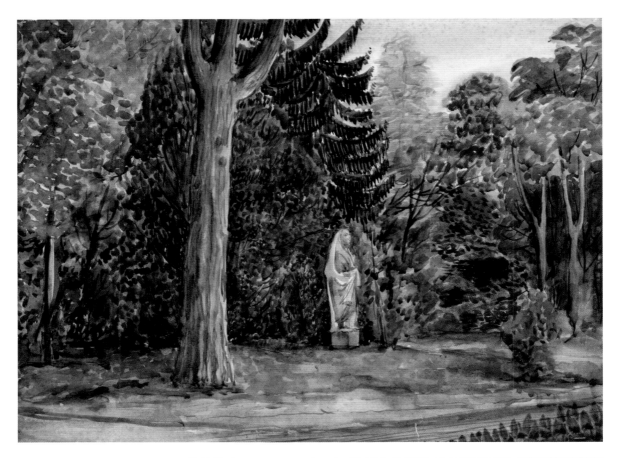

Statua in giardino
(Statue in the garden)
1940s
Watercolour on cardboard
50 × 37 cm

Spiaggia (Beach)
1940s
Tempera on cardboard
45 × 35 cm

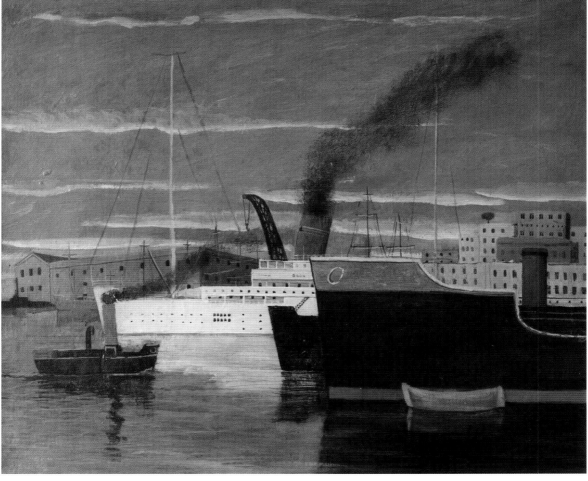

Nudo femminile con sfondo della Città ideale
(Female nude with background
of the Ideal City)
1930s
Pencil and tempera on paper
45.5 × 25 cm

Porto di Genova (Port of Genoa)
1932
Oil on panel
60 × 50 cm

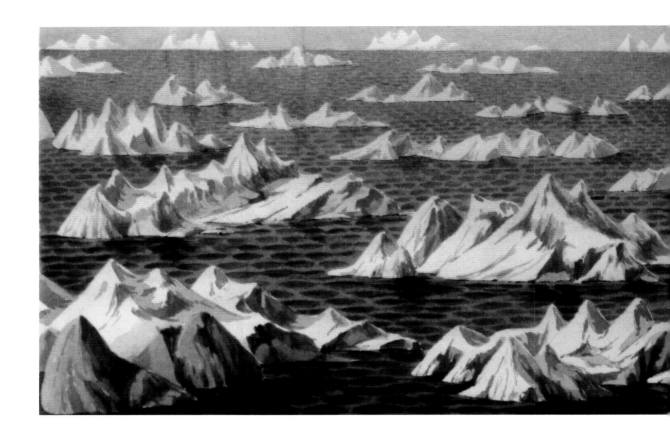

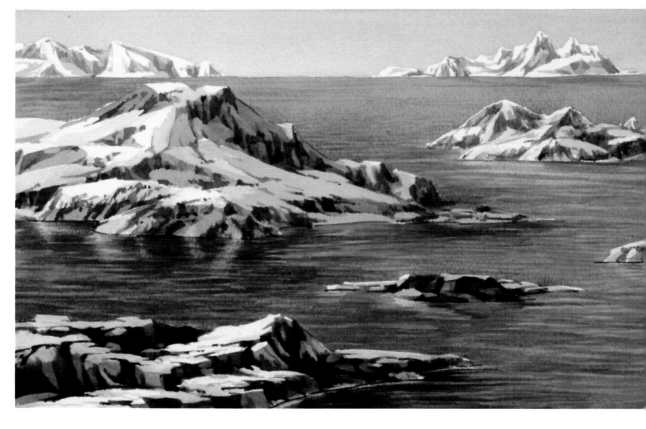

Iceberg
1950s
Preparatory sketch in monochrome
watercolours
88 × 30 cm

Iceberg
1950s
Preparatory sketch in monochrome
watercolours
88 × 30 cm

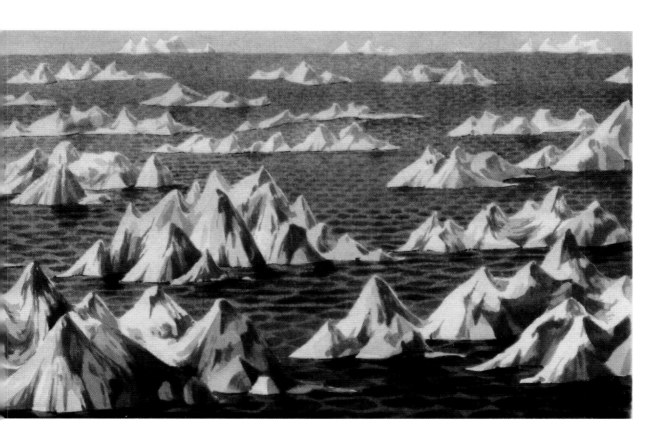

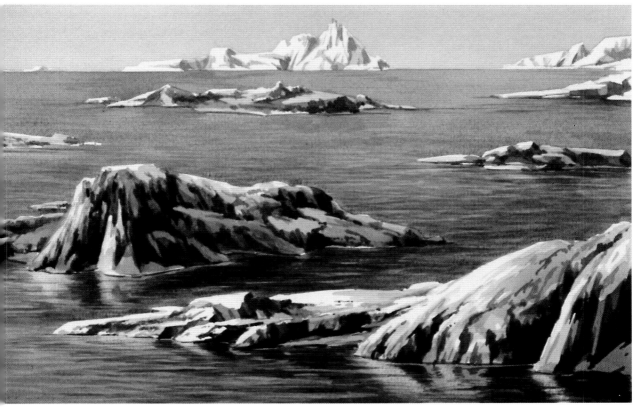

59

Pesce (Fish), from the series 'Pesci' (Fishes)
1940s
Coloured Indian inks on paper
31 × 37.5 cm

Pesce (Fish), from the series 'Pesci' (Fishes)
1940s
Coloured Indian inks on paper
21 × 29.5 cm

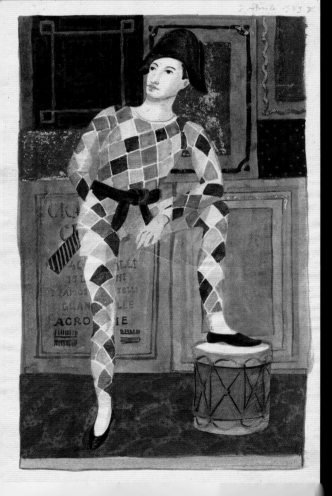

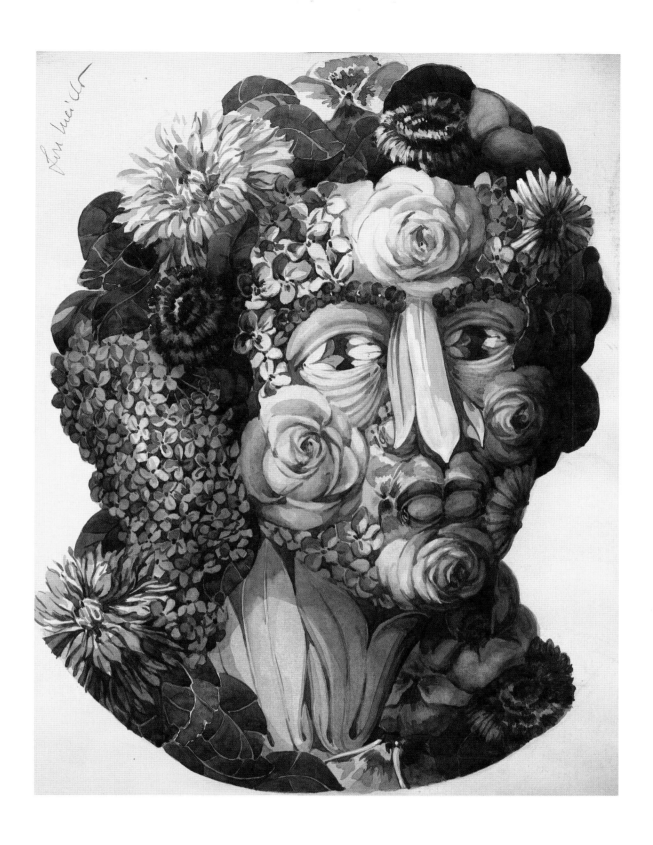

Arlecchino (Harlequin)
1939
Tempera on paper
30 × 39 cm

Ritratto di Raffaele Carrieri
(Portrait of Raffaele Carrieri)
1932
Tempera on paper
29 × 39 cm

Untitled study for fresco
1930s
Tempera on paper
18.5 × 49.5 cm

Uomo con passamontagna
(Man with balaclava)
1930s
Tempera on paper
23.5 × 26 cm

Fiori arcimboldeschi
(Flowers in the style of Arcimboldo)
1940s
Watercolour on paper
28 × 35 cm

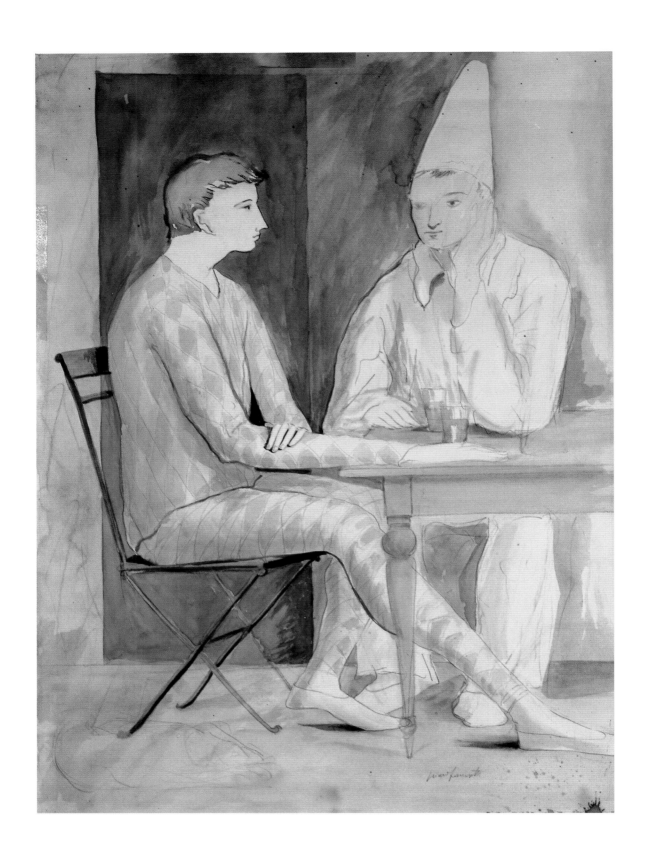

Arlecchini (Harlequins)
1949
Watercolour on paper
40 × 51.5 cm

Untitled painting on an erotic theme
1940s
Oil on panel
31.5 × 41 cm

Melograno (Pomegranate)
1975
Pencil on paper
31 × 23 cm

Bottiglie (Bottles)
1972
Mixed technique on paper
24 × 17.5 cm

Pagliaccio (Clown)
1940s
Watercolour on paper
27 × 39 cm

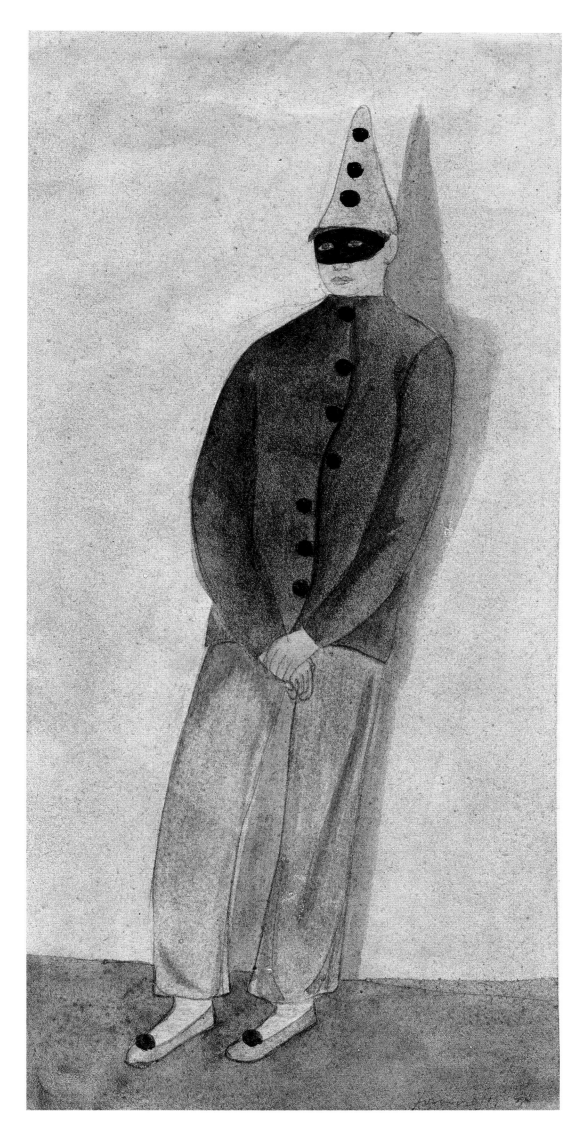

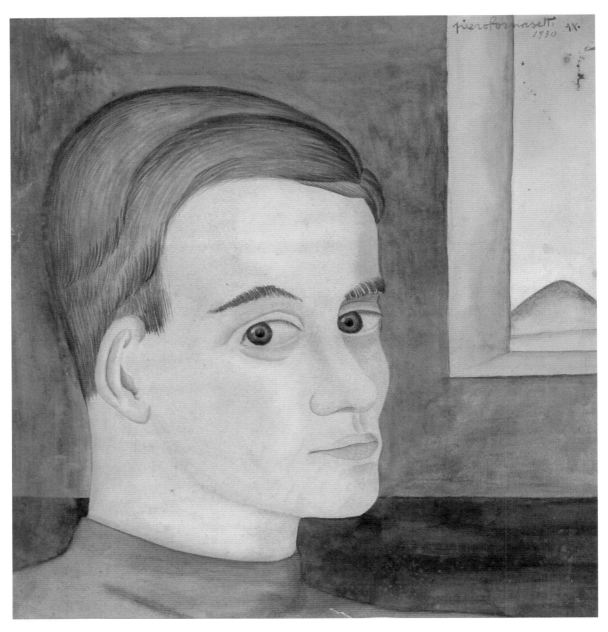

Ritratto maschile (Portrait of a man)
1930
Tempera on cardboard
30 × 28.5 cm

Profilo femminile (Profile of a woman)
Watercolour on paper
1978
56.5 × 26 cm

Untitled
1970s
Mixed media
42 × 21 cm

Zeus, from the Dei (Gods) series
1945
Watercolour and Indian ink on paper
21 × 29.5 cm

Chitarre e maschere (Guitar and Masks)
1930s
Oil on wood
39 × 75 cm

Natura morta (Still Life)
1930s
Watercolour on cardboard
43.5 × 29 cm

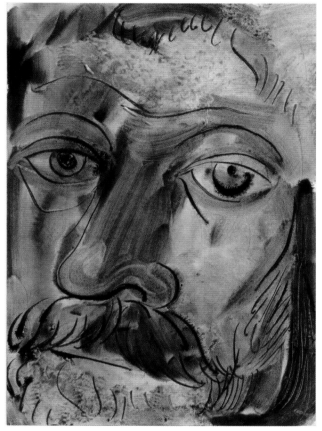

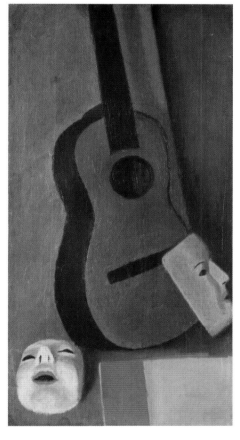

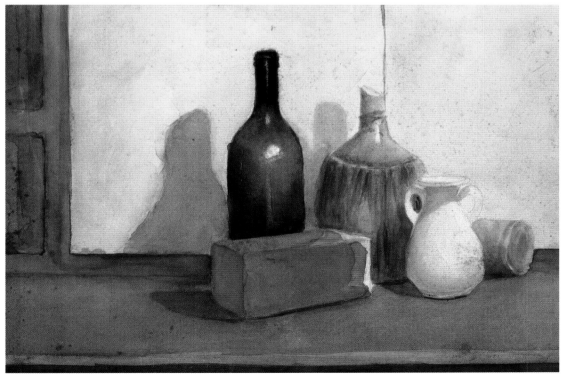

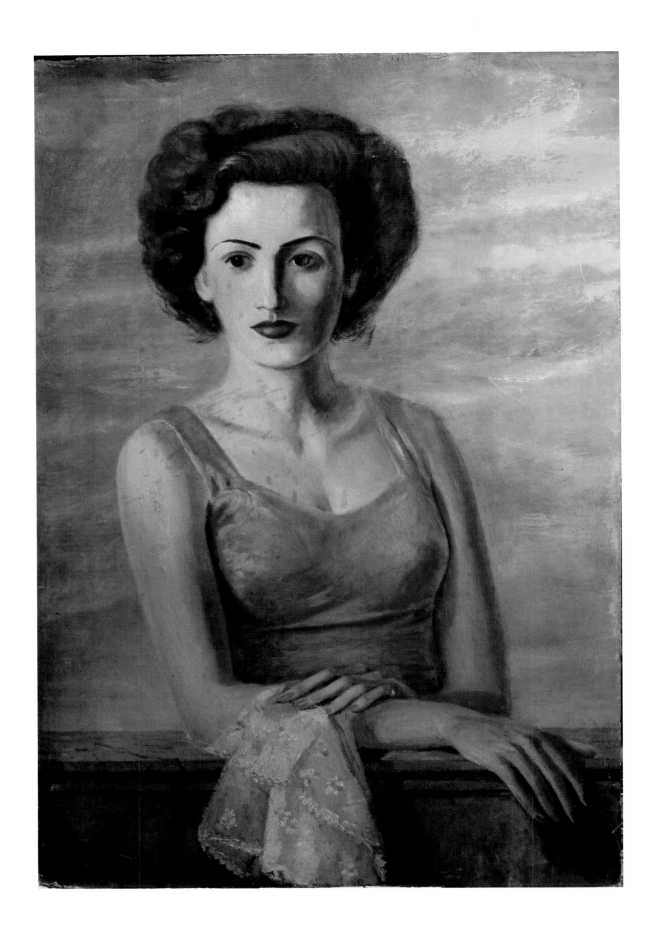

Ritratto femminile (Portrait of a woman)
1940s
Oil on cardboard
51 × 75 cm

Profilo maschile (Profile of a man)
1972
Pencil on paper
31 × 50 cm

Ritratto maschile (Portrait of a man)
1970s
Pencil on paper
36 × 50 cm

1/50

THE GENIUS OF THE LINE

Since the Renaissance, the Italian word *disegno* has referred as much to the trace of the line as it does to the mental activity itself, to the calculation that precedes the simple act of drawing, and sustains it. By absorbing this traditional value, Fornasetti turns *disegno*, the genius of the line, into a founding notion, a true principle, both the ethic and aesthetic, of his approach: as he stated it, 'drawing as a discipline, as a way of life, as a way of organizing one's existence, and as an uninterrupted study of things, in what makes their essence.'

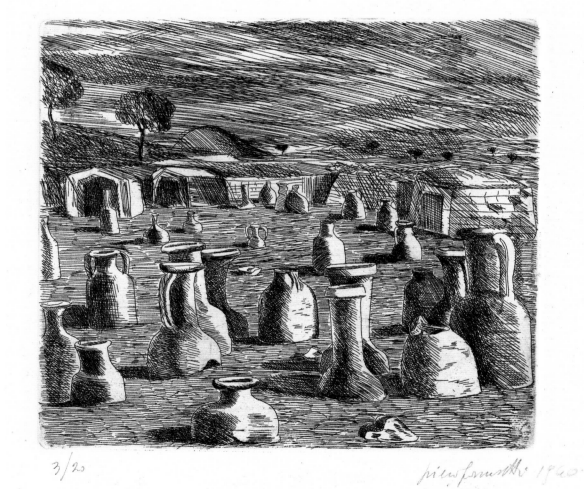

3/20 pierfrancesco 1940

Preparatory sketch
for *Leopardo* chest of drawers
1950s
Mixed technique on paper
37 × 20.5 cm

Frammenti di anfore sulla spiaggia
(Fragments of amphorae
on the beach)
1940
Lithograph
49.5 × 35.5 cm

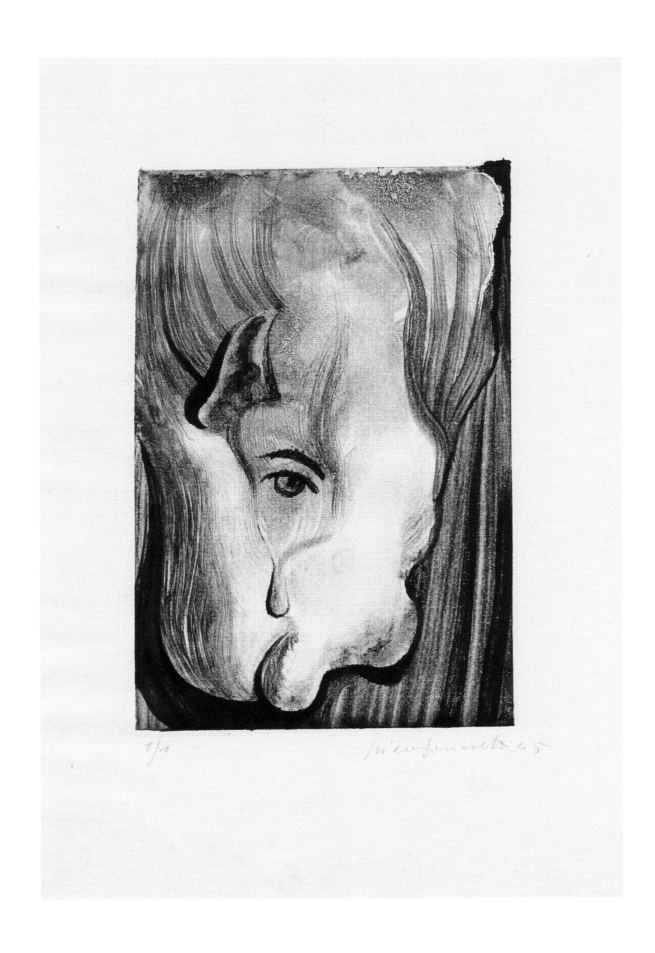

1/1

La lacrima del satiro (The satyr's tear)
1945
Monotype on paper
9 × 14 cm

75

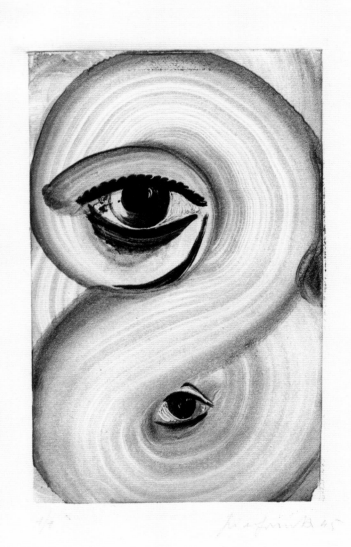

Untitled
1945
Monotype on paper
9 × 14 cm

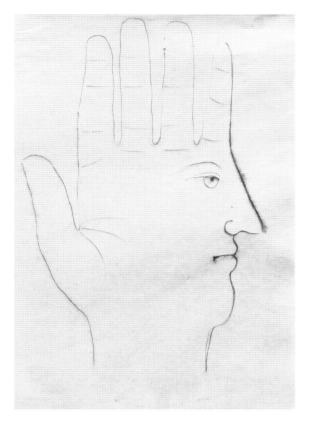

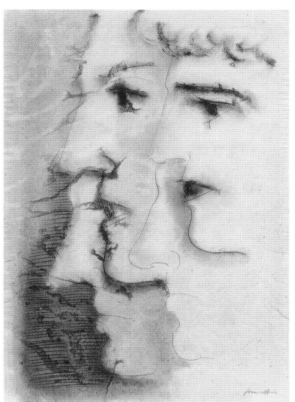

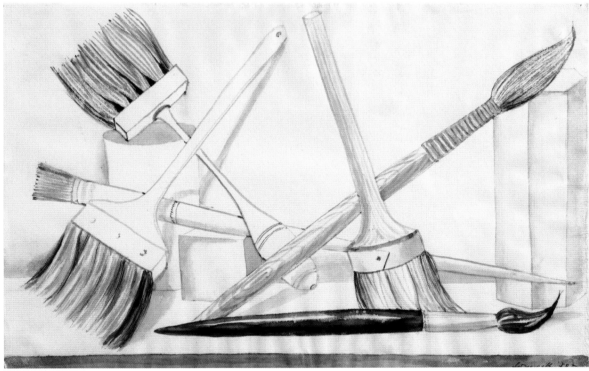

Mano profilo (Hand profile)
from the 'Mani' (Hands) series
1940s
Indian ink on paper
21 × 29.5 cm

Untitled,
from the series 'Sogni e Mostri'
(Dreams and monsters)
1940s
Indian ink on paper
20.5 × 29.5 cm

Pennelli (Brushes)
1940s
Indian ink on paper
33 × 22 cm

Untitled, from the 'Erotica' series
1973
Indian ink on paper
21 × 29 cm

Untitled, from the 'Erotica' series
1945
Indian ink on paper
21 × 29 cm

79

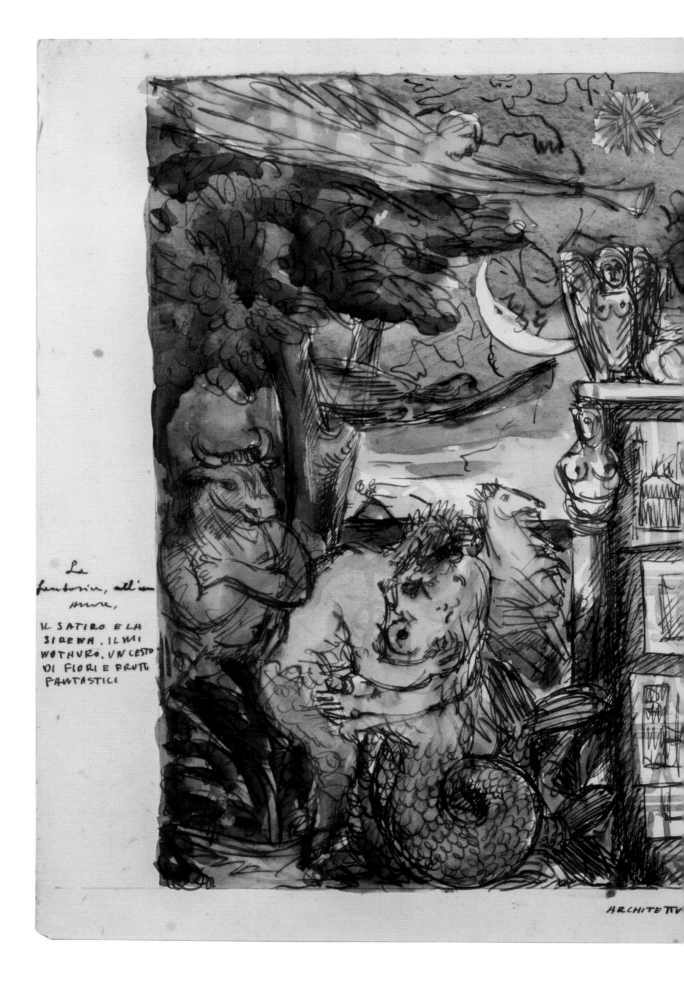

La
fantasia, all'...
anne,
IL SATIRO E LA
SIRENA. IL MI
NOTHURO. UN CESTO
DI FLORI E FRUTI
FANTASTICI

ARCHITETTU

Architetture Fantastiche
(Fantastic architecture)
Watercolour and pencil on paper
1950s
50 × 36 cm

80

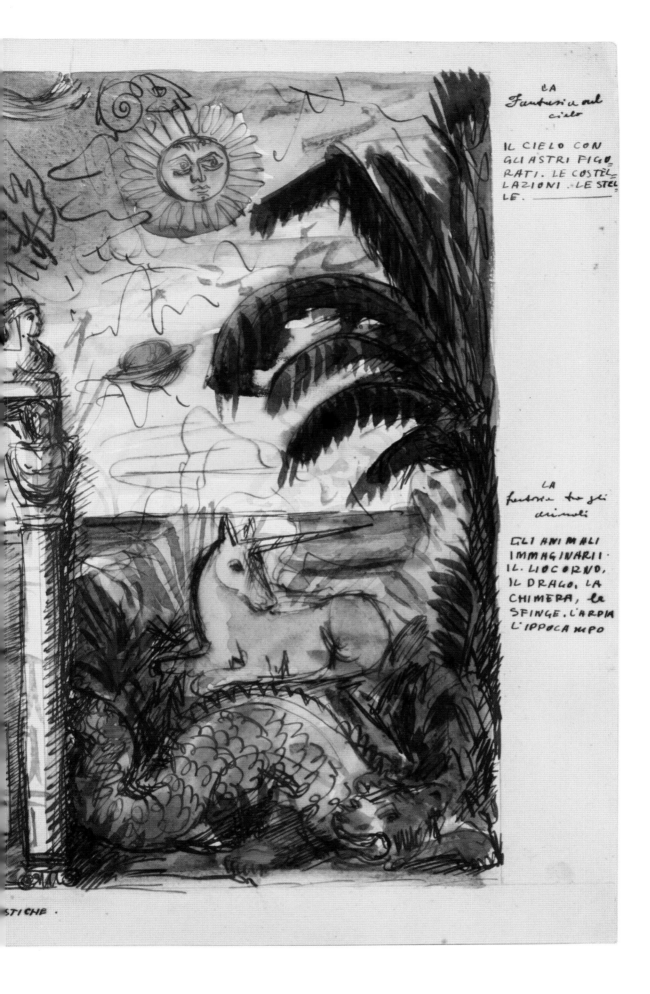

LA
Fantasia nel
cielo

IL CIELO CON
GLI ASTRI FIGU-
RATI. LE COSTEL-
LAZIONI . LE STEL-
LE. _____

LA
fantasia tra gli
animali

GLI ANIMALI
IMMAGINARII ·
IL. LIOCORNO,
IL DRAGO, LA
CHIMERA, le
SFINGE. L'ARPIA
L'IPPOCAMPO

...STICHE .

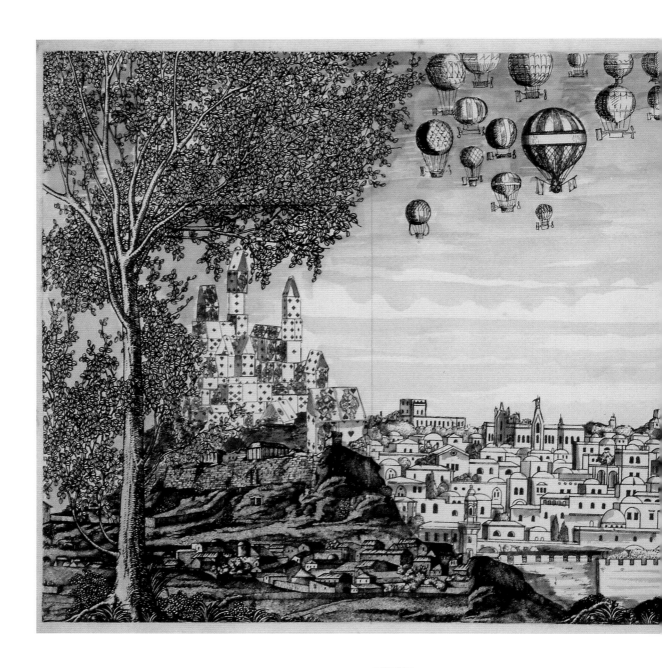

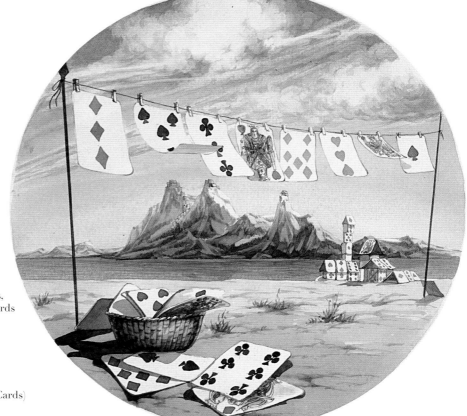

Sketch of a composition
with several themes:
Arcadia, Hot-air balloons,
Jerusalem and City of Cards
Pen and brush on panel
1950s
61 × 32 cm

One of the twelve
preparatory drawings
for *Città di carte* (City of Cards)
1950s
Watercolour on paper
Diam. 26 cm

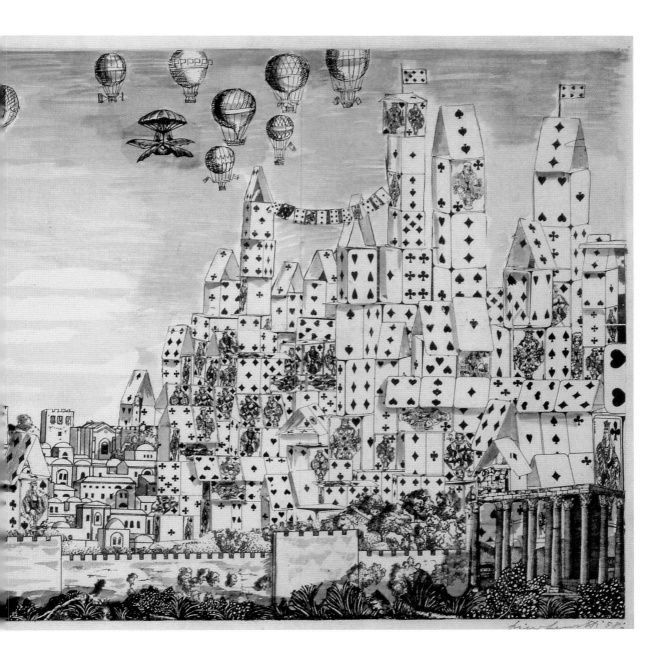

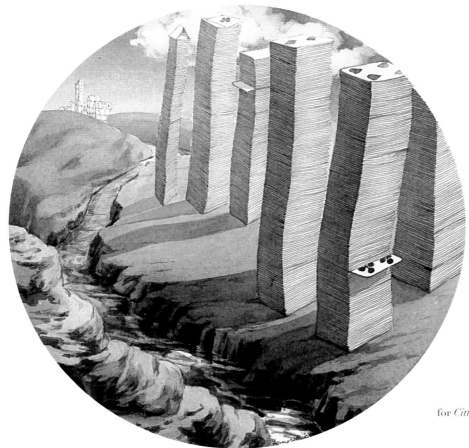

One of the twelve
preparatory drawings
for *Città di carte* (City of Cards)
1950s
Watercolour on paper
Diam. 26 cm

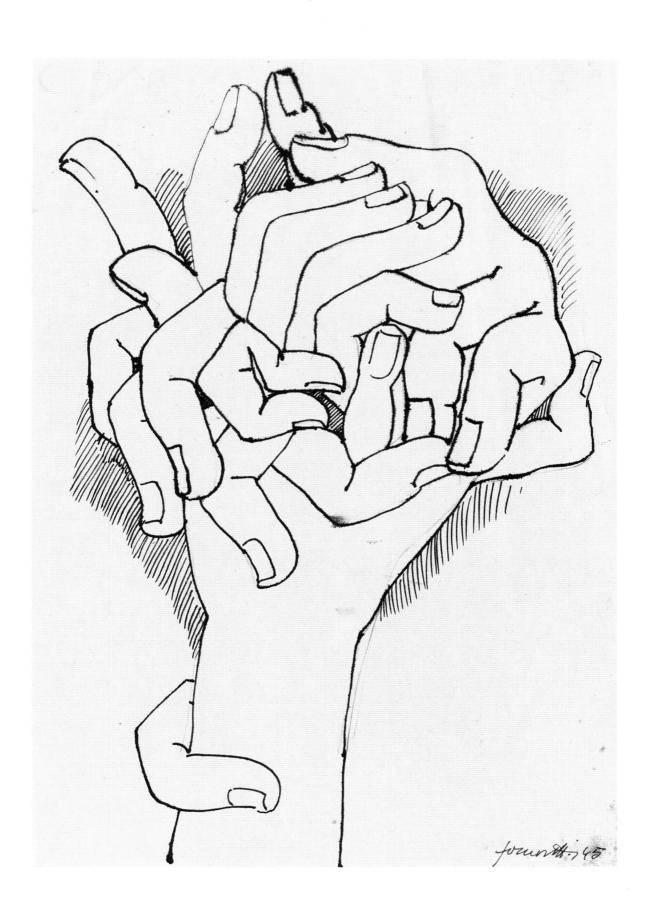

Preparatory sketch
for the screen *Arlecchini*
(Harlequins)
Late 1940s
Mixed technique on paper
40 × 48 cm

Ragazza con uova
(Girl with eggs)
1930s
Lithograph
9.5 × 10 cm

Untitled,
from the 'Sogni e mostri'
(Dreams and monsters) series
1940s
Indian ink on paper
21 × 35 cm

Untitled,
from the 'Mani' (Hands) series
Indian ink on paper
1945
21 × 29.5 cm

Untitled,
from the 'Erotica' series
1945
Indian ink on paper
21 × 29 cm

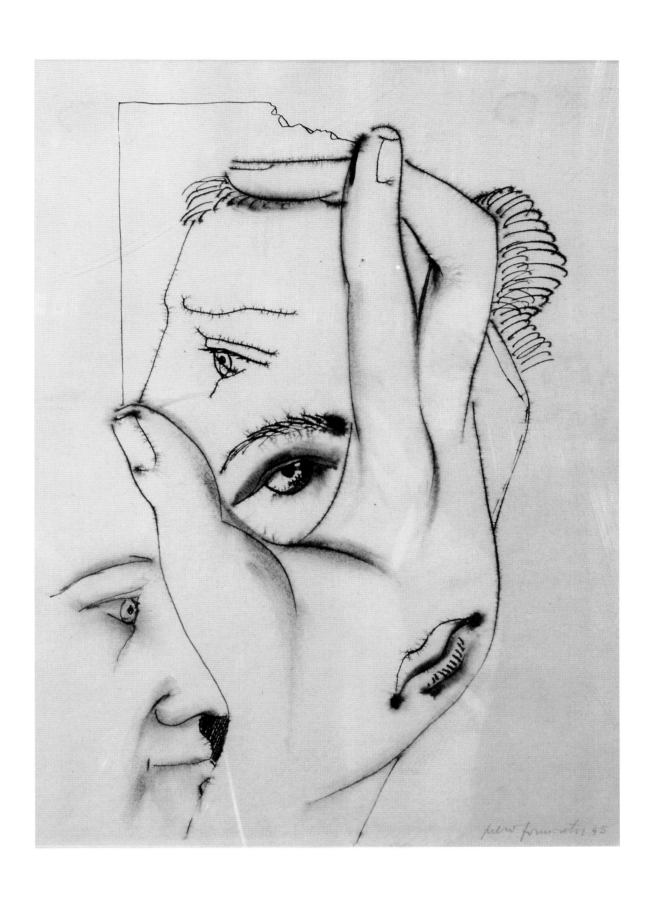

Untitled,
from the 'Mani' (Hands) series
1945
Indian ink on paper
21 × 29.5 cm

87

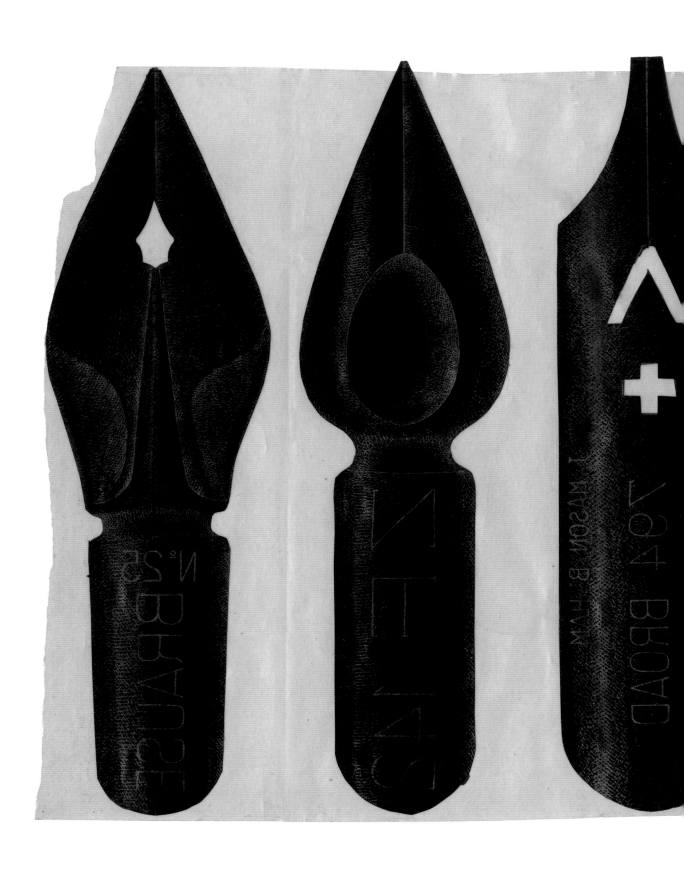

Pennini (Pen nibs)
1940s
Lithograph on paper
40 × 26 cm

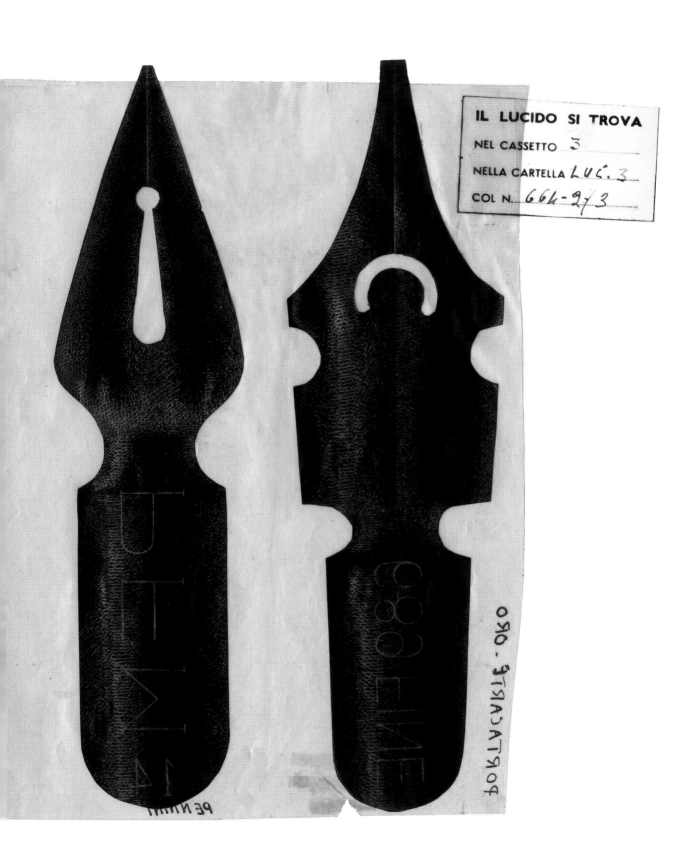

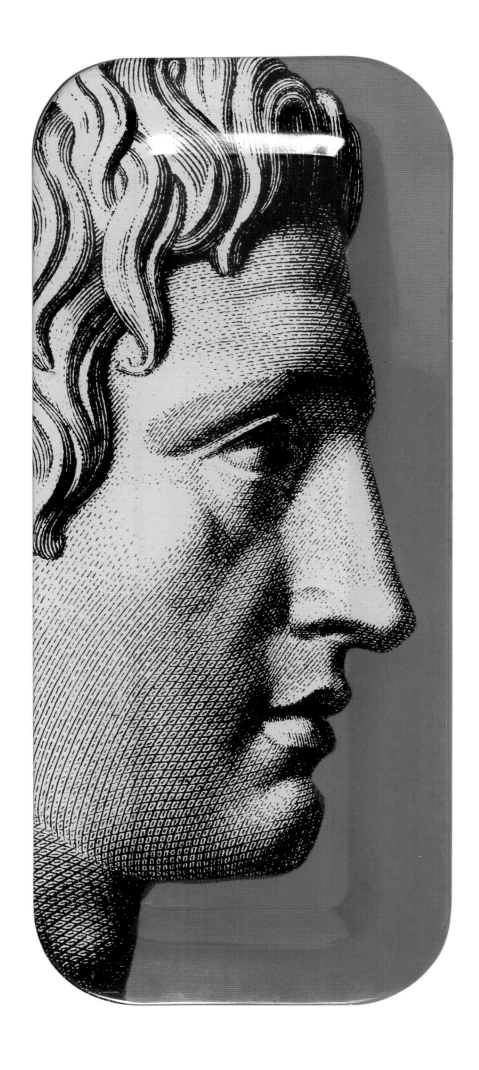

Profilo maschile
(Profile of a man) tray
Early 1950s
Lithograph on metal
25 × 60 cm

Disegno Metafisico
(Metaphysical drawing)
from the 'Temi Surreali'
(Surreal themes) series
1940s
Indian ink on paper
26 × 34 cm

Visione metafisica
(Metaphysical vision)
Indian ink on paper
1940s
26 × 34 cm

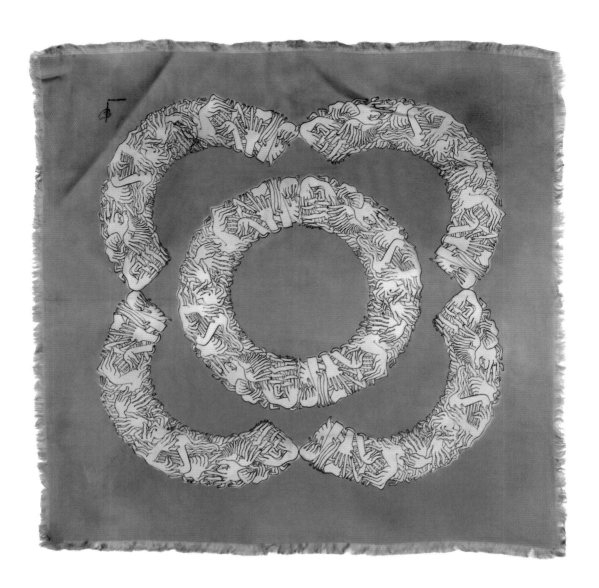

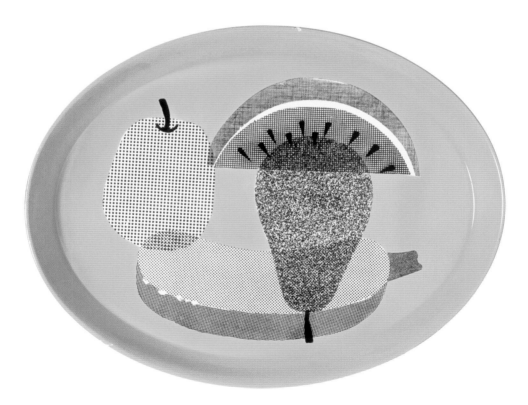

Manomania scarf
1946
Silk
82 × 82 cm

Frutti retinati
(Screened fruit) tray
Early 1960s
Lithograph on metal
50 × 40 cm

Untitled
Lithograph
1940s
49 × 35.5 cm

Poliedri
(Polyhedrons) tray
Late 1950s
Lithograph on paper
65 × 45 cm

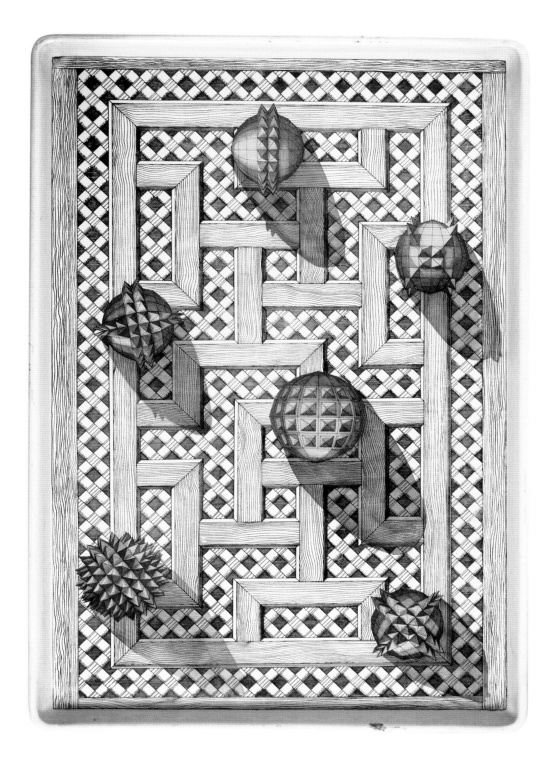

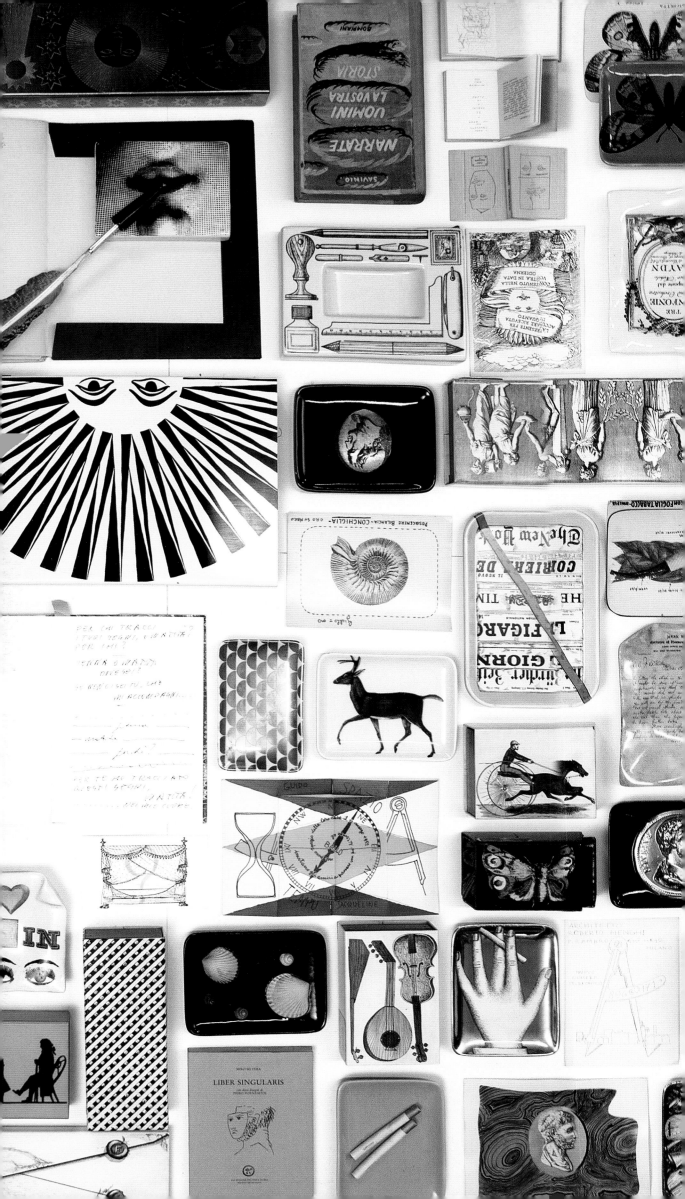

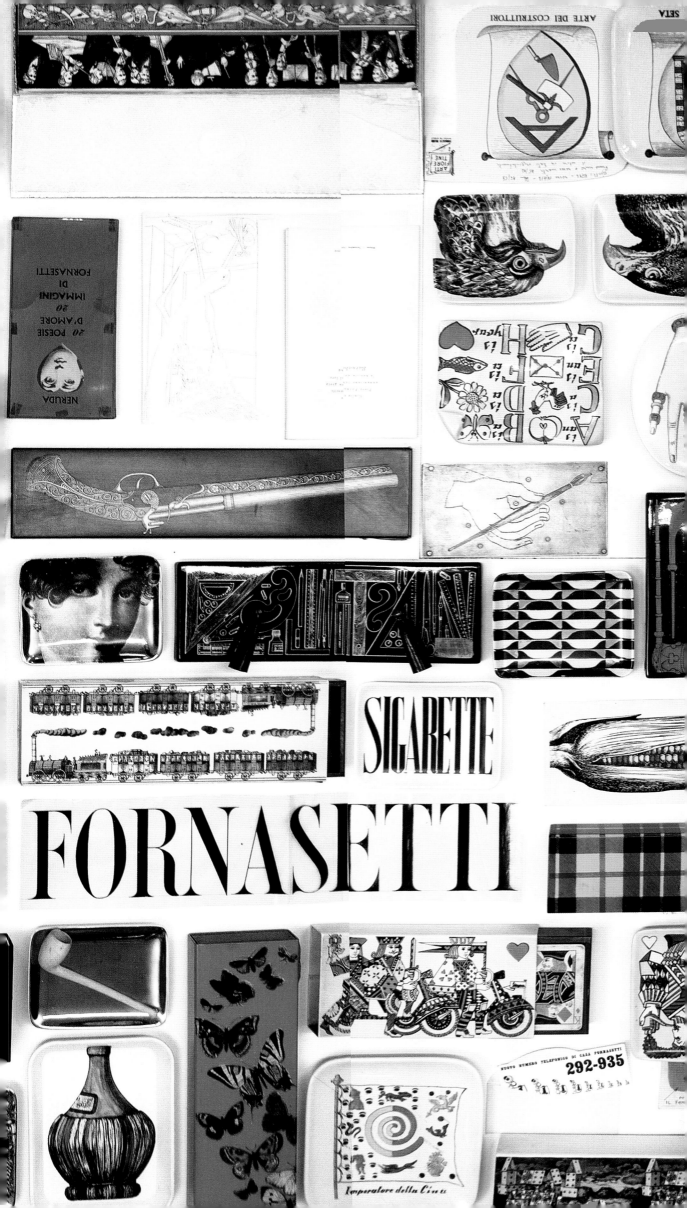

SETA

ARTE DEI COSTRUTTORI

NERUDA
20 POESIE D'AMORE
20 IMMAGINI DI
FORNASETTI

SIGARETTE

FORNASETTI

292-935

Imperatore della Cina

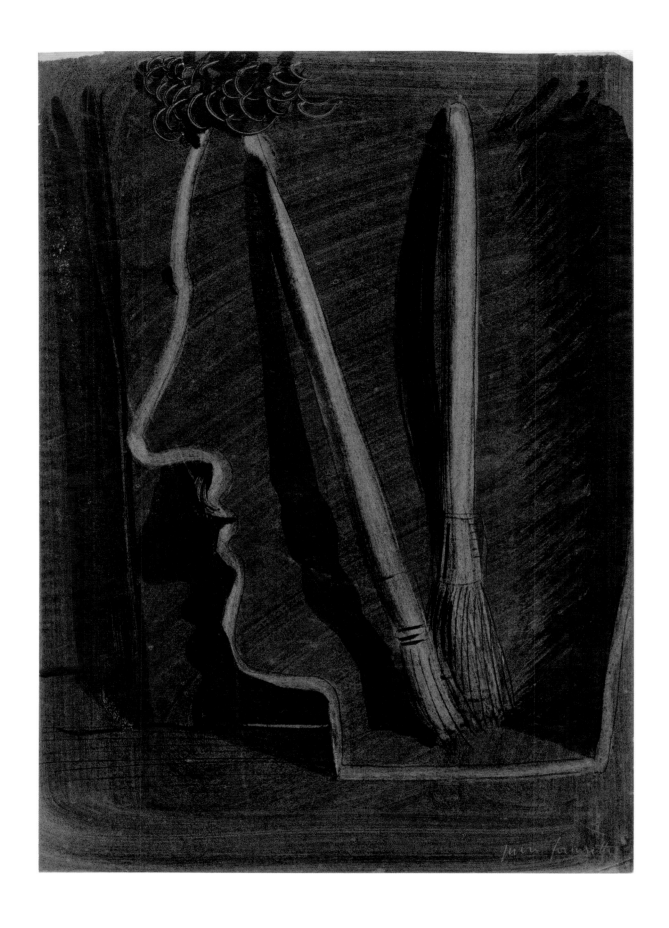

p.94-95
Various objects by Fornasetti:
ashtrays, boxes, designs for books
and covers, invitation
and greeting cards.
1940s, 1950s and 1960s

Autoritratto (Self-portrait)
1941–45
Indian ink and pastel on paper
21 × 29.5 cm

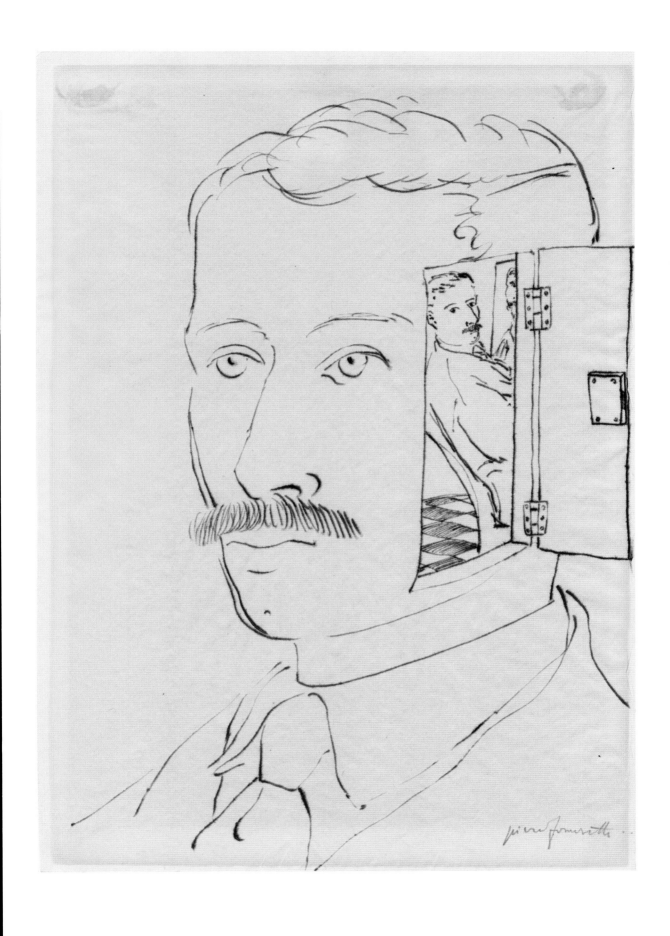

Autoritratto (Self-portrait)
1941–45
Indian ink on paper
21 × 29.5 cm

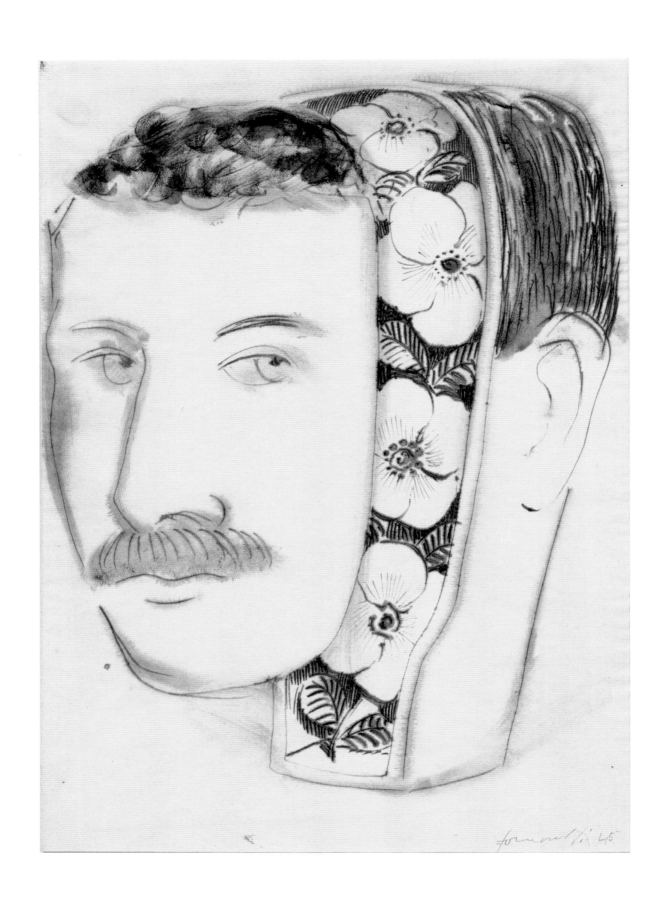

Autoritratto (Self-portrait)
1941–45
Indian ink on paper
21 × 29.5 cm

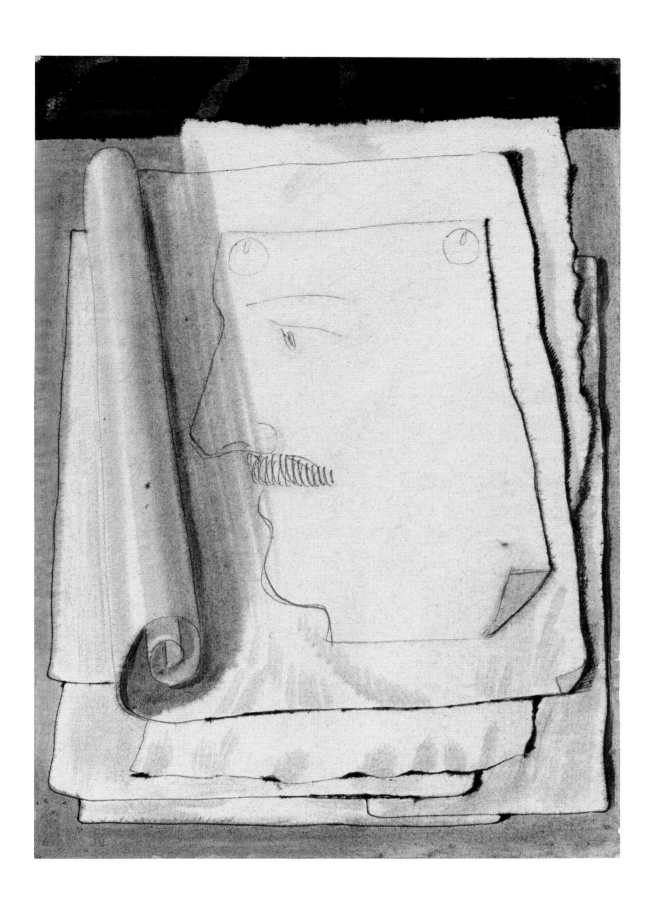

Autoritratto (Self-portrait)
1941–45
Indian ink on paper
21 × 29.5 cm

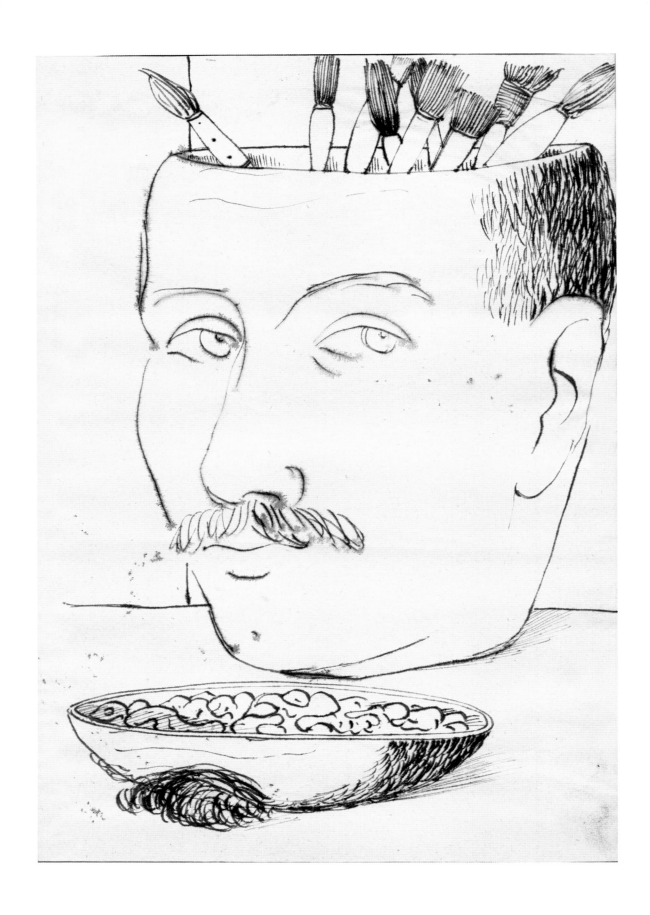

Autoritratto (Self-portrait)
1941–45
Indian ink on paper
21 × 29.5 cm

Mano (Hand)
1971
Pen and pencil on paper
22 × 29.5 cm

Pera spirale e melina
(Spiral pear and apple)
1975
Pencil on cardboard
34 × 49 cm

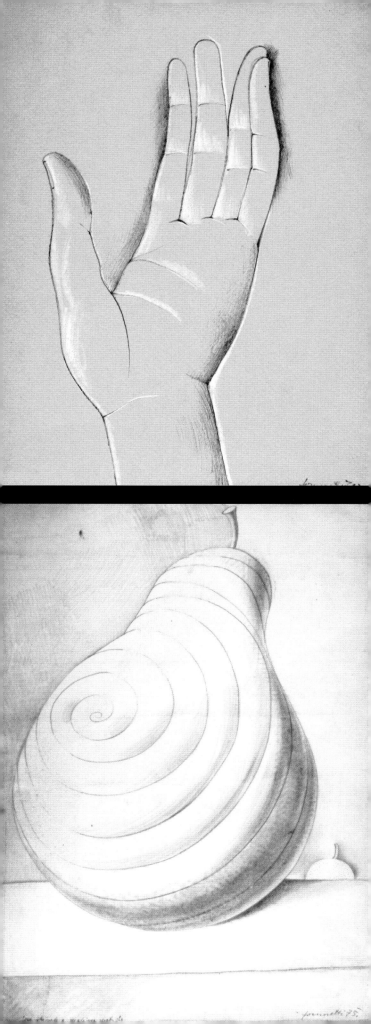

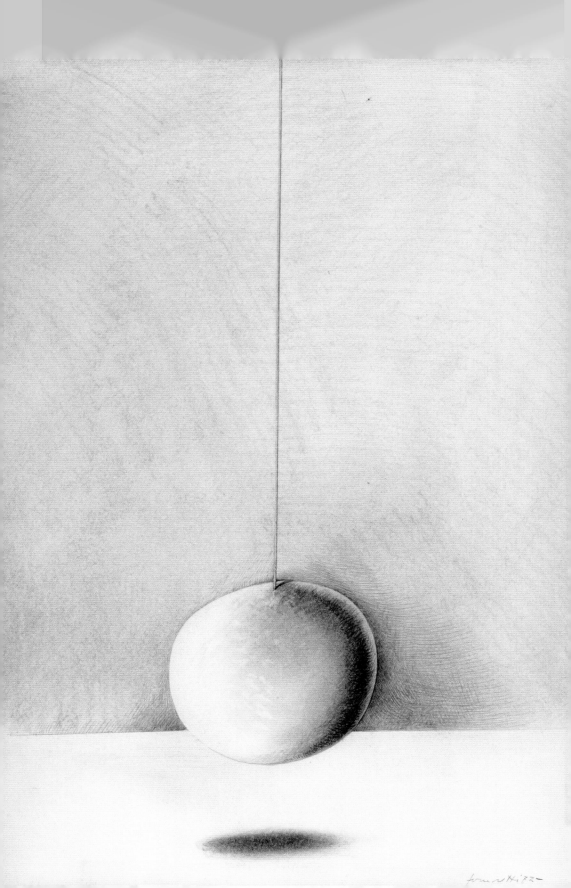

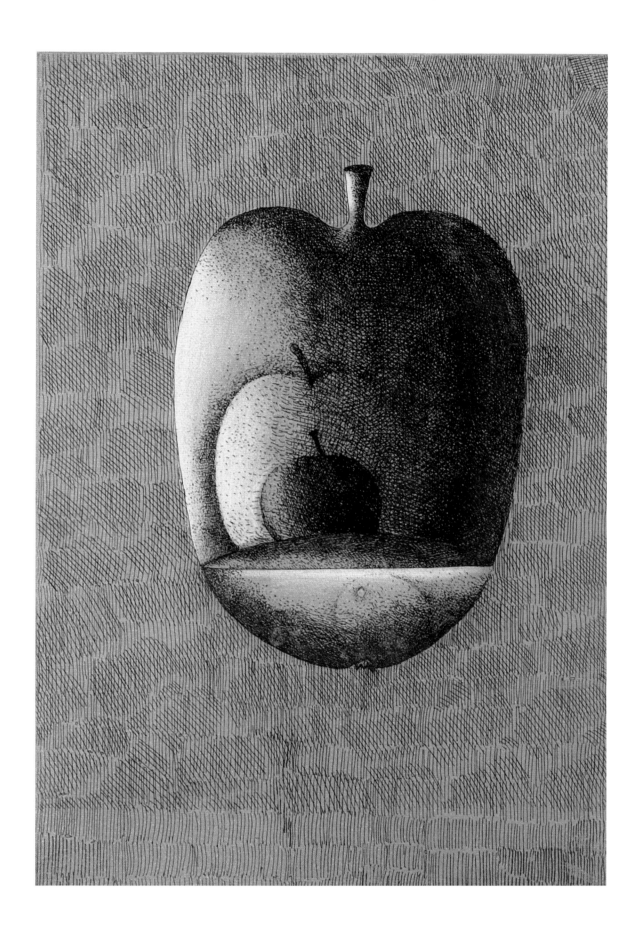

Arancia appesa a un filo rosso
(Orange suspended from a red wire)
1972
Pencil on paper
34.5 × 50 cm

Le Ottobrine
(October Fruit)
1976
Etching
50 × 70 cm

103

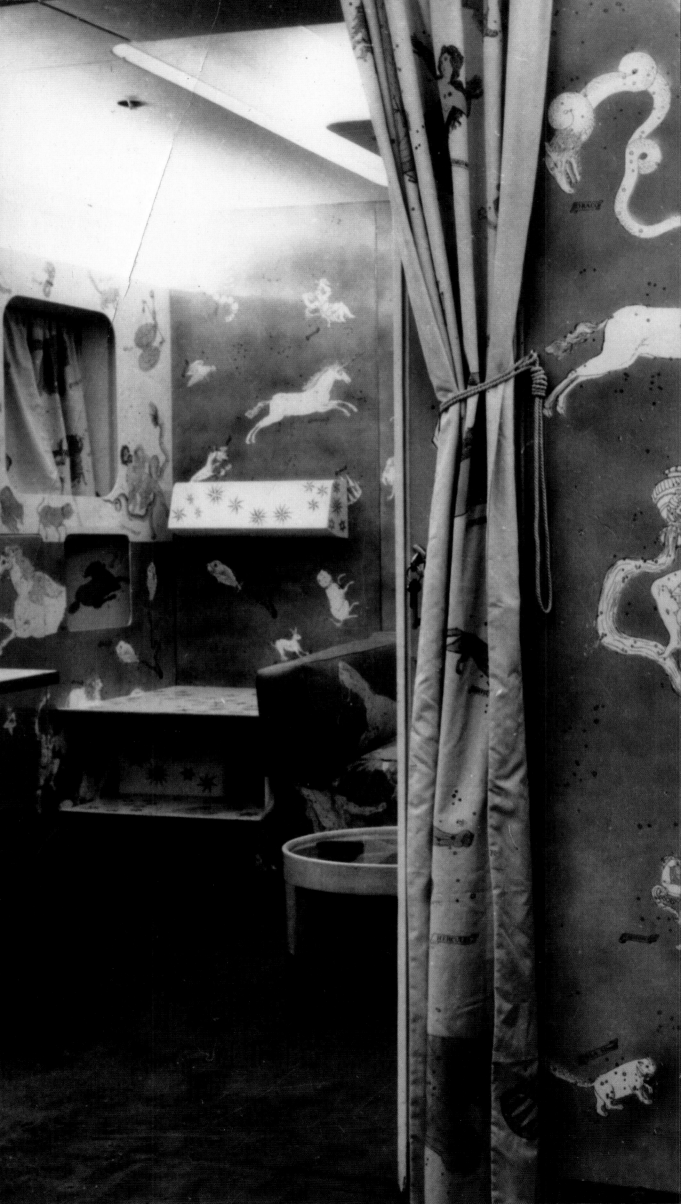

PIERO AND GIO

The Zodiac Suite on the transatlantic liner
Andrea Doria
Gio Ponti and Piero Fornasetti
1951

'Meeting the architect Gio Ponti was a decisive moment for me. He was the director of the Fifth Triennale where he launched a competition for young designers. I entered a series of my scarves printed on silk, and Ponti was very excited about my way of using this technique, so much so that he gave me a long list of jobs straight away. We had a great deal of respect for one another, although we always addressed each other formally. That is how we launched into a series of works together in the 1950s. I would decorate all kinds of things: from luxury apartments on the liner *Andrea Doria*, to furnishing fabric or cinema interiors.'

Prototype of *Farfalle*
(Butterflies) chair
Design by Gio Ponti,
decoration by Piero Fornasetti
1950
Lithograph on silk
108 × 55 × 55 cm

Astratto (Abstract) table
Reissue 2014
Silkscreen on wood
115 × 53 × 60 cm

Losanghe e passamaneria
(Diamonds and ribbon)
1942
Hand-coloured proof on paper
81 × 71 cm

Oggetti su legno
(Objects on wood) scarf
1938
Hand-printed silk
87 × 87 cm

113

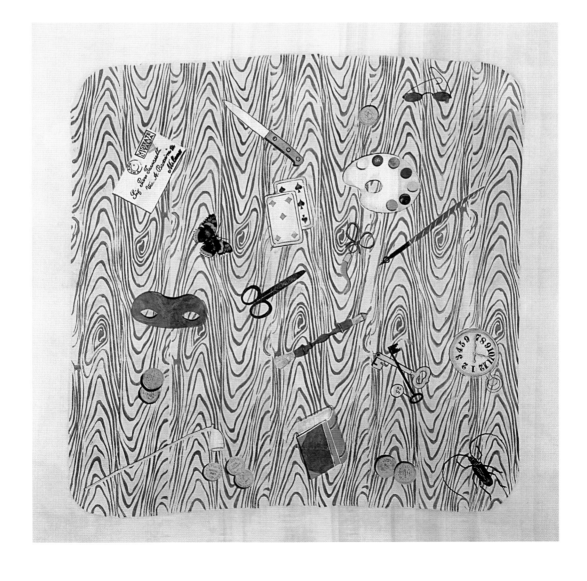

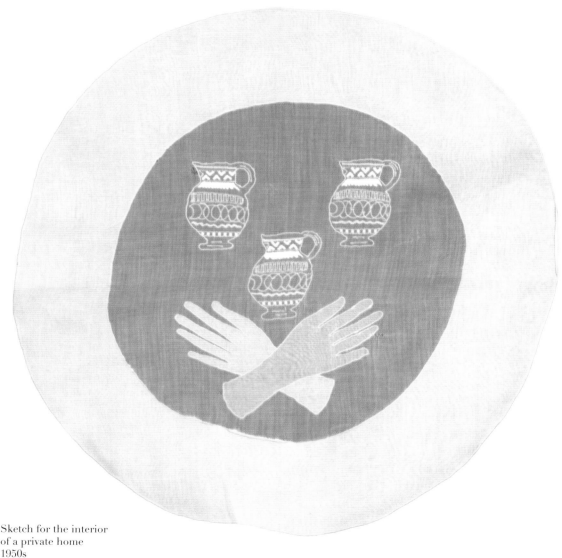

Sketch for the interior
of a private home
1950s
Pencil on paper
69 × 47.5 cm

Table centrepiece
1939
Embroidered cotton
Diam. 42 cm

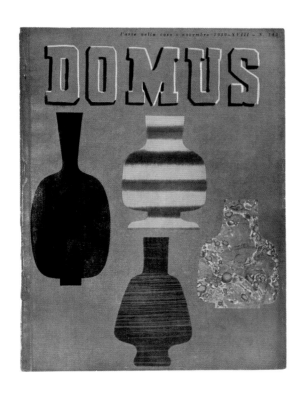

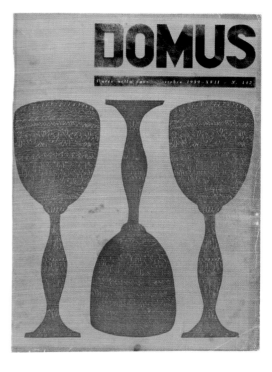

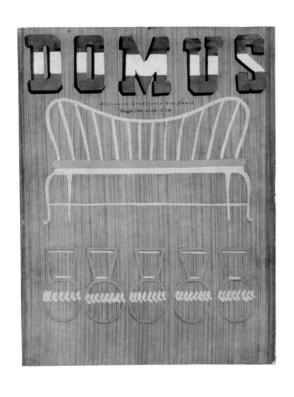

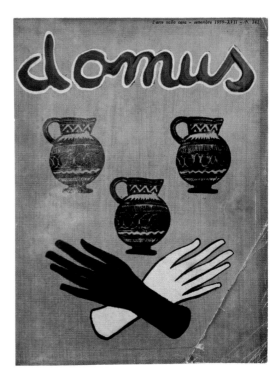

Cover for *Domus*
November 1939, no. 143

Cover for *Domus*
October 1939, no. 142

Cover for *Domus*
September 1939, no. 141

Cover for *Domus*
May 1940, no. 149

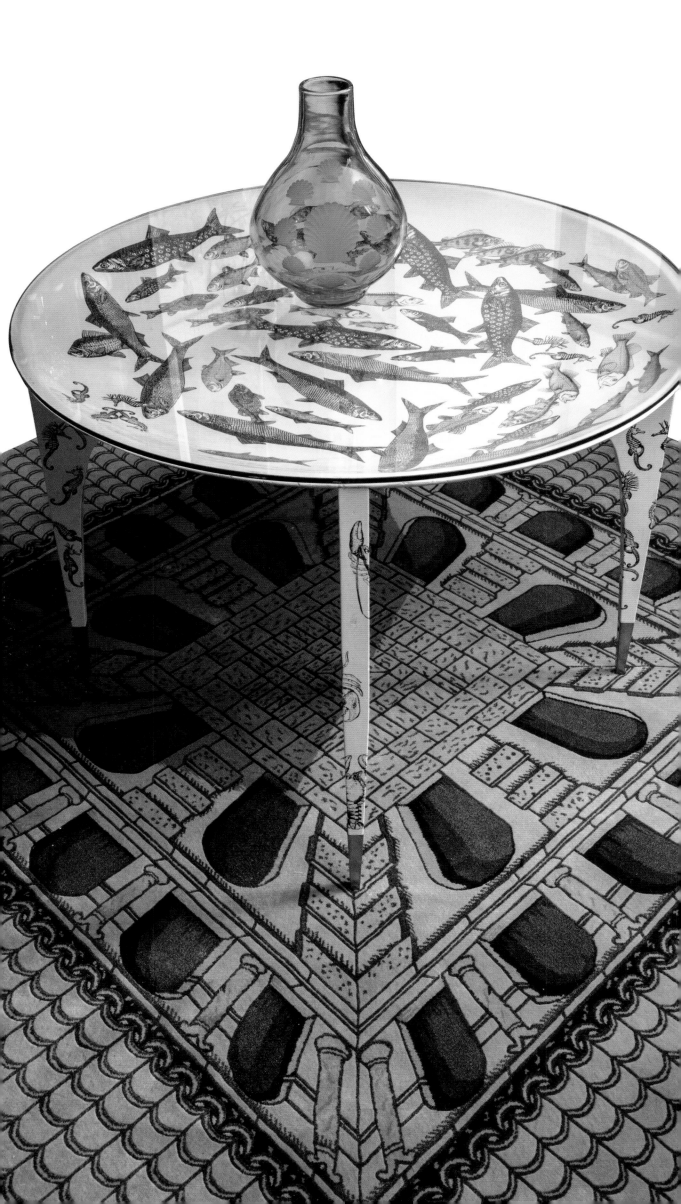

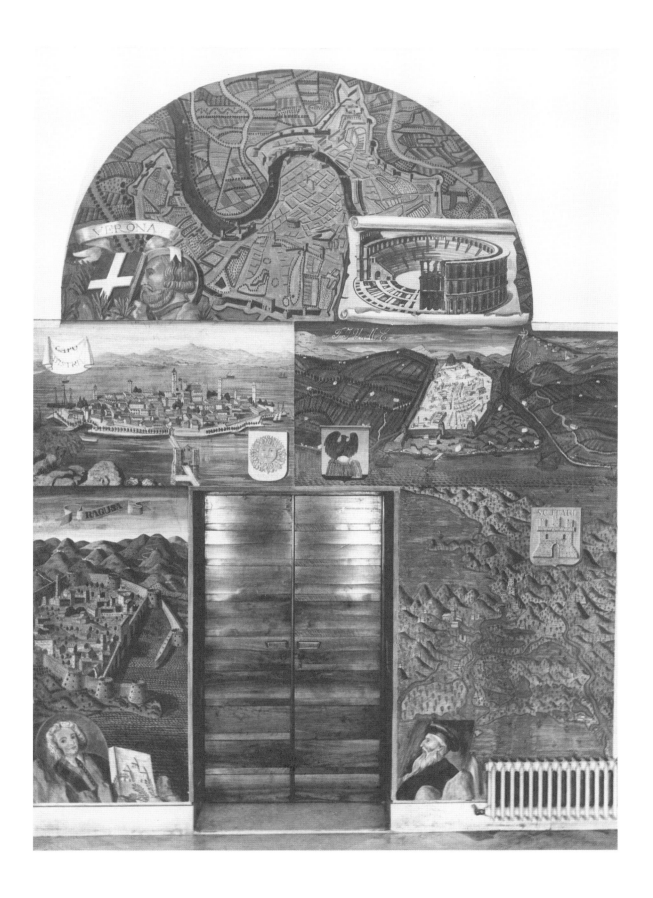

Conchiglie (Seashells) vase
1940
Glass
H. 29 cm

Cortile (Courtyard) rug
Reinvention by Barnaba Fornasetti
2008
Hand-knotted wool
220 × 220 cm

Pesci, cavalluci marini e astici
(Fish, seahorses and crayfish)
concave table
1950
Lithograph on wood
Diam. 100 cm

Doorway dedicated
to the City of Rome
for the Palazzo Bo, Padua
1940

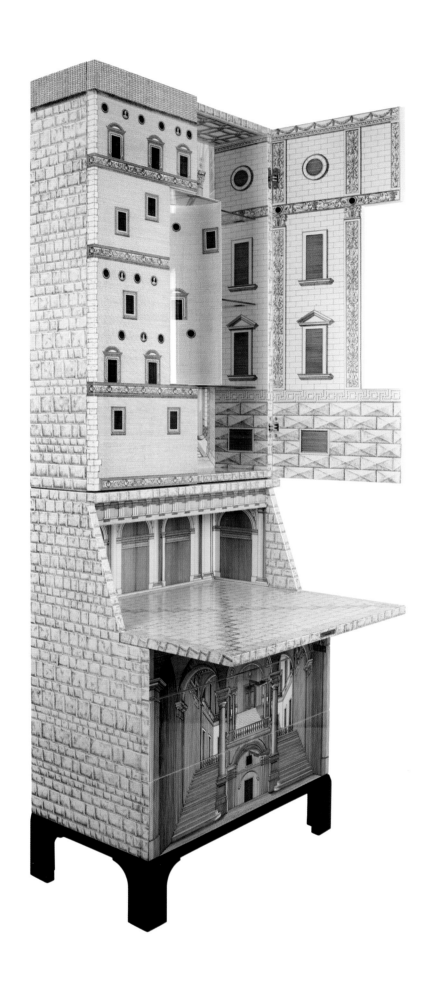

Architettura
(Architecture) trumeau
1951
Lithograph on wood
81 × 39 × 219 cm

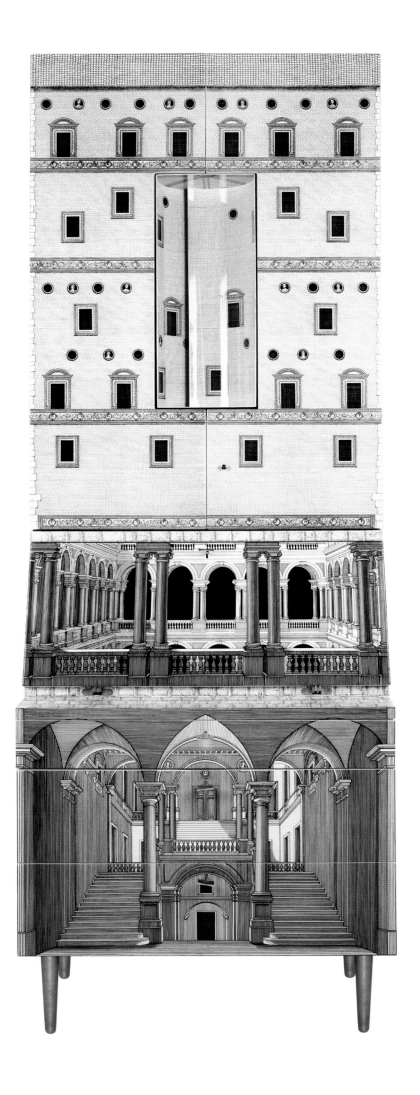

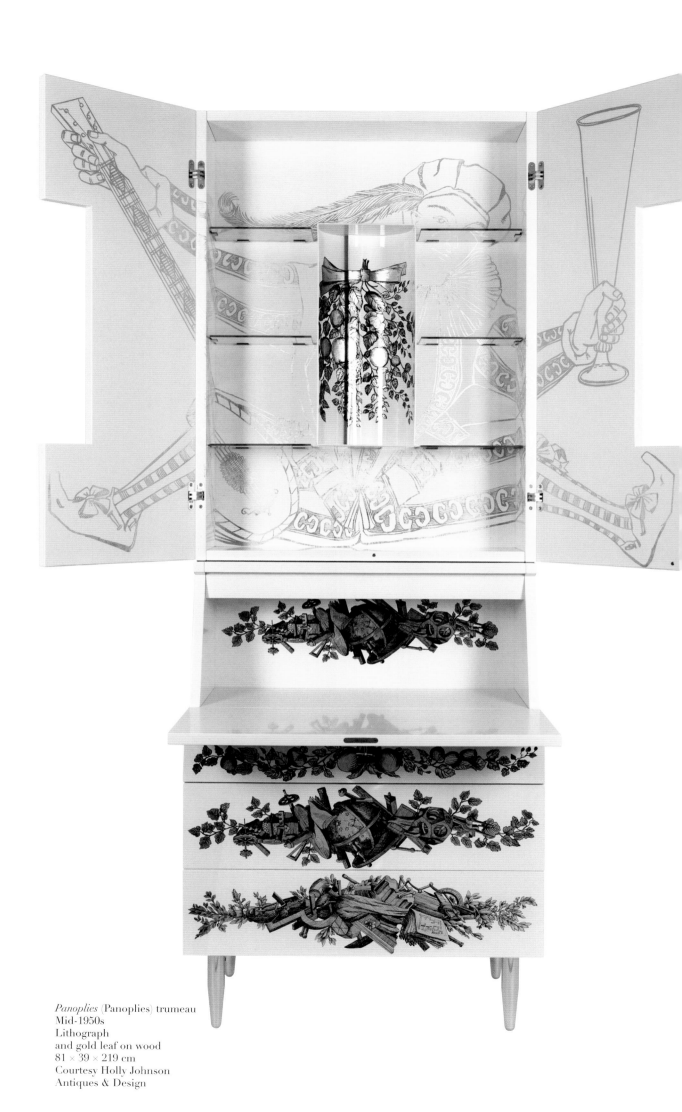

Panoplies (Panoplies) trumeau
Mid-1950s
Lithograph
and gold leaf on wood
81 × 39 × 219 cm
Courtesy Holly Johnson
Antiques & Design

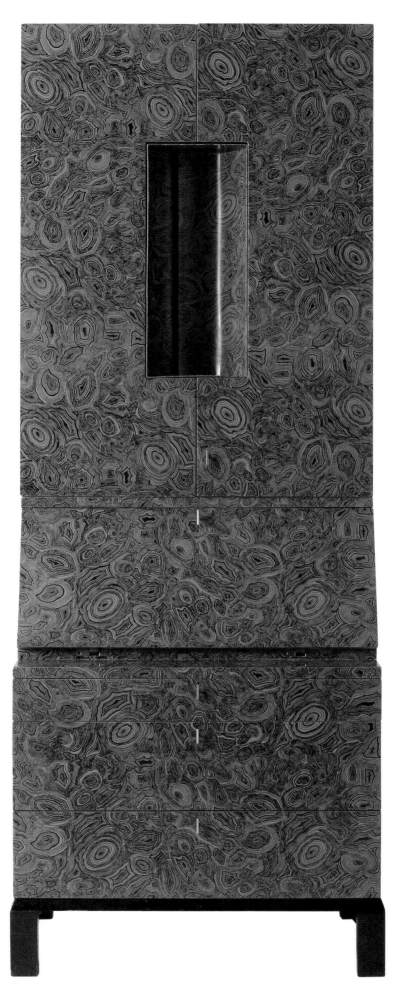

Malachite trumeau
Reissue 2014
Lithograph on wood
81 × 39 × 219 cm

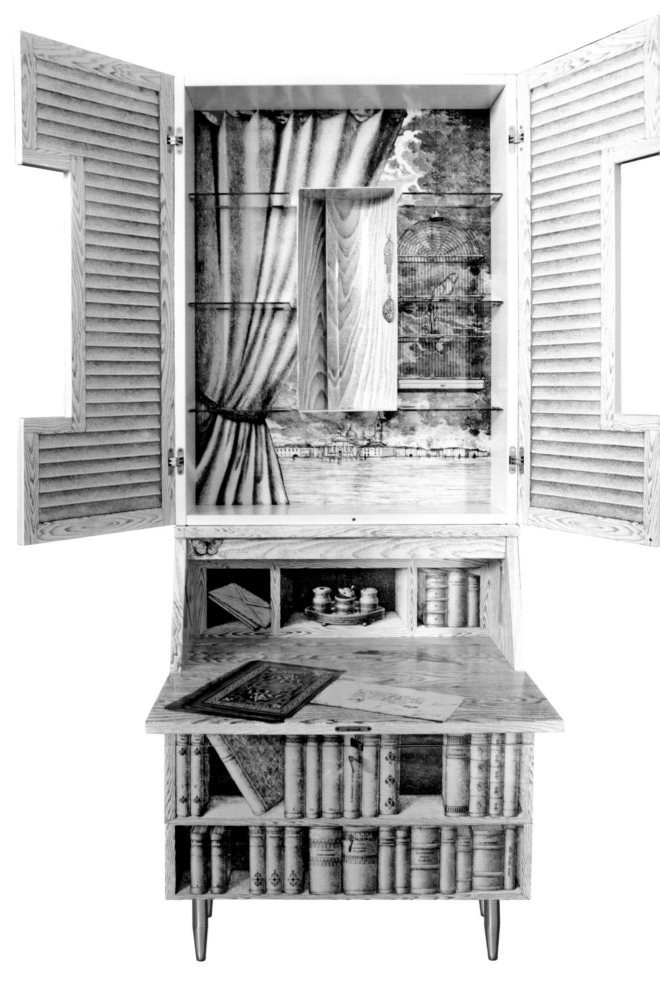

Libri (Books) trumeau
1954
Lithograph on wood
81 × 39 × 219 cm

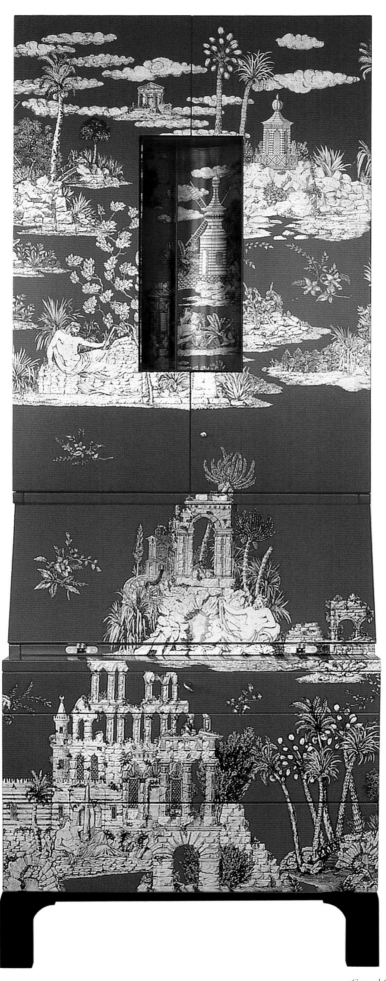

Grand Coromandel trumeau
2005
Lithograph
and gold leaf on wood
81 × 39 × 219 cm
Private collection
Bonera Salvoni, Brescia

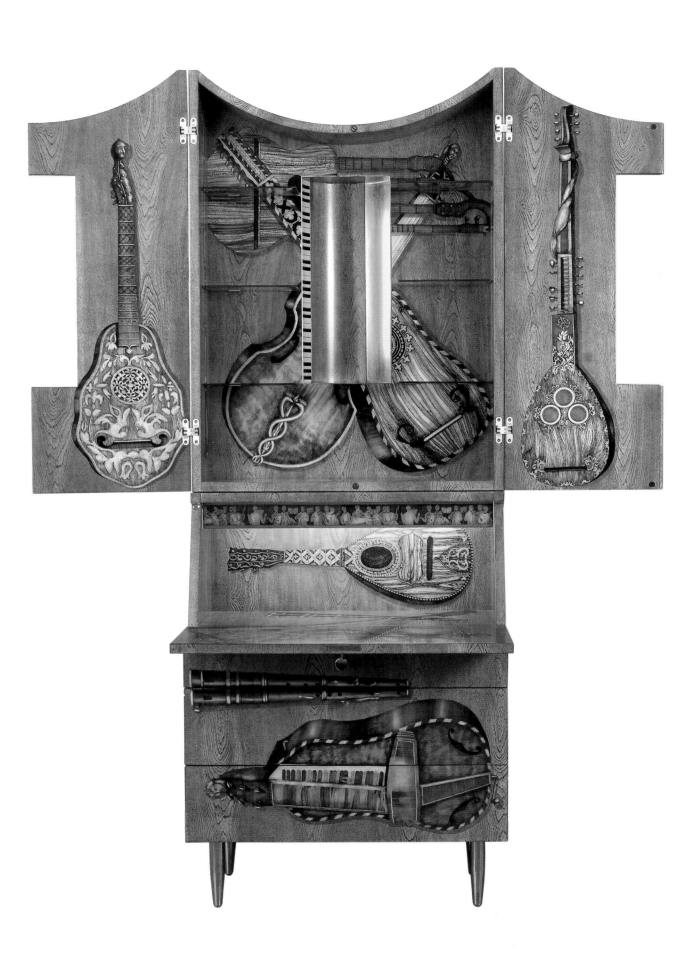

Strumenti musicali
(Musical Instruments) trumeau
2000
Silkscreen on wood
with painting by hand
81 × 39 × 219 cm
Courtesy Turin Gallery

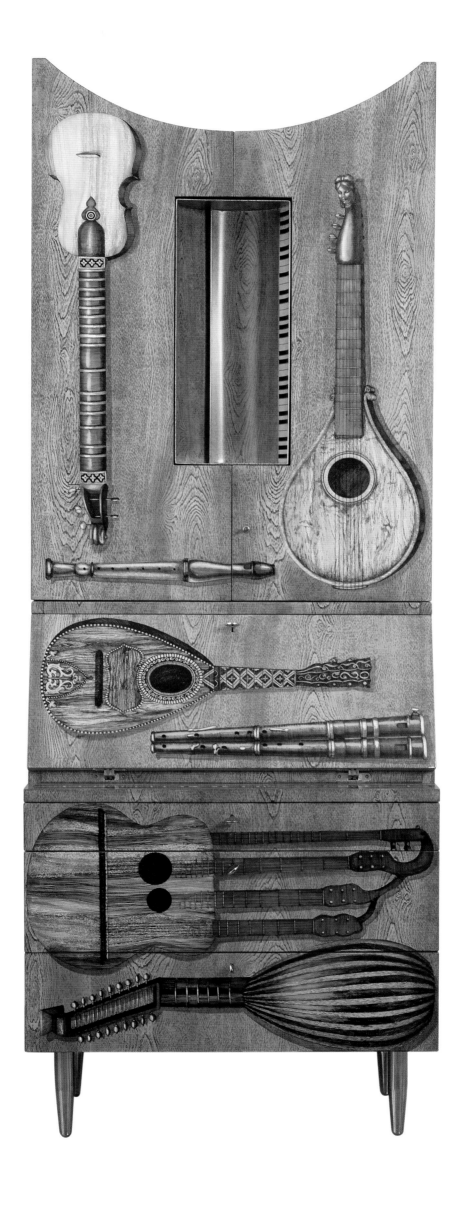

Credenza
Design by Gio Ponti,
inside decoration by Piero Fornasetti
1948
Lithograph on wood
with painting by hand
240 × 55 × 201 cm
Private collection Massimo Barracca

(FROM DOMUS NO. 270, MAY 1952)

THE FANTASY HOME

Gio Ponti

If ever my life as an architect were one day deserving of a book, the chapter that starts in 1950 could be called 'The Fornasetti Passion'. Articles on Fornasetti in *Domus* and *Graphis*, Fornasettian radio, bar, cabinets, ceilings in the house and villa Cremaschi, Fornasettian study, sofa, beds, furniture and radio in the Ceccato house, cabinet for the Licitra house, the first-class bar on the *Conte Grande*, the entire wall surface of the first-class dining room on the *Oceania*, panels, ceilings, armchairs, sofas, curtains and drapes for the new hall of the San Remo Casino, ceiling and figures in the first-class games room on the *Giulio Cesare*, armchairs and sofas at the Vembi-Burroughs offices in Turin, Florence and Genoa, furniture for Macy's, the Dulciora patisserie in Milan dedicated in its entirety to Fornasetti... All of this, and some I forget, before we arrive at the Lucano apartment in Milan (where a piano and billiard table are still in preparation).

What does Fornasetti bring to me? The possibility of having 'unique' things, thanks to a process of printing on cloth, with prodigious inventiveness and speed: chair after chair, panel after panel, drape after drape. To which one may add this lightness of touch, whose power to evoke makes such an impression.

The exceptional understanding of the project's generous patrons has allowed me to meet the challenge posed by the small area that they had entrusted to me by means of a reversible set of views and enfilades, allowing one to see from the sitting room to the bedroom through doors and windows, facing a burr walnut composition 'à la Ponti' (nature fantasy), or, looking the other way (from the bedroom to the sitting room), to a set of Fornasetti prints (human fantasy); it makes everything a little magical, with neither

Pp. 123-133
Casa Lucano, Milan
Design by Gio Ponti, trompe l'oeil decorations by Piero Fornasetti. 1951

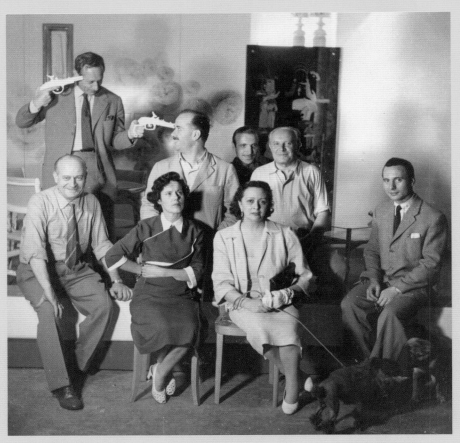

Piero Fornasetti (in profile), Gio Ponti (second from the right)
with friends and collaborators 1950s Photograph

weight or volume, since the print abolishes volume: here we are, basically, facing readable walls. This is the 'key' to the apartment, to this fantasy home; this is what the 'architecture' makes of it, or more accurately the 'scenario', with a suggestion of set changes. Living inside a scenario? This idea has pleased our generous patrons, who have backed this fantasy munificently, becoming the sponsors and partners in a vision of the ensemble that includes an admirable collection of modern art objects. Giordano Chiesa is the perfect organizer of this apartment.

The colours? A yellow carpet covers the floor throughout. This note *sostenuto* resonates in counterpoint with the colours of the printed elements and wood.

Gio Ponti kept a regular chronicle of his designs in the journal *Domus*, which he founded in 1928. As well as letting the voices of the big players in the International Style movement be heard, from Mies van der Rohe to Le Corbusier or Niemeyer, he also made sure of the place of Italian design of the time (from Carlo Mollino to Giovanni Michelucci), and of his own too. Even in its brevity, this text from May 1952 in number 270 of the journal shows how his partnership with Fornasetti was neither accidental nor one-sided for the architect. It traces their shared path and confirms the essential role that the two designers accorded to ornament or 'the decorative'.

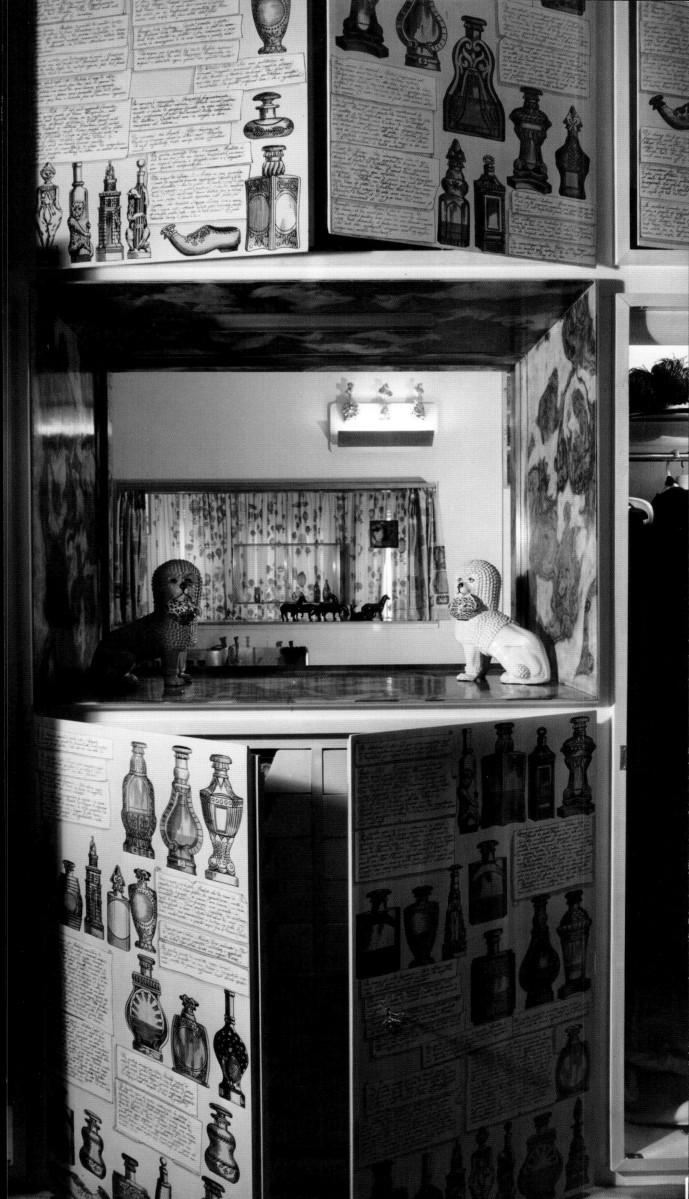

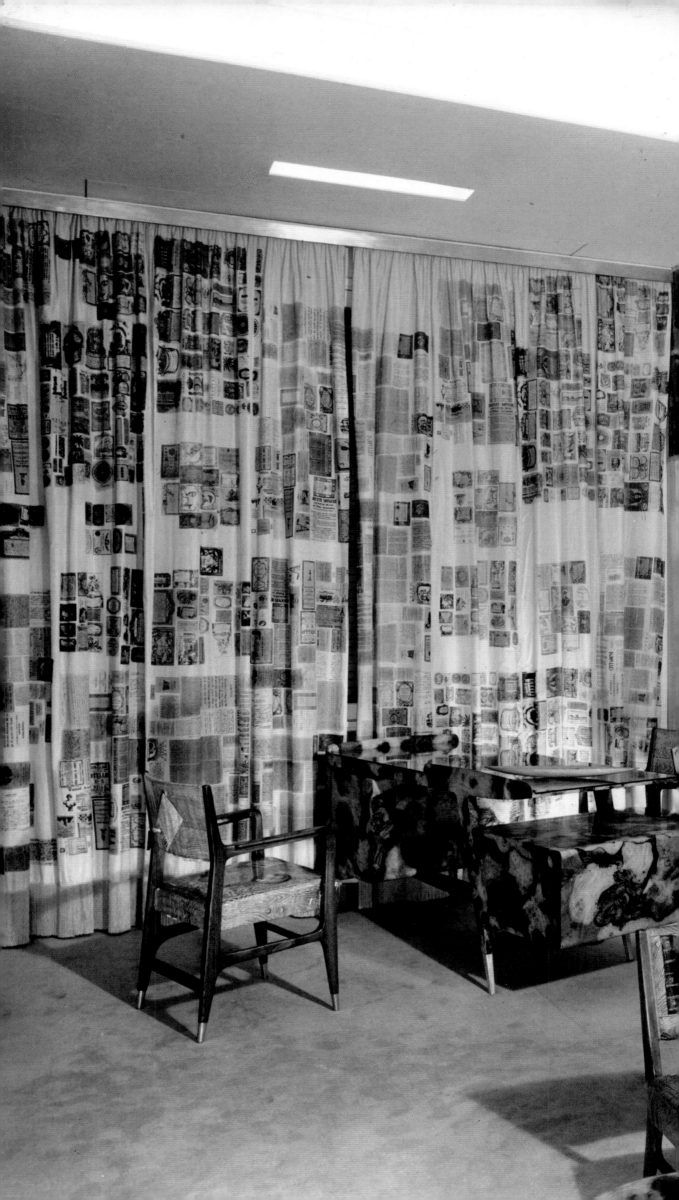

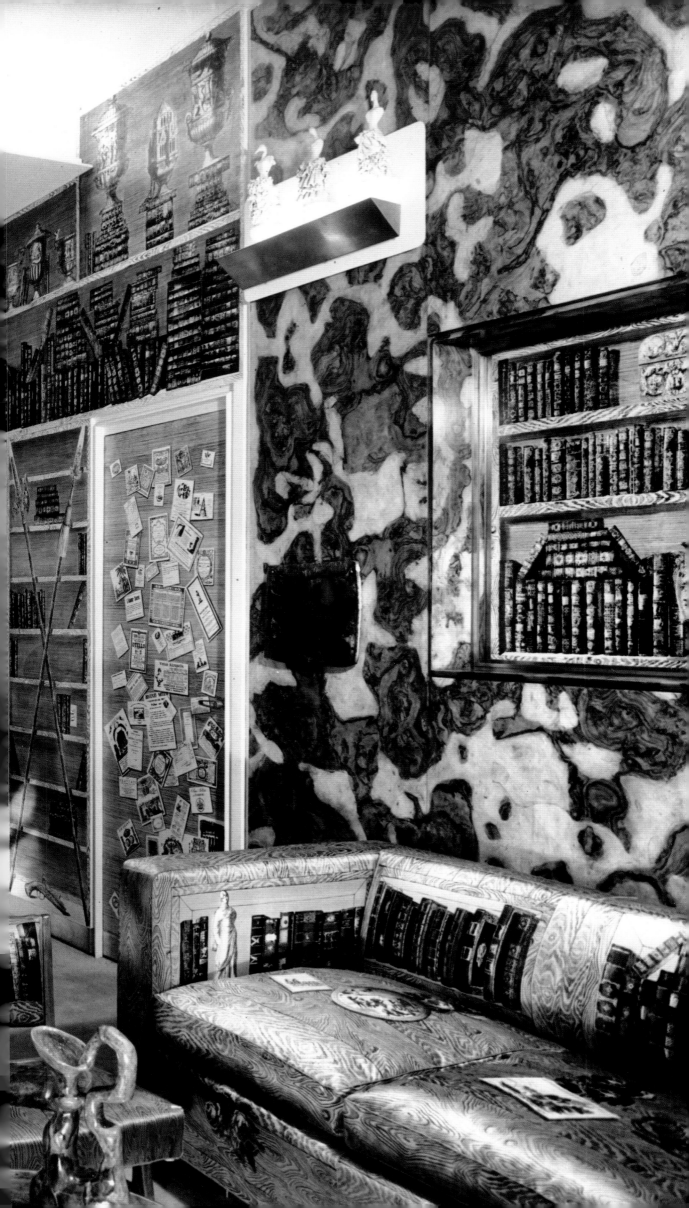

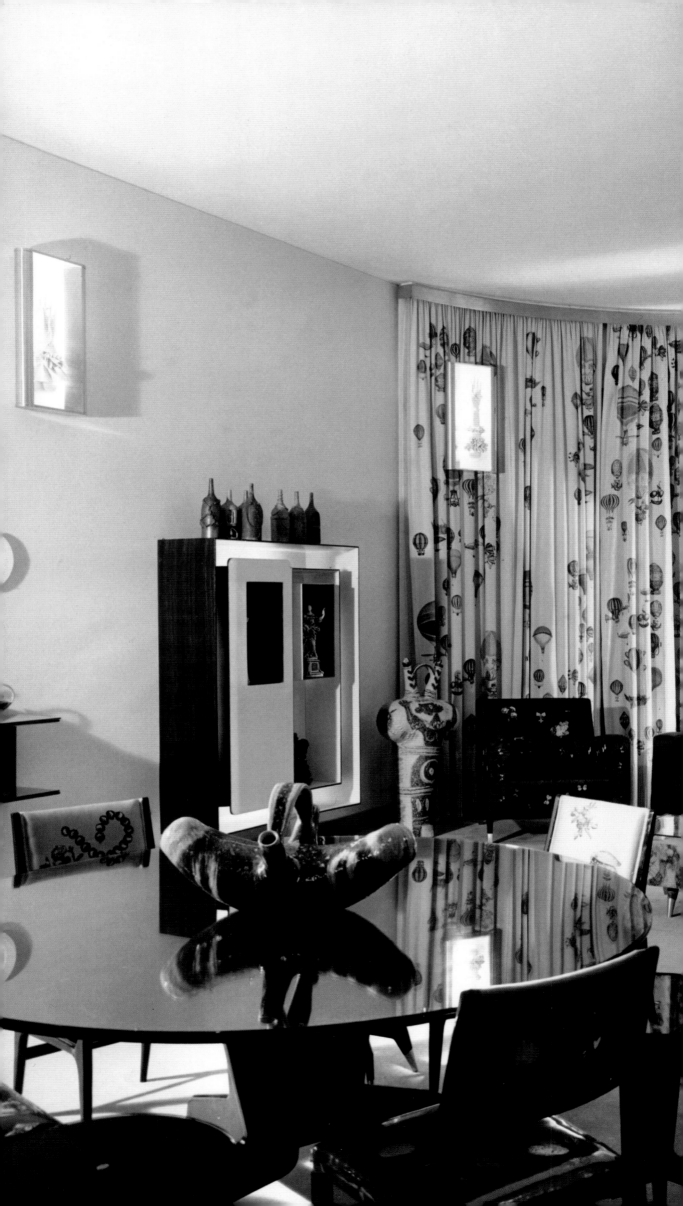

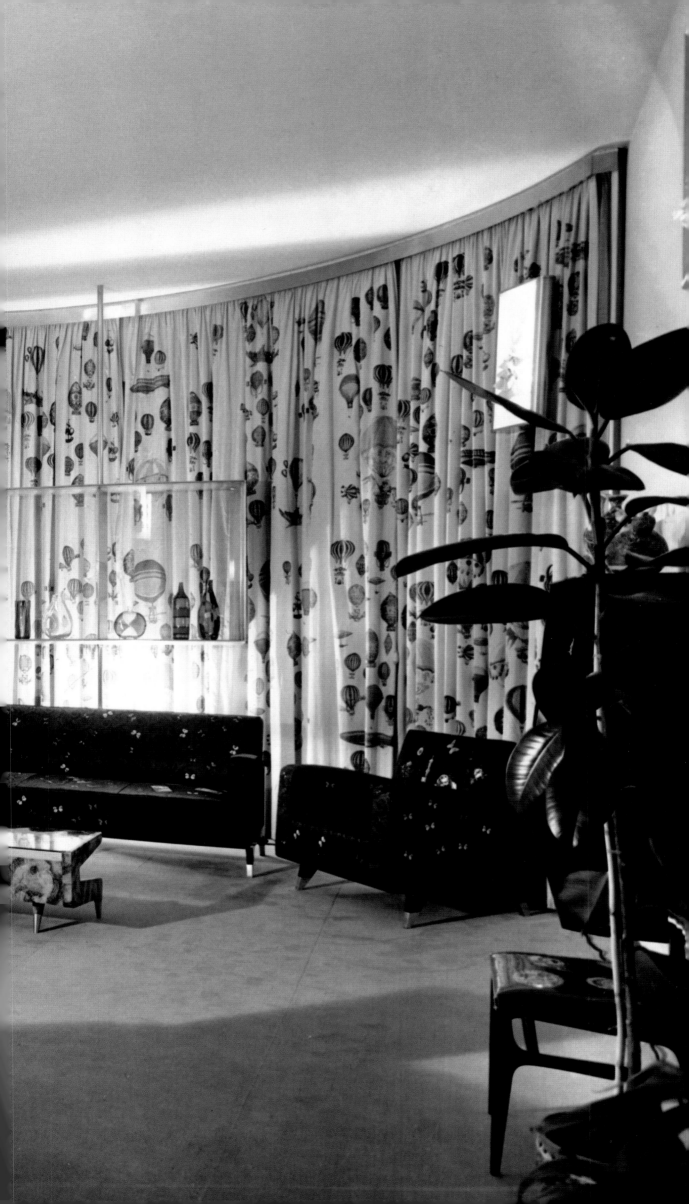

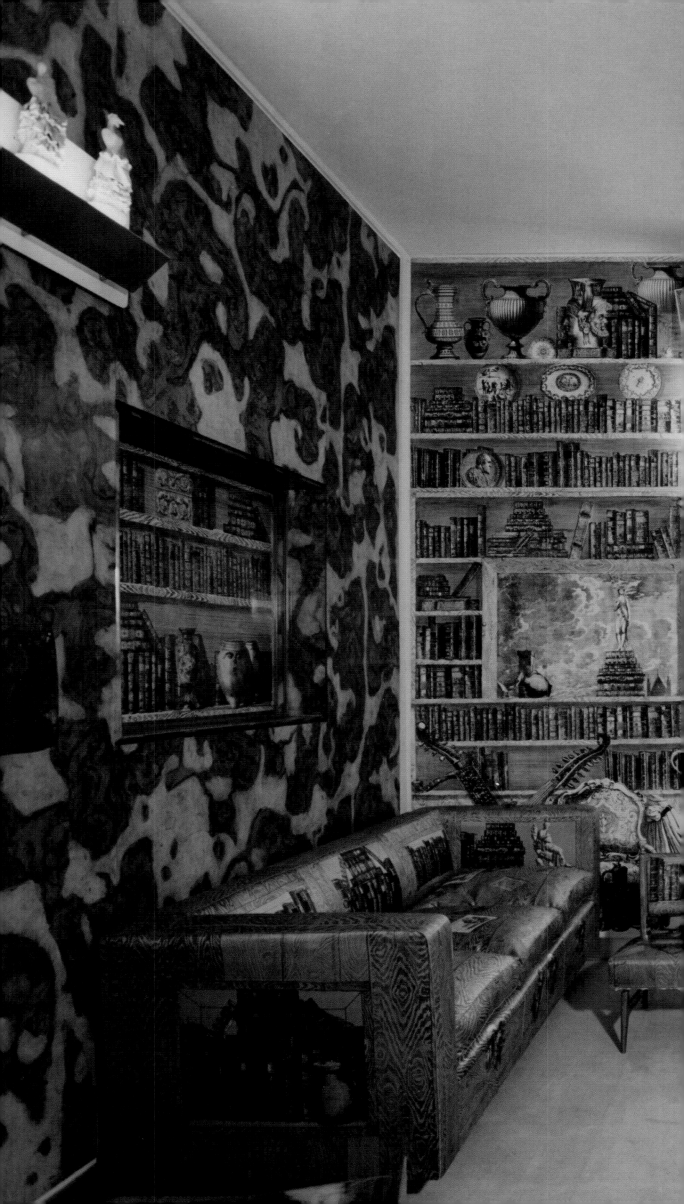

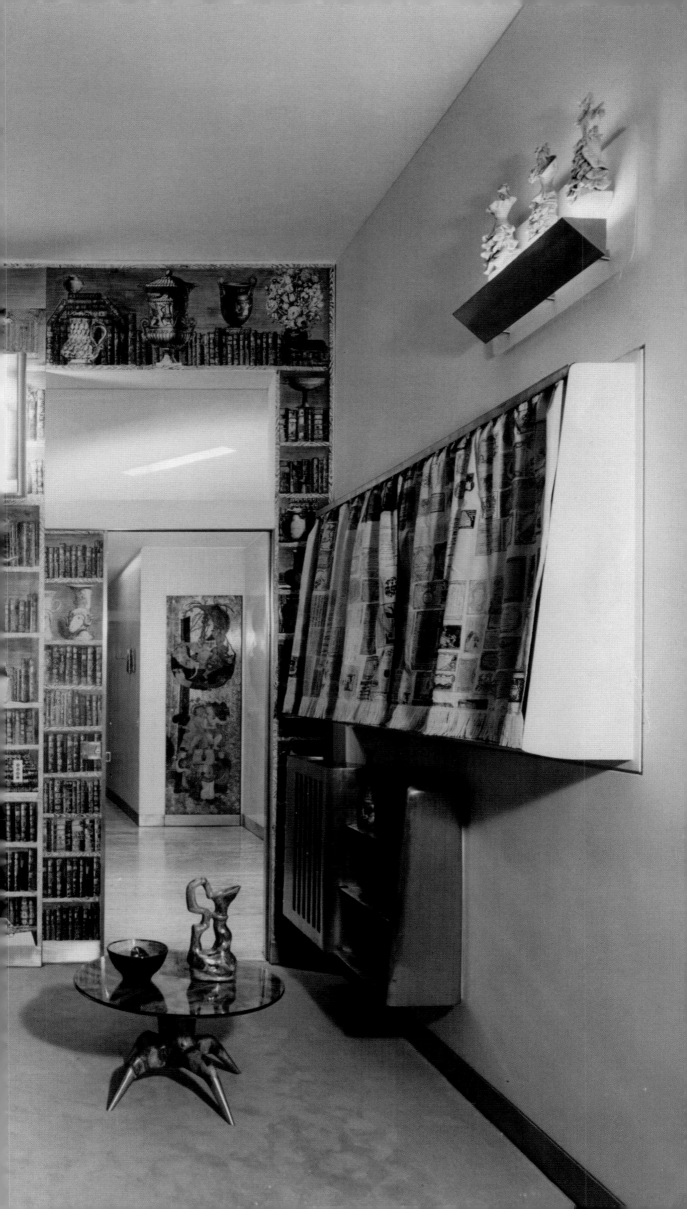

AN ARTIST

WHATEVER HE DOES,

IS ALWAYS DRAWING

HIS OWN

SELF-PORTRAIT

Selected aphorisms by
Piero Fornasetti

*Decoration is created from the
need to illustrate and embellish
everyday things as well
as enhancing forms. If you love
a woman then you like her to be
well dressed, adorned with jewelry;
it is well known that the beauty
of a picture stands out if it is
framed. This is also true for objects.*

*People
no longer know
how to see.
Knowing
how to see
means knowing
how to find.
In front of
the most disparate
objects it is essential
to find and choose
those that
are of interest
for the type of things
you are doing
and searching for.*

*The public explained to me that
what I did was something more
than decoration. It was an
invitation to the imagination,
to think, to escape from
those things around us that are too
mechanized and inhuman.
They were tickets to travel through
the realm of the imagination.*

I read everything, from abbé
Ferdinando Galliani to any
magazine, pamphlet,
newspaper from any country;
in everything there is the
sign of the passage of man,
and this fascinates me.
Herrigel's short book, Zen and
the Art of Archery is my
gospel. Here I found the rules
that have governed my way
of living and working;
it has been an important,
fundamental revelation.

Why have I collected old spectacles, or paper samples? Love of the material, the tactile quality of a fine paper is another of the themes that interest me and they are part of the refinement of sensibility that is fundamental for my work.

Whenever someone asks for my advice about how to 'design', I always say: go and learn life drawing. That's the only way to learn how to design. Knowing how to draw, as the Ancients did, makes it possible for you to organize and design an object, a car, a frontispiece or page of a book.

*I was staying in a room that
was the same size as the bed,
leaving a passageway of just
32 centimetres. I stayed in
bed from morning to evening,
stayed in bed drawing.
This meant that I covered
ceramics, furniture and objects
with left-over dreams, and
thus concealed a message in
every work, a little story,
sometimes ironic, wordless
of course, but audible to those
who believe in poetry.*

*I consider myself also
the inventor of the tray,
because, at a certain point
in our civilization, no one
knew how to pass a glass,
a message, a poem any
more. I was born into
a family of wretched good
taste and I use wretched
good taste as the key
to liberate the imagination.*

Some objects I fall in love
with, I want to own,
then I live with them for years,
I look at them,
I forget them,
I use them as an influence
for making others, thinking
perhaps to improve on them.
I like giving them to those
who make me think they
love them as I myself
think I love them. In this
way they don't stop giving
pleasure and reproducing.
Sometimes I am interested
in an object because
I see I can transform it, give
it some use that is different
to the one for which
it was intended.

It is said that my objects
are produced with secret
methods... I laugh quietly
to myself... My only secret
is the rigour with which
I carry out my work,
the clarity of my choices;
I hope that my critical sense
doesn't lose its edge over time.

*I'm the conductor of an orchestra
that uses first violins and players,
but conducts everyone to produce
the symphony.*

I made love all night long...
with a black wax plate
and a thin steel point.
It was a long night and
I don't know whether
I won or lost. I certainly
had no enjoyment...

The whole of my work is based on design, design as a discipline, as a way of living and organizing my own personal existence, as well as a continuous study of things, of their essence. I prefer order, but this doesn't prevent me admiring what is casual and unexpected.

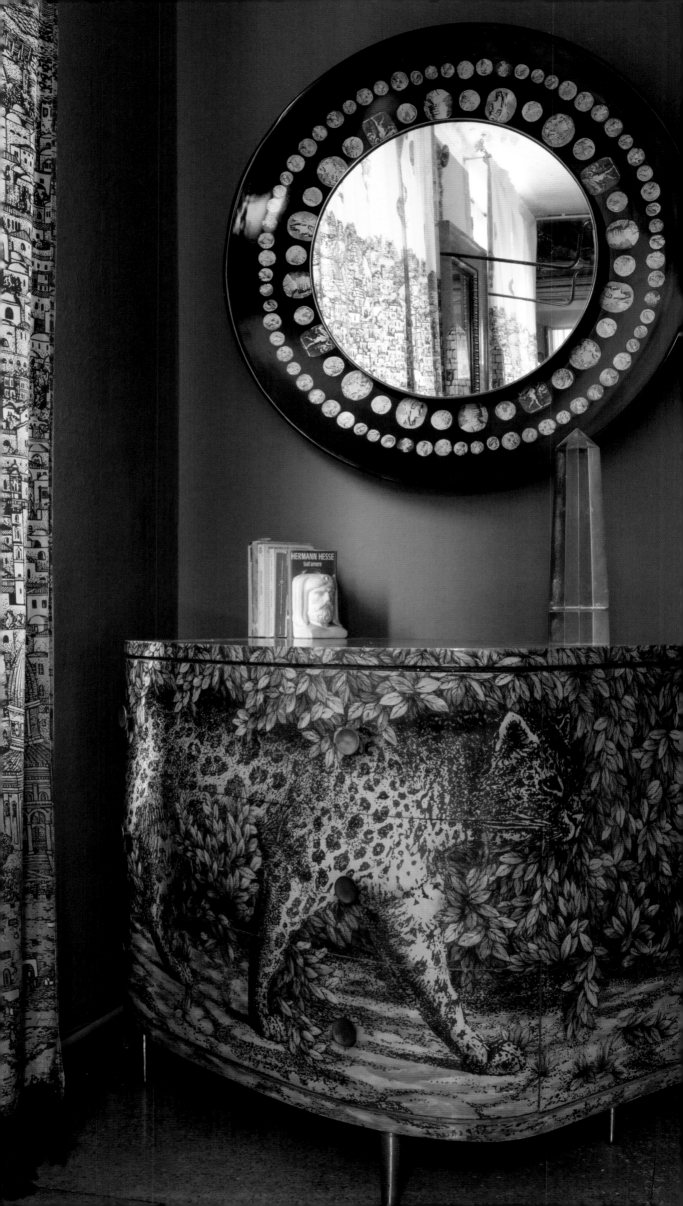

TROMPE L'ŒIL

Leopardo (Leopard) chest of drawers
Lithograph on wood
with painting by hand
1950s
100 × 56 × 86 cm

Cammei (Cameos) mirror
Lithograph and gold leaf on wood,
glass
1950s
Diam. 100 cm

From the marquetry walls of Urbino's *studiolo* to the dizzy heights of Tiepolo's ceilings, trompe l'œil spans all of Italian art history. Halfway between the decorative arts and fine art, using all the tricks of illusion in a playful relationship with the viewer, trompe l'œil could not but appeal to Fornasetti's imagination. However, for him it was not only a question of situating himself somewhere in the groove of a tradition. Long considered a minor artistic pursuit, trompe l'œil underwent a real re-evaluation in the 1930s, exactly at the time that the young artist settled on his vocation. Examples can be found in the work of Salvador Dalí, but also in the work of Pierre Roy in France, Gino Severini, Gregorio Sciltian and Fabrizio Clerici in Italy, and Rex Whistler and Martin Battersby in England, to name only a few; not forgetting Eugene Berman, a virtuoso of the genre, who became Piero's friend and for whom he printed *Viaggio in Italia*. Without wishing to subject Fornasetti to this game of influences, one cannot dissociate the importance of trompe l'œil from the artistic context, whose importance Fornasetti himself underlined.

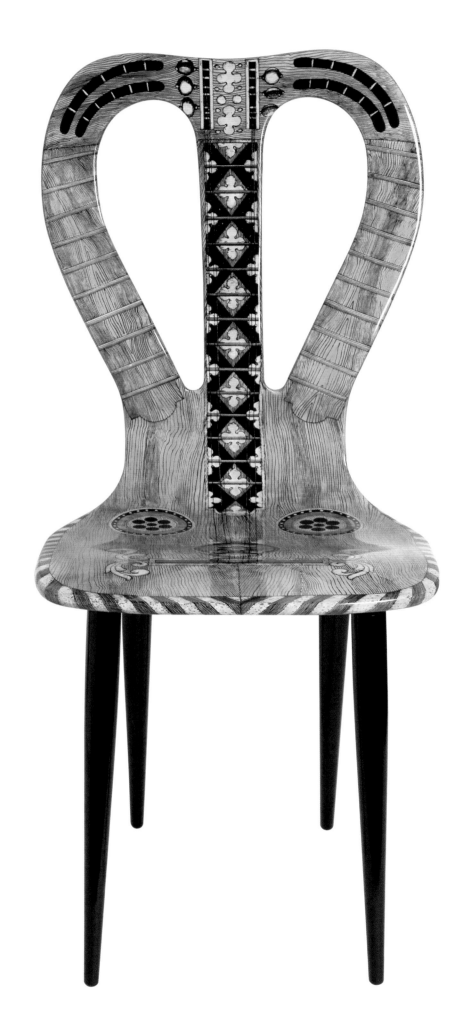

Strumenti musicali
(Musical Instruments) Chair
Lithograph on wood
with painting by hand
1951
40 × 40 × 95 cm

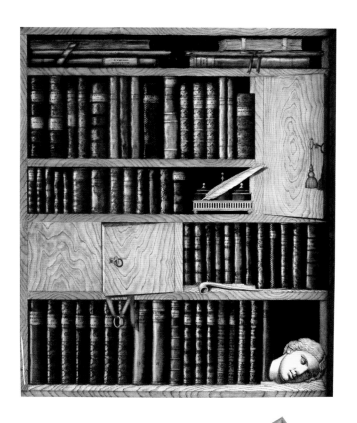

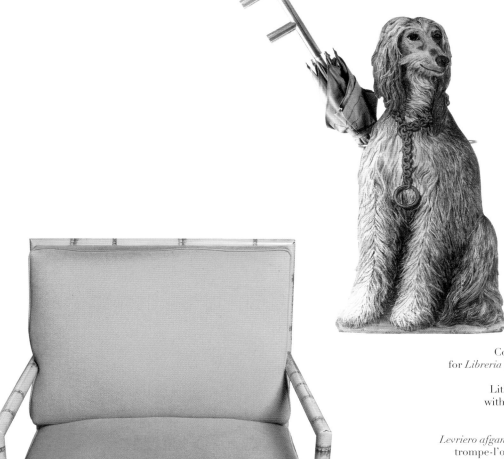

Colour composition
for *Libreria* (Bookcase) screen
Late 1950s
Lithograph on paper
with painting by hand
115 × 110 cm

Levriero afgano (Afghan hound)
trompe-l'œil umbrella stand
1950s, 1960s, 1970s
Lithograph on metal
with painting by hand
50 × 80 cm

Lettera F (Letter F)
umbrella
1960s
Copper, fabric, wood
H. 96 cm

Armchair in faux bamboo
for the dining room
of the villa in Varenna
1950s
Lithograph on metal
with painting by hand
68,5 × 78 × 76 cm

Import-Export
trompe-l'œil umbrella stand
1950s, 1960s, 1970s
Lithograph on metal
with painting by hand
52 × 74 cm

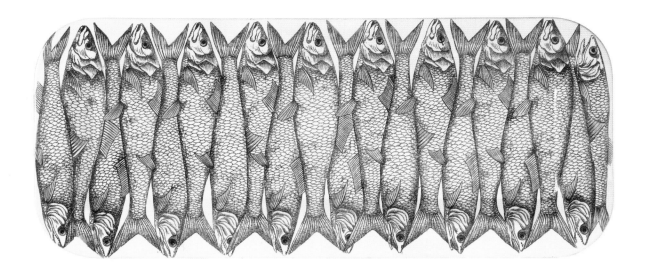

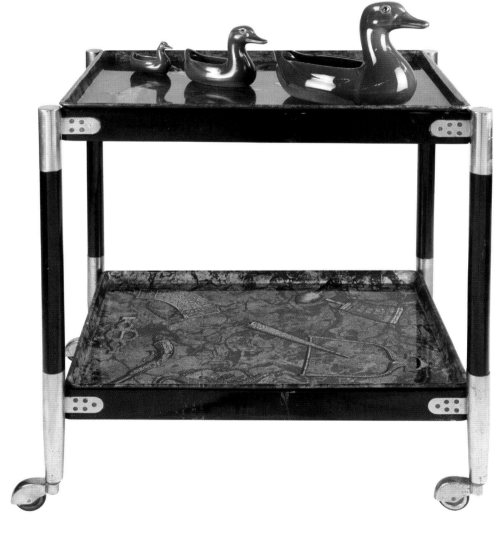

Sardine (Sardines) tray
Mid-1950s
Lithograph on metal
with painting by hand
and silver leaf
25 × 60 cm

Chiavi e pistole
(Keys and pistols) wheeled table
1960s, 1970s
Lithograph on metal
with painting by hand
and gold leaf
71 × 50 × 74 cm

Anitre (Ducks)
1950s and 1960s
Porcelain
H. 17, 11 and 6 cm

153

Interno Armadio
(Closet interior) screen
1950
Lithograph on wood
with painting by hand
200 × 205 cm

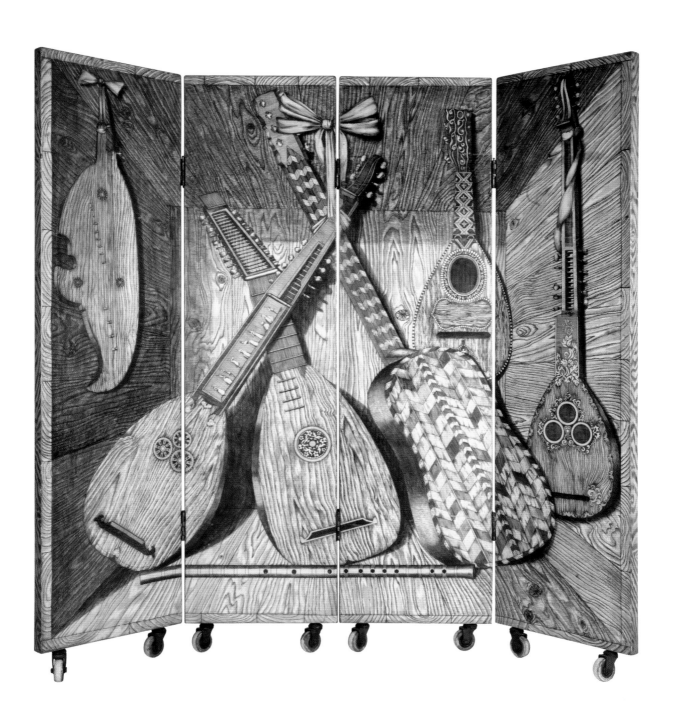

Colour composition
for the *Libreria* (Bookcase) screen
Lithograph on card
with painting by hand
1950s
70 × 56 cm

Strumenti musicali
(Musical instruments) screen
1970s
Lithograph on wood
with painting by hand
130 × 145 cm

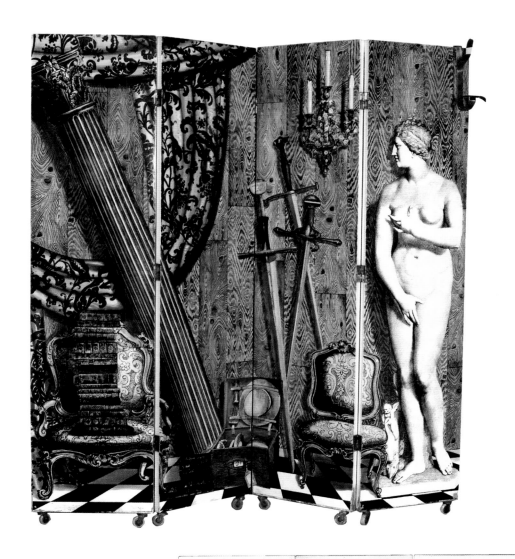

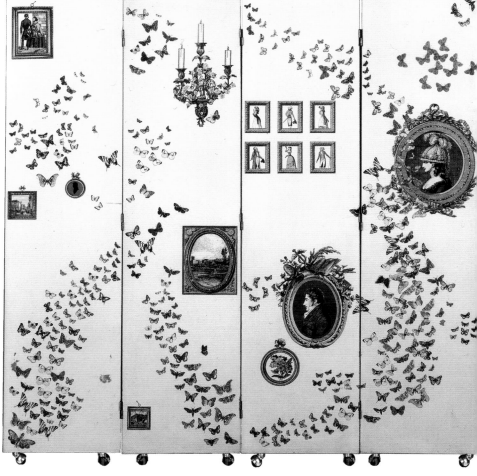

Angolo antico con Eva
(Antique corner with Eve)
screen
1950
Lithograph on wood
with painting by hand
200 × 205 cm

Farfalle (Butterflies) screen
1950
Lithograph on wood
with painting by hand
200 × 200 cm

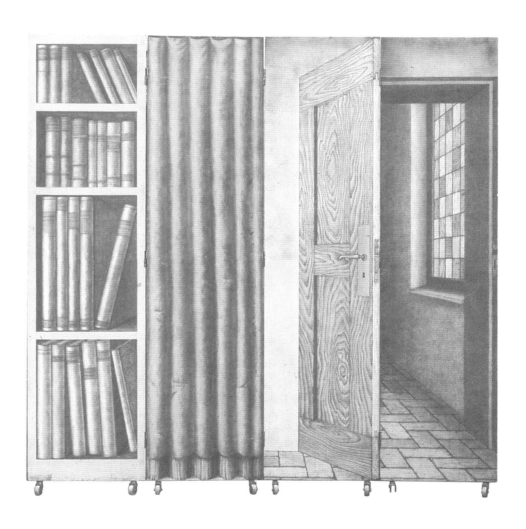

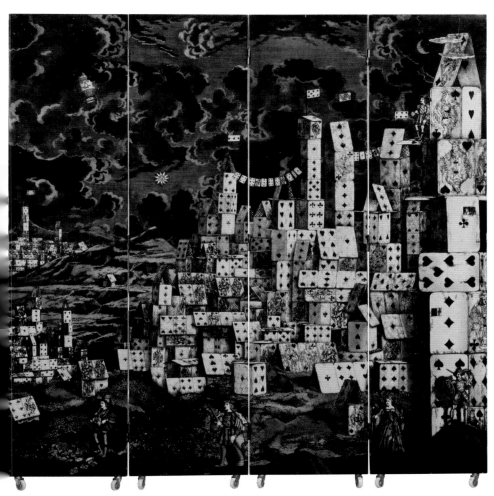

Magia domestica
(Domestic magic) screen
1958
Lithograph on wood
with painting by hand
200 × 205 cm

Città di carte
(City of cards) screen
1958
Lithograph on wood
with painting by hand
200 × 205 cm

159

Forziere (Strongbox) cabinet
Mid-1950s
Lithograph on wood
with painting by hand
92 × 100 cm

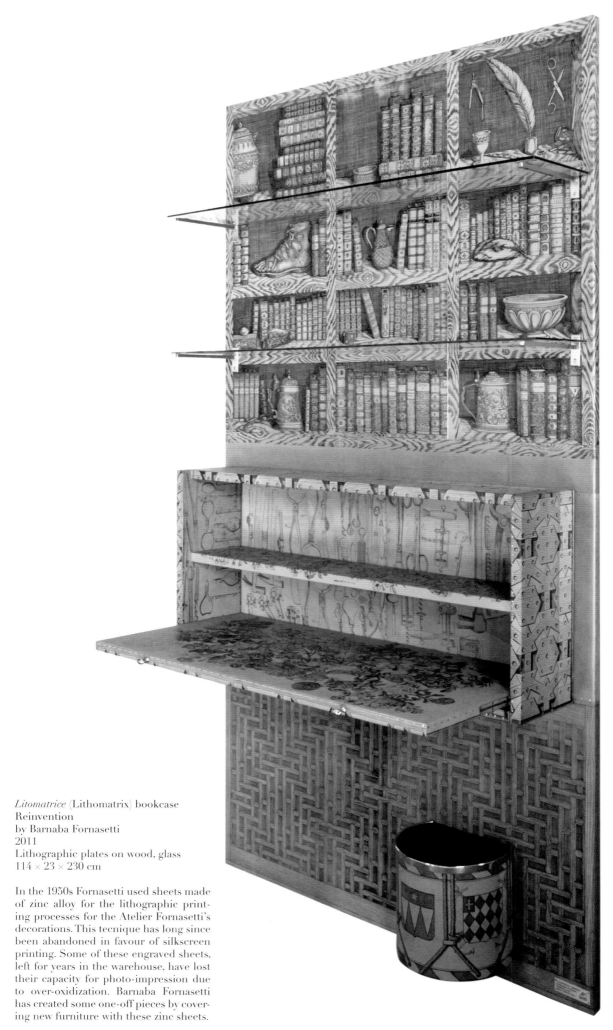

Litomatrice (Lithomatrix) bookcase
Reinvention
by Barnaba Fornasetti
2011
Lithographic plates on wood, glass
114 × 23 × 230 cm

In the 1950s Fornasetti used sheets made of zinc alloy for the lithographic printing processes for the Atelier Fornasetti's decorations. This tecnique has long since been abandoned in favour of silkscreen printing. Some of these engraved sheets, left for years in the warehouse, have lost their capacity for photo-impression due to over-oxidization. Barnaba Fornasetti has created some one-off pieces by covering new furniture with these zinc sheets.

Scaletta (Ladder) screen
1955
Lithograph on wood
with painting by hand
200 × 205 cm

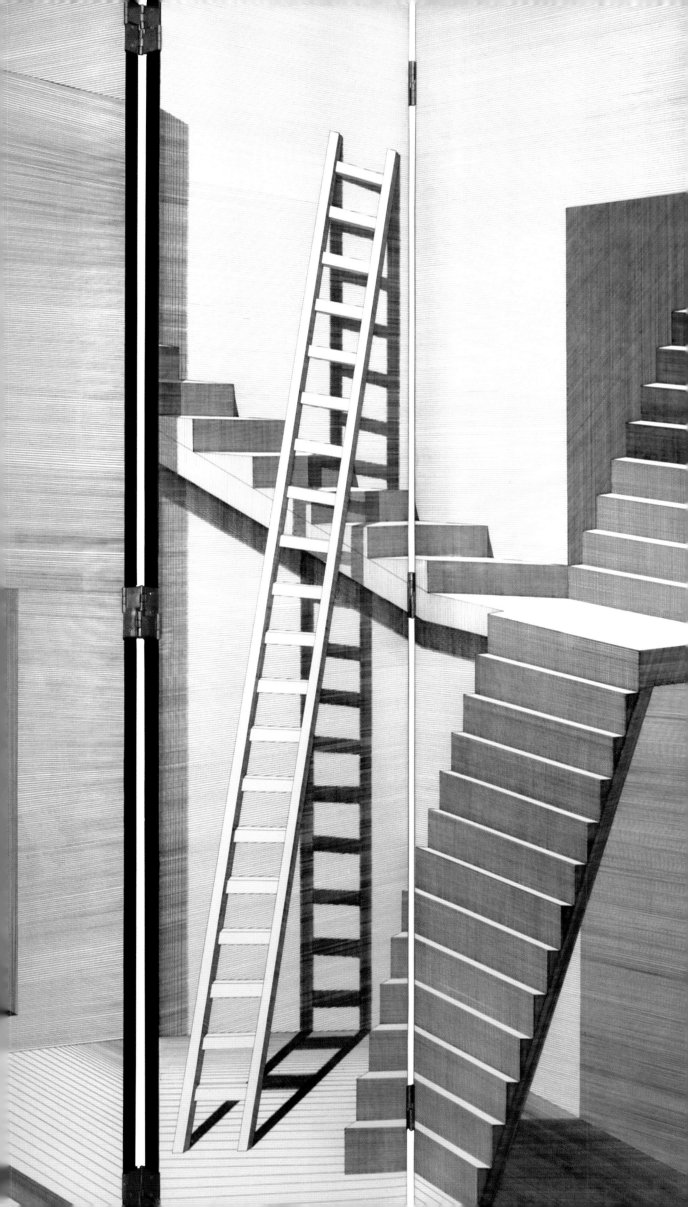

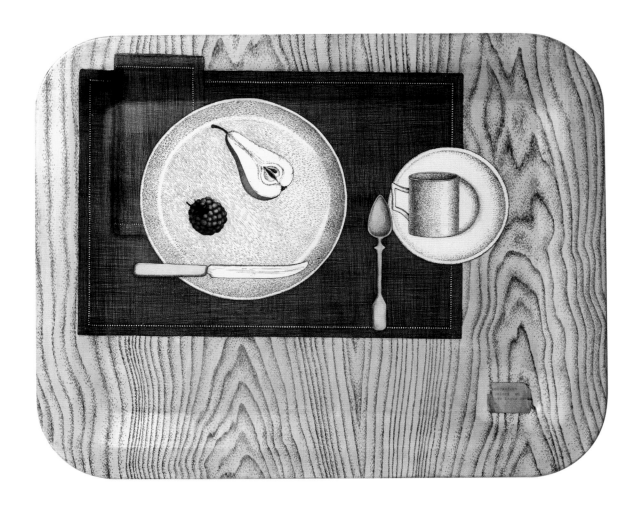

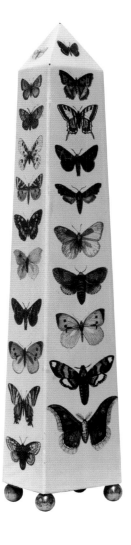

Vegetariana (Vegetarian) tray
Lithograph on metal
with painting by hand
Late 1950s
60 × 48 cm

Farfalle (Butterfly) obelisk lamp
Lithograph on metal
with painting by hand
1950s
10 × 8 × 51 cm

Piscibus plate
1950s, 1960s
Lithograph on porcelain
with painting by hand
Diam. 26 cm

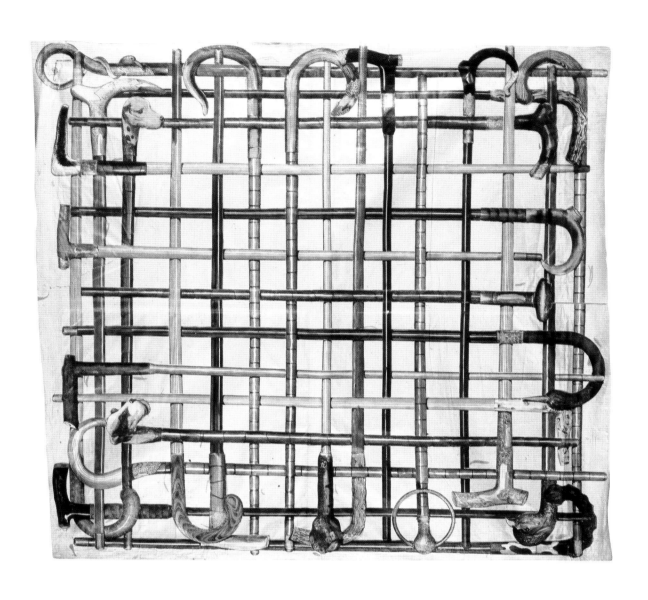

Colour composition
for the *Bastoni intrecciati*
(Entwined canes) scarf
1940
Printing proof
with painting by hand
79 × 69 cm

Registro (Register)
magazine rack
1950s
Lithograph on metal
with painting by hand
42 × 27 × 39 cm

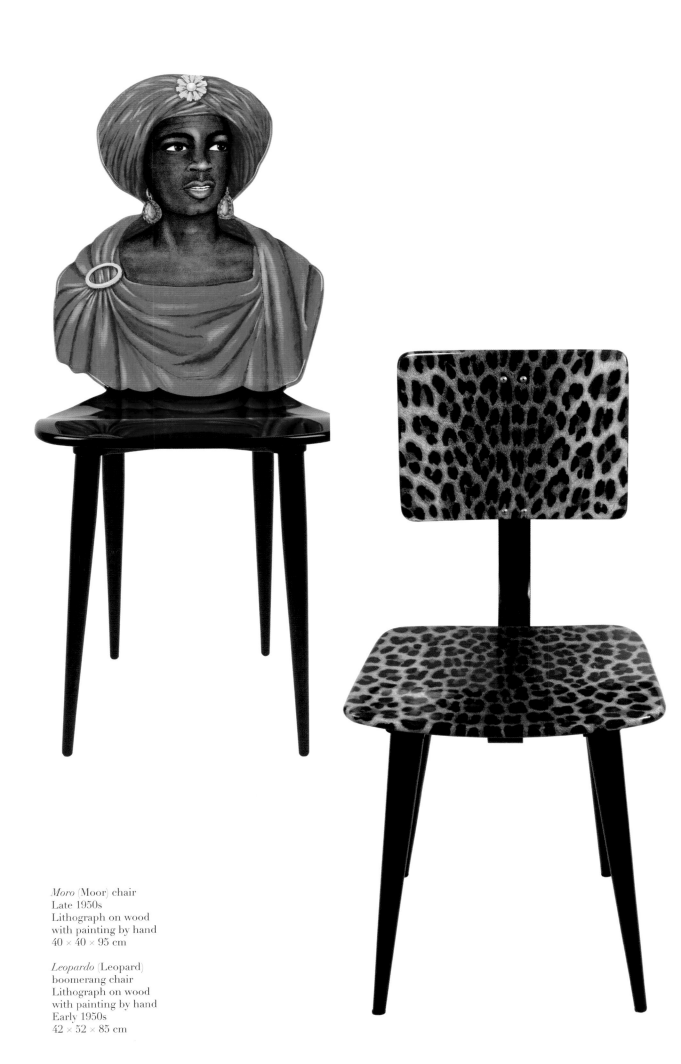

Moro (Moor) chair
Late 1950s
Lithograph on wood
with painting by hand
40 × 40 × 95 cm

Leopardo (Leopard)
boomerang chair
Lithograph on wood
with painting by hand
Early 1950s
42 × 52 × 85 cm

166

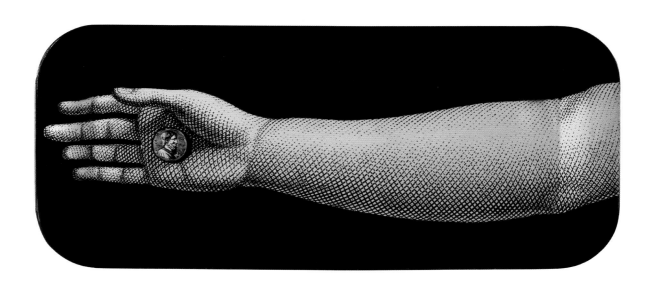

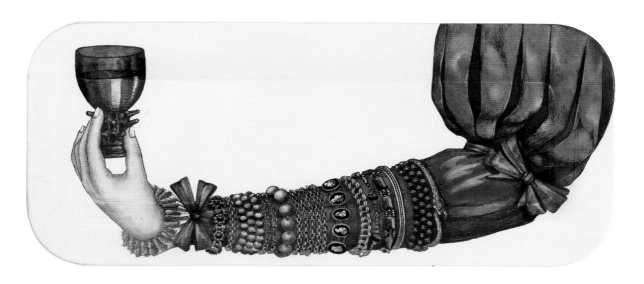

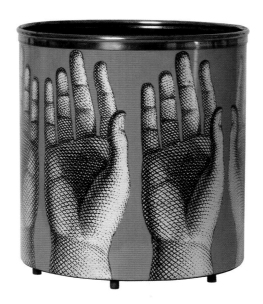

Braccio con moneta
(Arm with coin) tray
Mid-1950s
Lithograph on metal
60 × 25 cm

Braccio ingioiellato
(Bejewelled arm) tray
Lithograph on metal
with painting by hand
Early 1950s
60 × 25 cm

Mani (Hands)
wastepaper basket
1950s
Lithograph on metal
Diam. 26 × 28 H cm

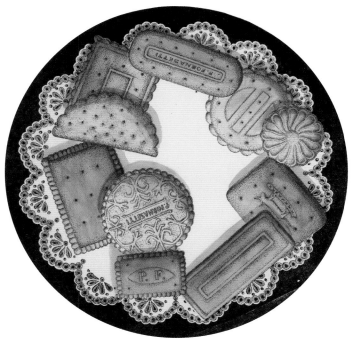

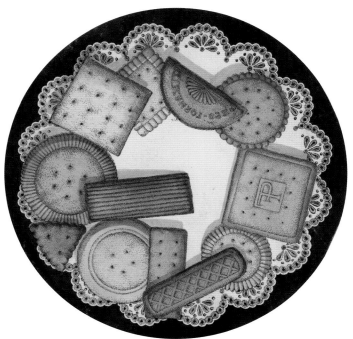

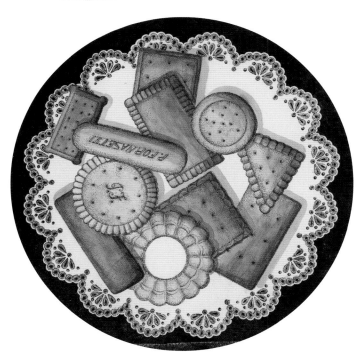

Colour compositions
for the *Biscotti con pizzo*
(Biscuits and doilies) plates
1950s
Lithograph on paper
with painting by hand
Diam. 26 cm

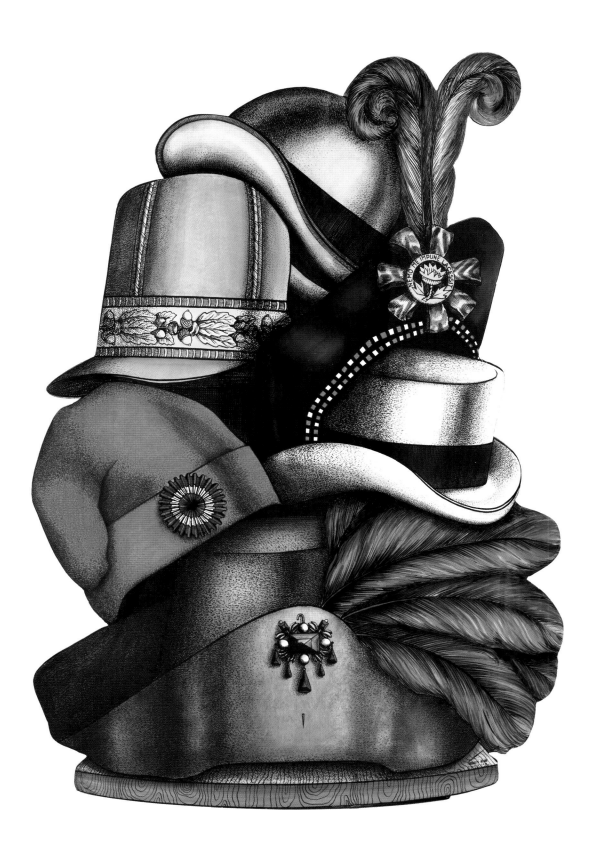

Cappelli (Hats)
trompe-l'œil umbrella stand
1950s, 1960s and 1970s
Lithograph on metal
with painting by hand
52 × 68 cm

169

ARCHI–TECTURES

The importance of *disegno* (drawing) and line in Fornasetti's imagination corresponds with that of architecture and spatial construction. These themes constitute a treasure trove of motifs and forms rooted in tradition, and provide the means for endless manipulations and distortions. The encyclopedic cultural knowledge that Fornasetti possessed allowed him to touch on the work of historically important figures from architecture, as well as minor masters of the Lombardy Enlightenment: essential to him among these were 'the five orders according to Vignola and Andrea Palladio, Vitruvius, Serlio, Longhena, Alberti, the Bibbiena family, Sanquirico and Piermarini'. Combining the most rigorous classicism and the most theatrical baroque, his work was inspired and subtly structured by the system of the orders: not as a rigid canon or credo to be followed slavishly, but as a source of elements to play with, as he wrote, 'like a juggler'.

Piero Fornasetti
Photograph by Ugo Mulas
1960s

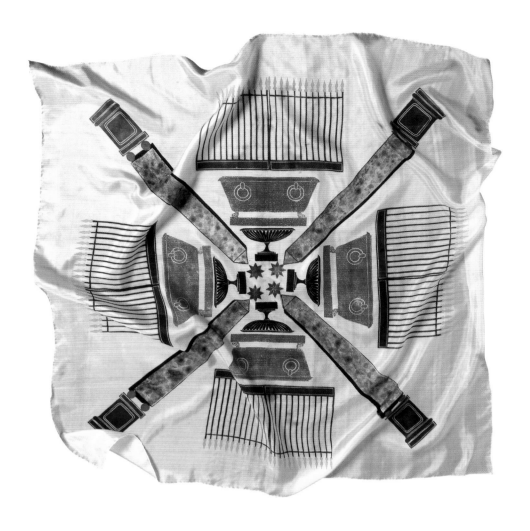

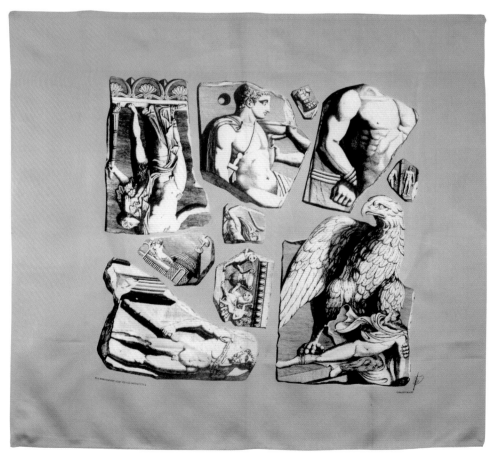

Obelischi (Obelisks) scarf
1939
Hand-printed silk
83 × 87 cm

Frammenti antichi
(Antique fragments) scarf
1948
Hand-printed silk
83 × 87 cm

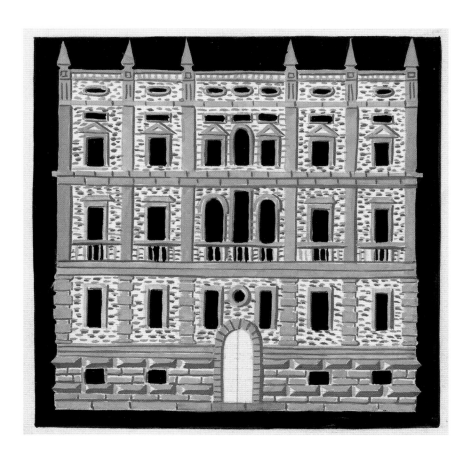

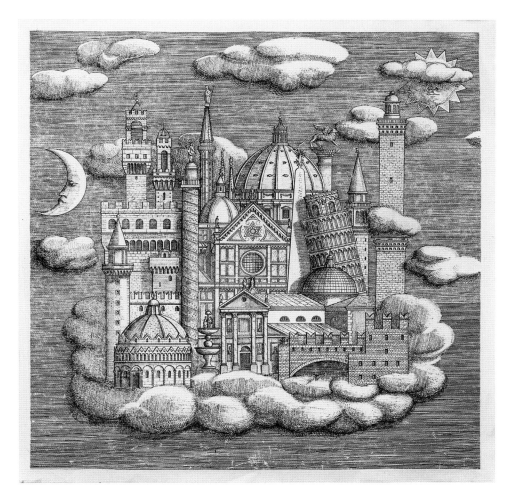

Sketch for scarf
with architectural motifs
1950
Mixed media on paper
19 × 19 cm

Sketch for *Italia che vola*
(Flying Italy) scarf
Early 1950s
Indian ink on paper
46 × 46 cm

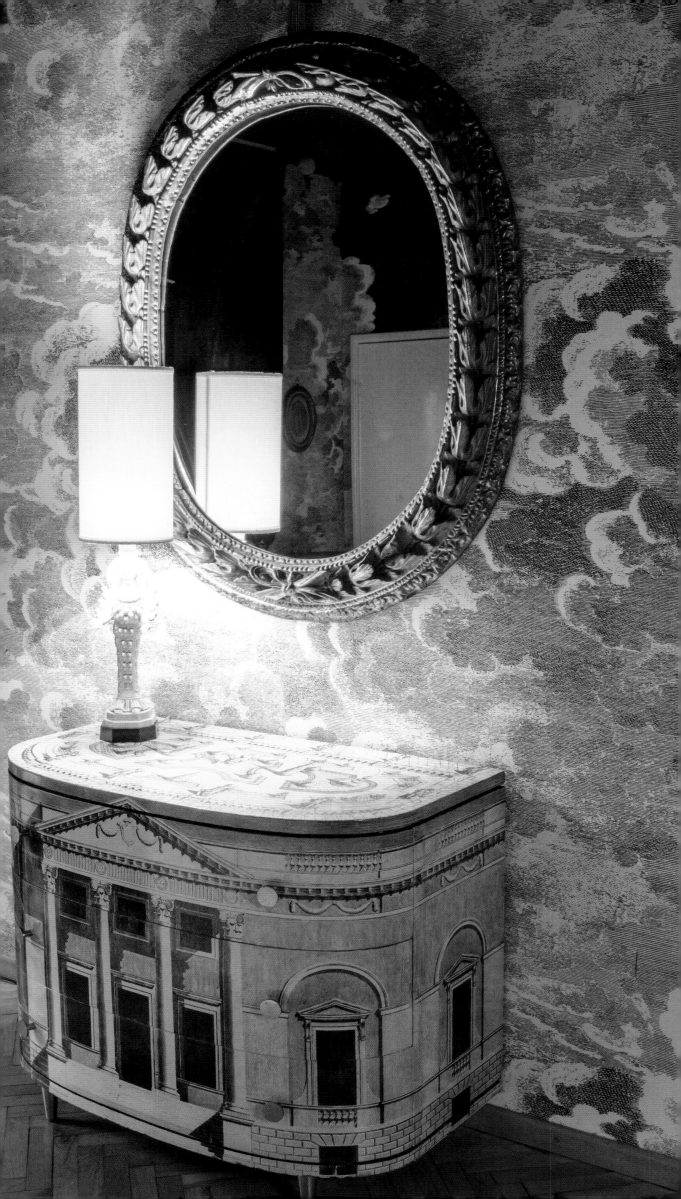

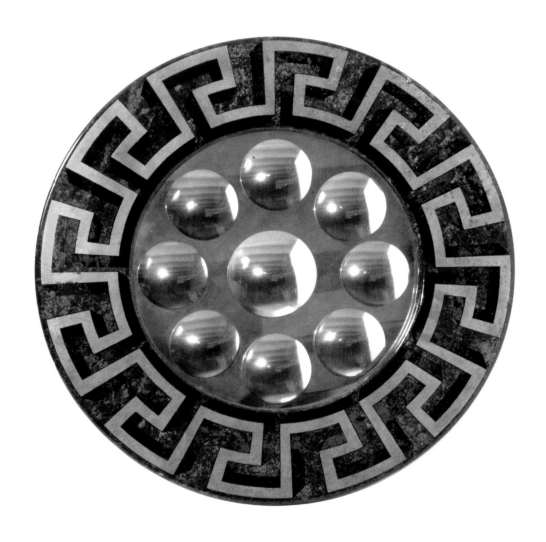

Palladiana chest of drawers
1950s
Lithograph on wood
100 × 56 × 86 cm

Greca (Greek fret) mirror
Mid-1950s
Lithograph on wood
with painting by hand and gold leaf
Diam. 48 cm

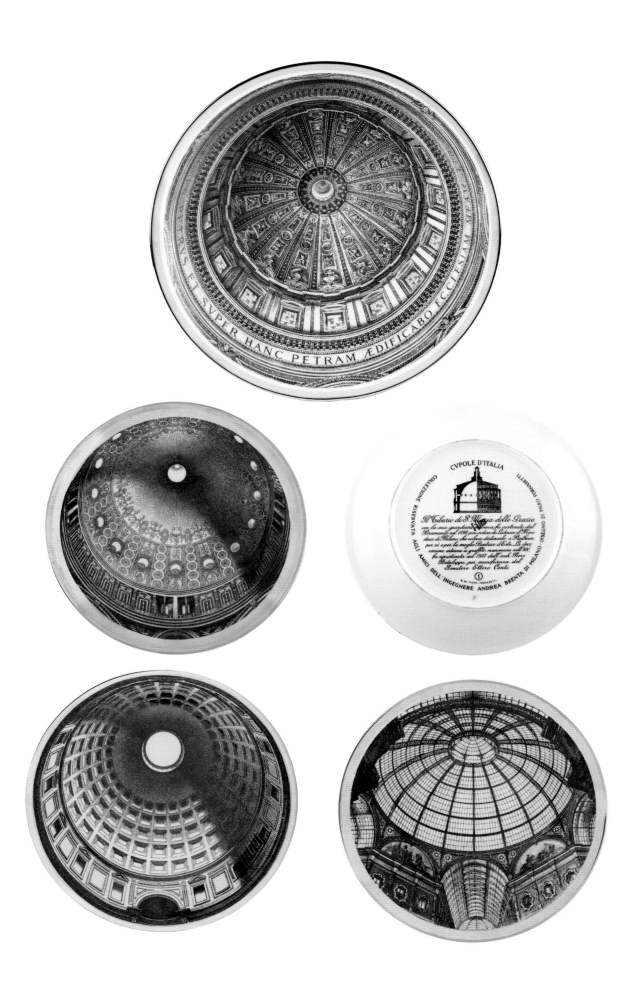

Five plates
from series of seventeen
Cupole d'Italia (Domes of Italy)
1950s, 1960s, 1970s
Lithograph on porcelain
with hand-painted gold
Diam. 31 and 24 cm

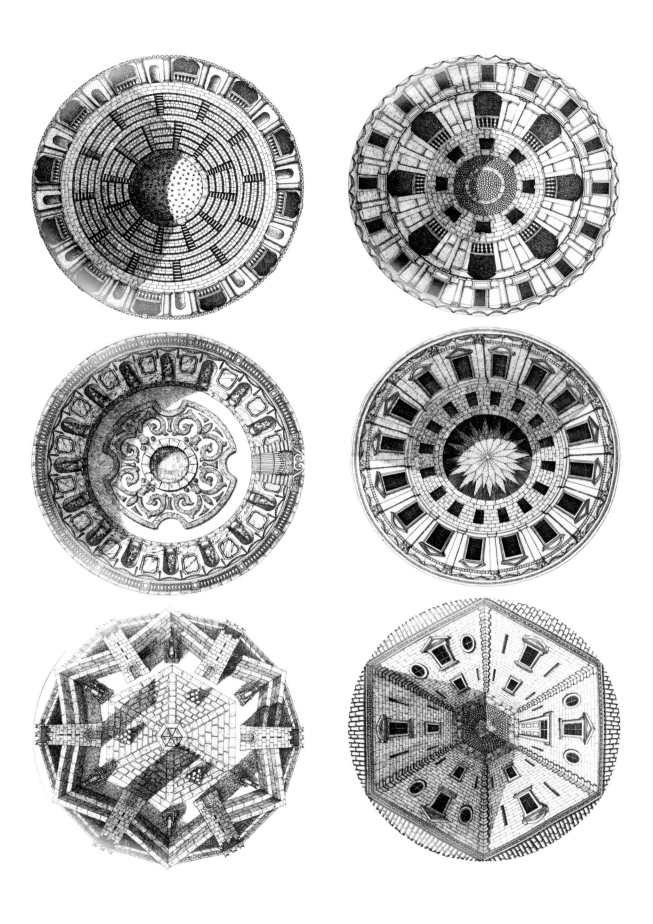

Set of *Cortili*
(Courtyards) plates
1950s, 1960, 1970s
Lithograph on porcelain
Diam. 26 cm

177

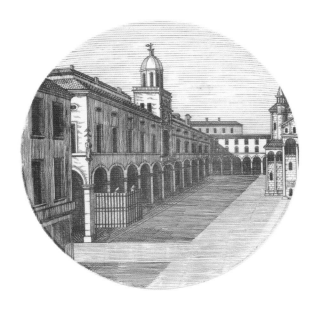

Five plates
from the *Prospettiva*
(Perspective) set
1950s, 1960s
Lithograph on porcelain
Diam. 26 cm

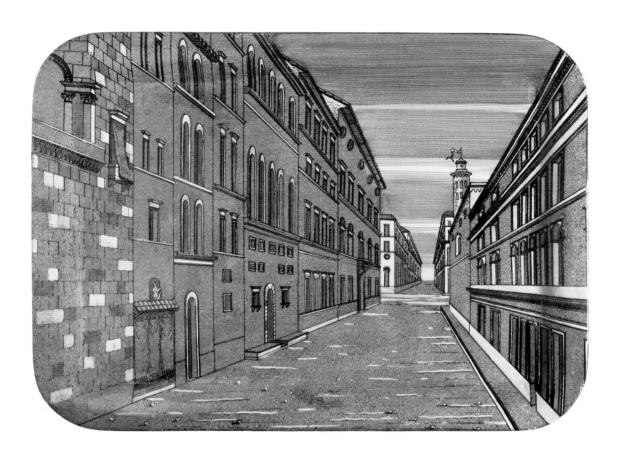

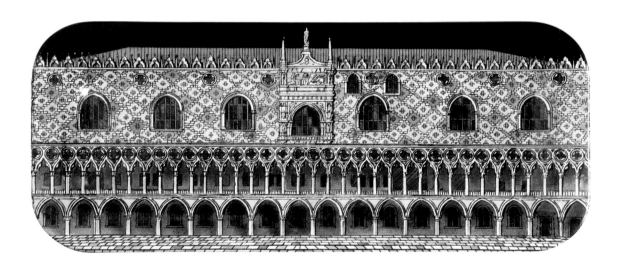

Prospettiva
(Perspective) tray
Late 1950s
Lithograph on metal
with painting by hand
80 × 60 cm

Palazzo Ducale
(Doge's Palace) tray
Early 1950s
Lithograph on metal
with painting by hand
60 × 25 cm

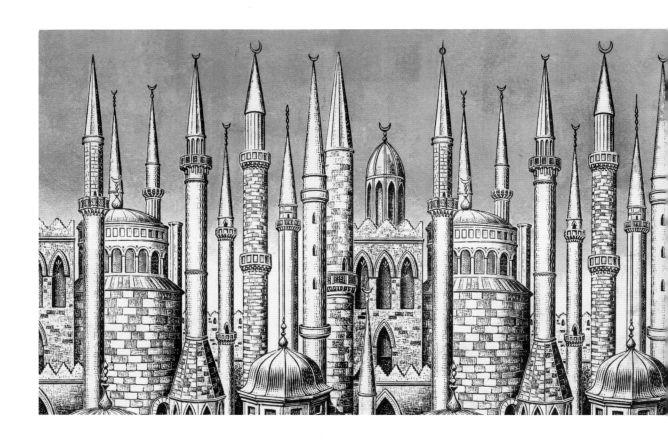

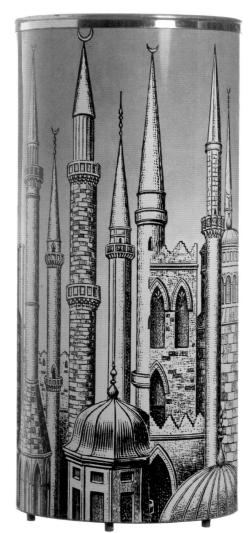

p.180-181
Original drawing
for the *Architettura*
(Architecture) trumeau
1950s
Indian ink on paper
84 × 38 cm

Colour composition
for the *Minareti*
(Minarets) umbrella stand
Lithograph on paper
with painting by hand
Early 1950s
82 × 56 cm

Minareti (Minarets) umbrella stand
Early 1950s
Lithograph on metal
with painting by hand
Diam. 26 × 56 cm

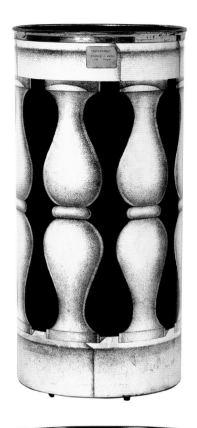

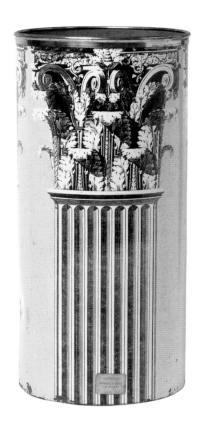

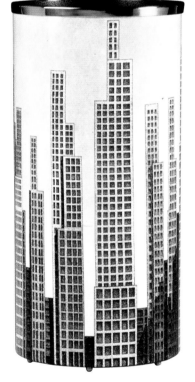

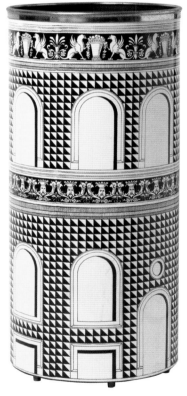

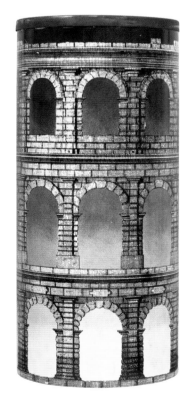

Acquedotto (Aqueduct)
umbrella stand
1950s, 1960s
Lithograph on metal
with painting by hand
Diam. 26 cm, H. 56 cm

Balaustra (Balustrade)
umbrella stand
Lithograph on metal
with painting by hand
1950s
Diam. 26 cm, H. 56 cm

Grattacieli (Skyscrapers)
umbrella stand
Early 1950s
Lithograph on metal
with painting by hand
Diam. 26 cm, H. 56 cm

Capitelli (Capital)
umbrella stand
Lithograph on metal
with painting by hand
1950s
Diam. 26 cm, H. 56 cm

Facciata quattrocentesca
(Fifteenth-century façade)
umbrella stand
Early 1950s
Lithograph on metal
Diam. 26 cm, H. 56 cm

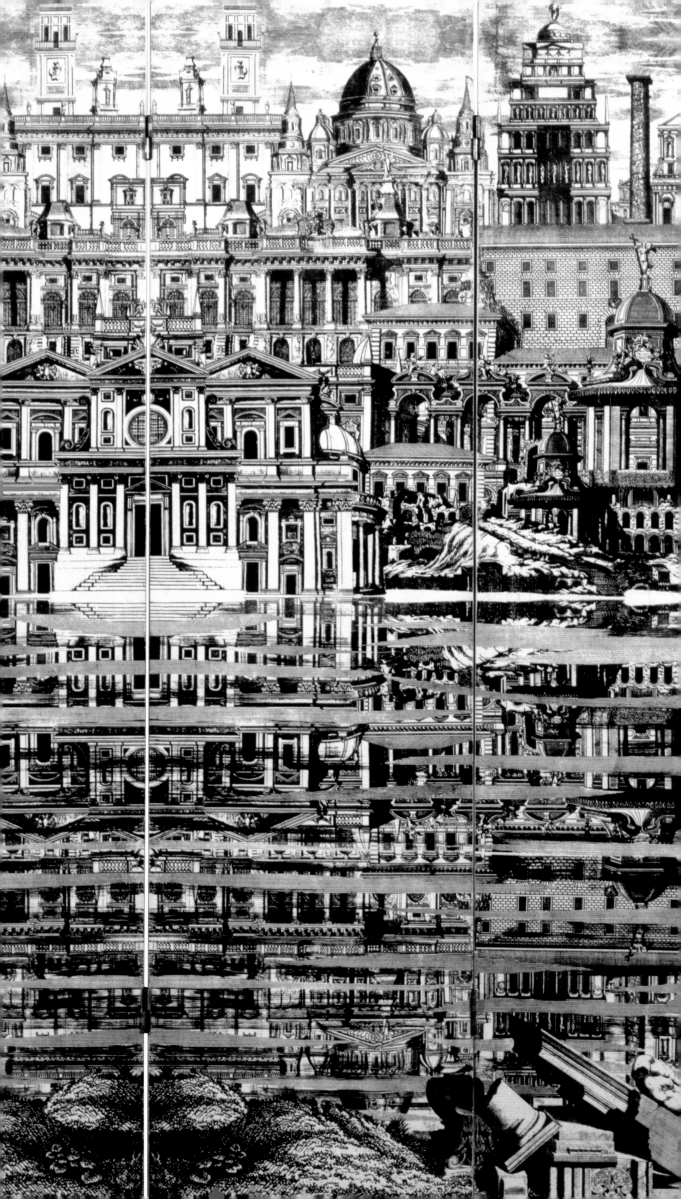

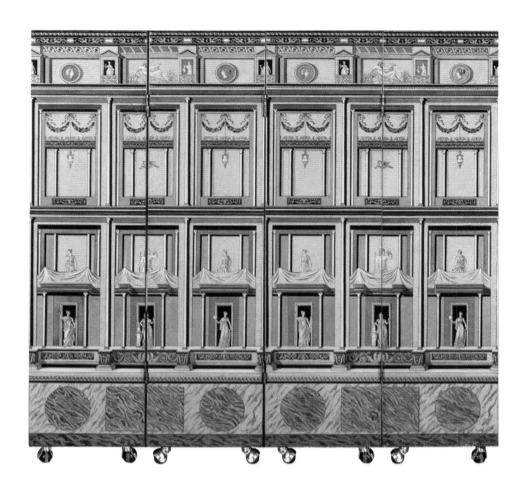

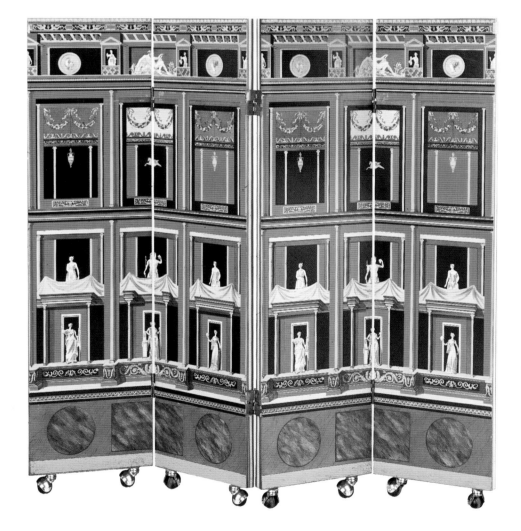

Città che si rispecchia
Reflected city) screen
1955
Lithograph on wood
200 × 205 cm

Pompeiana
(Pompeian motif)
ochre screen
1951
Lithograph on wood
with painting by hand
130 × 145 cm

Pompeiana
(Pompeian motif) red screen
1951
Lithograph on wood
with painting by hand
130 × 145 cm

185

Grattacieli in fiamme
(Skyscrapers on fire) sketch
Proposed for a large American store,
rejected
Early 1950s
27.5 × 27.5 cm

Anfiteatro Romano
(Roman amphitheatre) ashtray
1960s
Lithograph on porcelain
10 × 18 × 2.5 cm

Sketch for the furnishings
of a room with a fireplace
in a Fornasettian neo-Gothic style
Early 1950s
Indian ink and aniline on masonite
65 × 49.5 cm

Ideas and technical
drawings for a chest of drawers
1950s
Mixed technique
70 × 60 cm

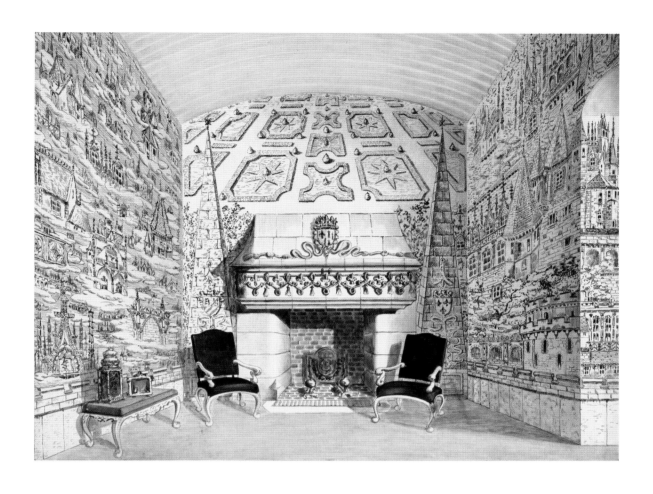

Architetto
(Architect) waistcoat
1947
Silk
48 × 70 cm

Capitello corinzio
(Corinthian capital) chair
Mid-1950s
Lithograph on wood
40 × 45 × 95 cm

Capitello ionico
(Ionic capital) chair
1980
Lithograph on wood
40 × 45 × 95 cm

Architettura
(Architecture) table
1970s
Lithograph on wood
Diam. 170 cm

Anfiteatro
(Amphitheatre) table
1950s
Silkscreen on wood, glass
116 × 58 × 50 cm

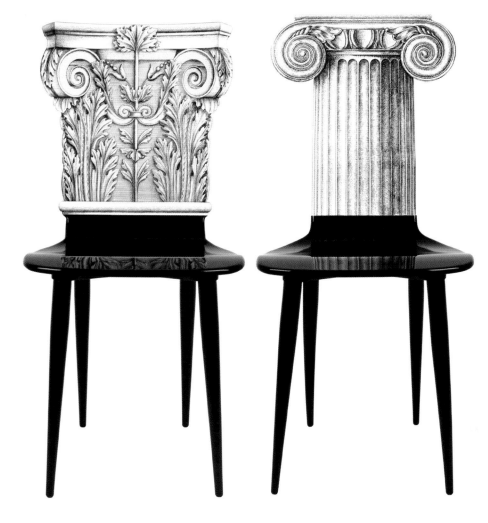

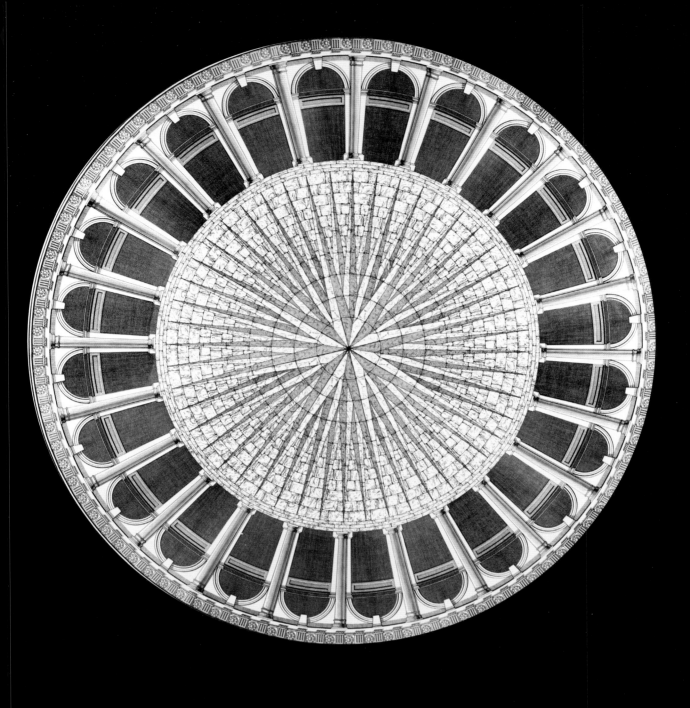

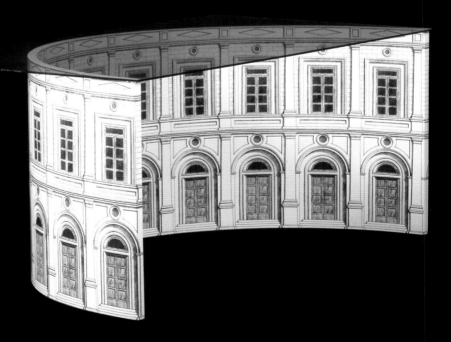

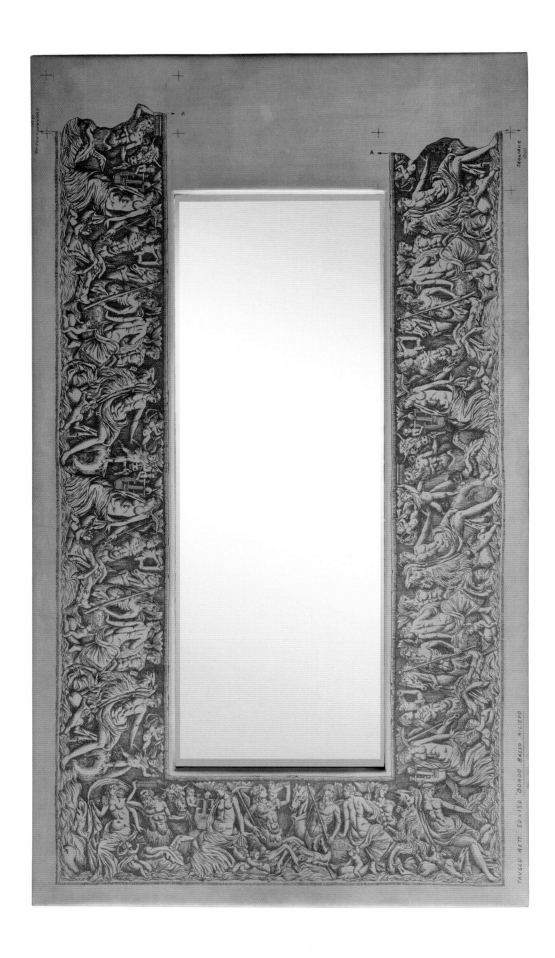

p.190-191
Living room,
Fornasetti's house at Varenna
1960s

Litomatrice Bassorilievo mirror
Reinvention Barnaba Fornasetti
2011
Lithographic plate on wood
44 × 3 × 79 cm

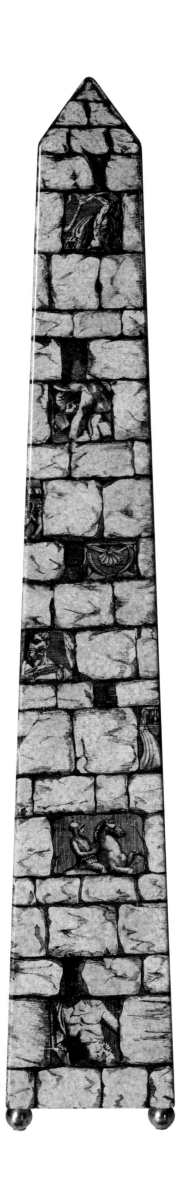

Muro Antico
(Ancient wall) obelisk
1950s
Lithograph on metal
with painting by hand
12 × 9 × 78 cm

193

THEME
AND
VARIATIONS

Léonor Fini, Max Ernst,
Enrico Colombotto Rosso,
with the first plate
of the *Tema e Variazioni*
(Theme and Variations) series
Photograph

Pp. 196-206
Plates from the *Tema e variazioni*
(Theme and variations) series
1950s-1960s
Lithograph on Porcelain
Diam. 26 cm

P. 207
Plates from the *Tema e variazioni*
(Theme and variations) series
Barnaba Fornasetti
1990s-2000s
Silkscreen on Porcelain
Diam. 26 cm

The expressionless face of a woman that
shines forth from the Fornasetti constella-
tion is both his emblem and a screen for his
endlessly fertile wealth of forms: she is known
and recognized even by those who don't know
the name of the original 'source'. She was
the subject of no fewer than 350 transforma-
tions, since her first appearance in 1952, and
nowhere can it be said that the cycle was ever
finished... It was only several decades later
that Piero lifted the veil on the identity of a
face that some had seen as that of the Mona
Lisa: in fact, it belonged to a late nineteenth-
century opera singer of somewhat wayward
fortunes, Lina Cavalieri, whom Fornasetti had
happened across by chance, in the course of
his omnivorous reading. The face is a shame-
less icon of kitsch, on the one hand, but on
the other hand, thanks to endless playing with
scale and ironic transformations, it is a real
cosa mentale, as much an intellectual device
as an aesthetic one, like so many of the most
acute creations by modern artists from Jarry
and Roussel to Duchamp and Warhol.

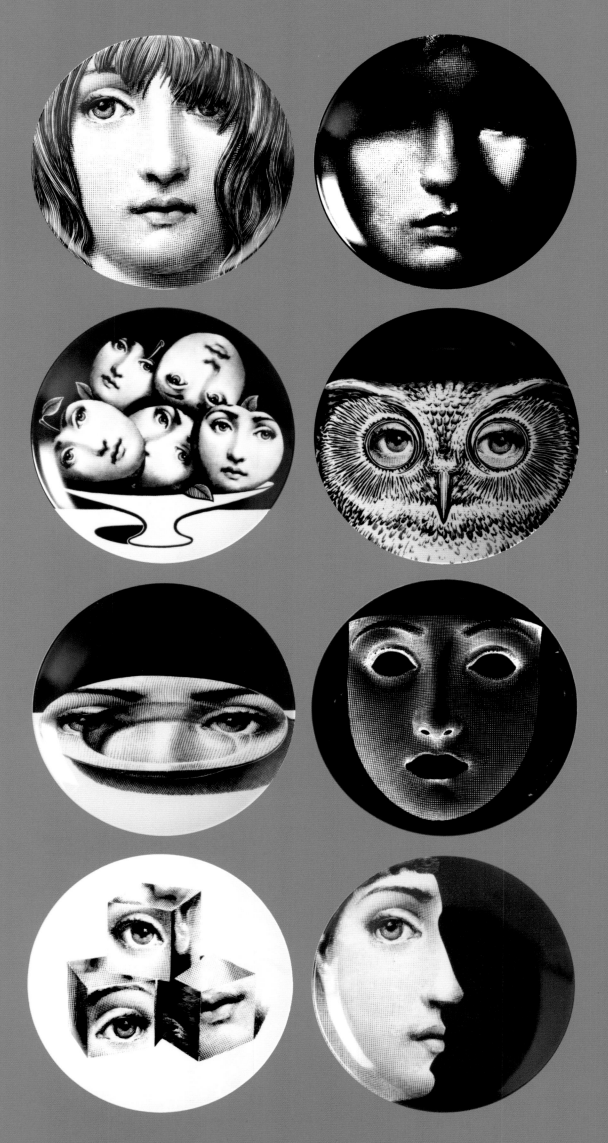

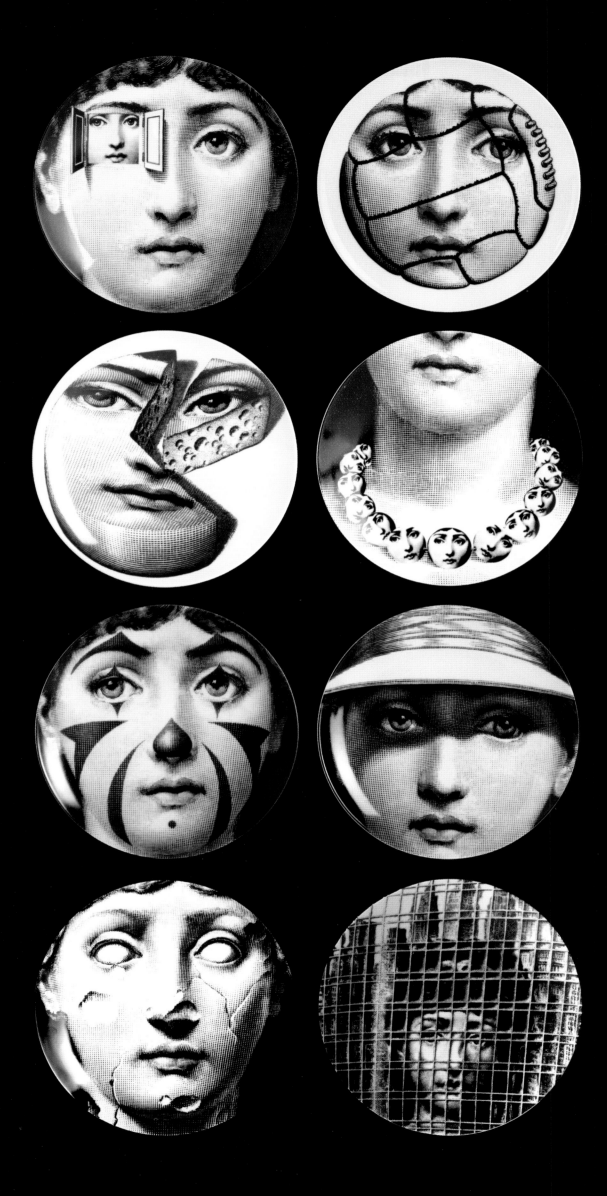

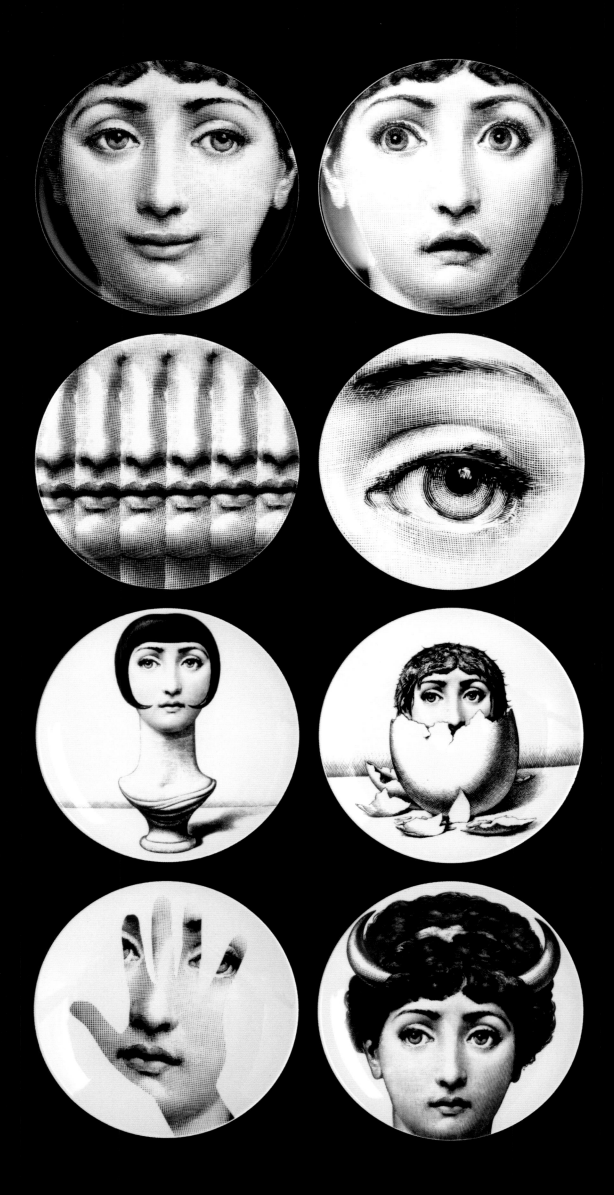

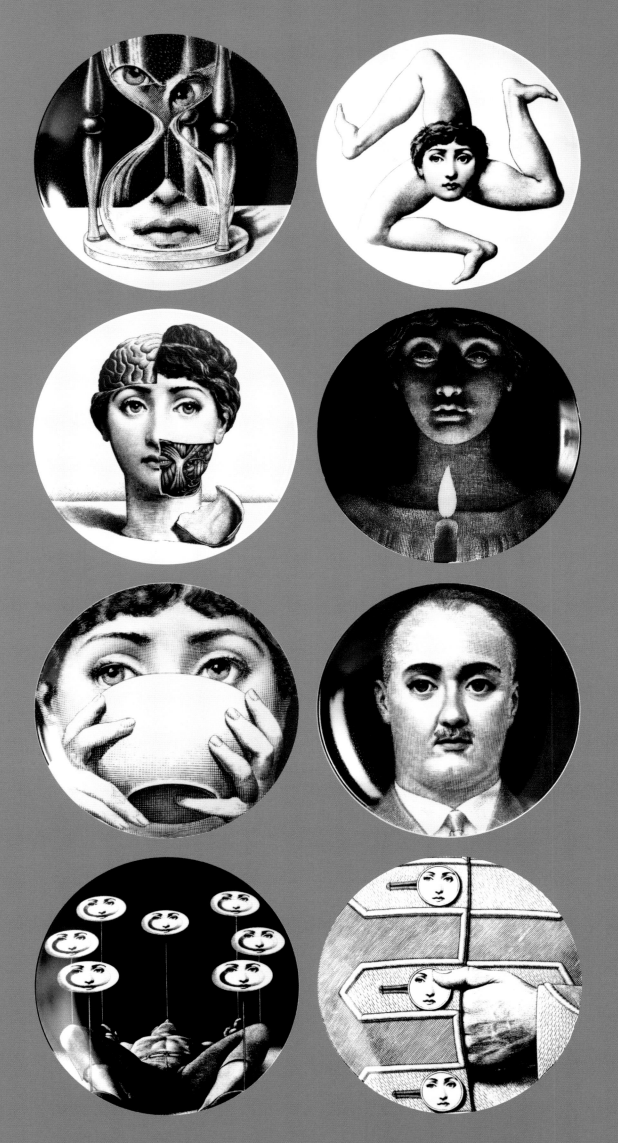

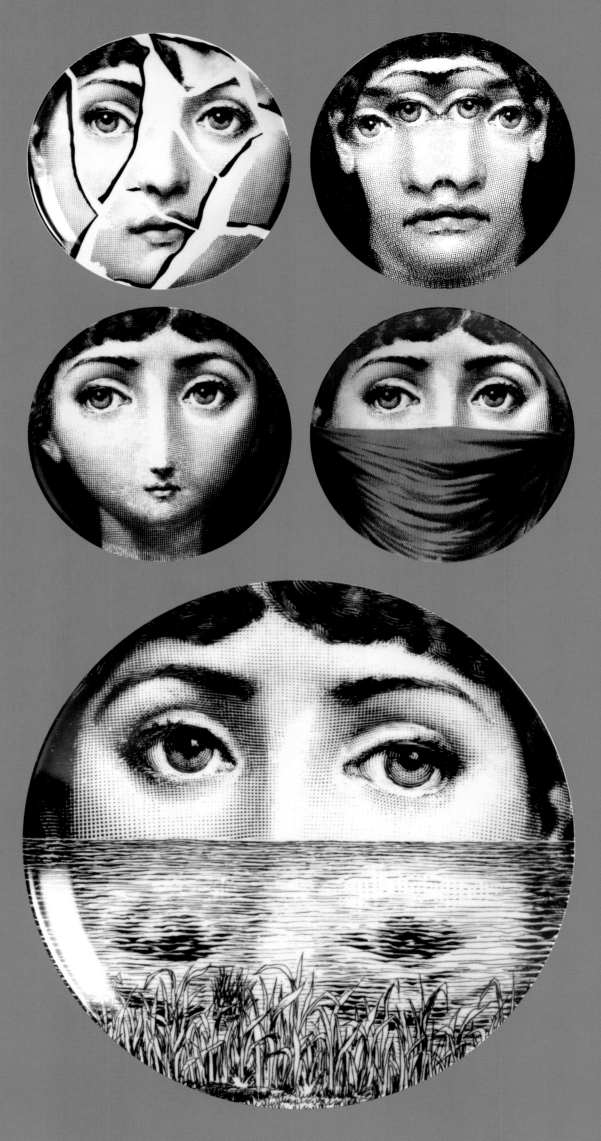

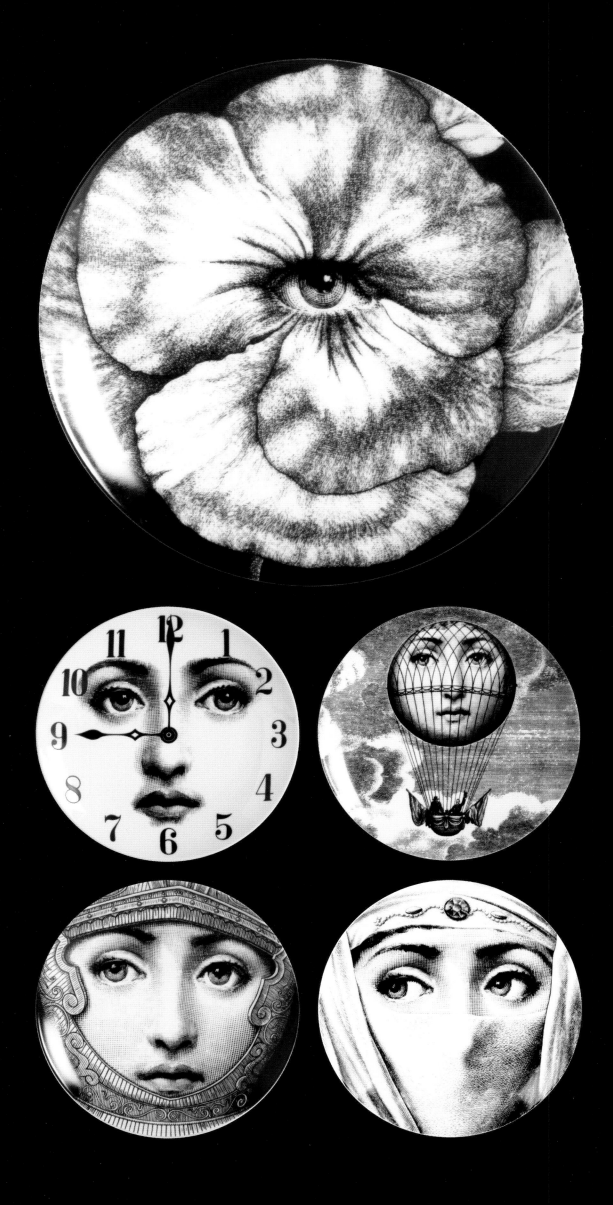

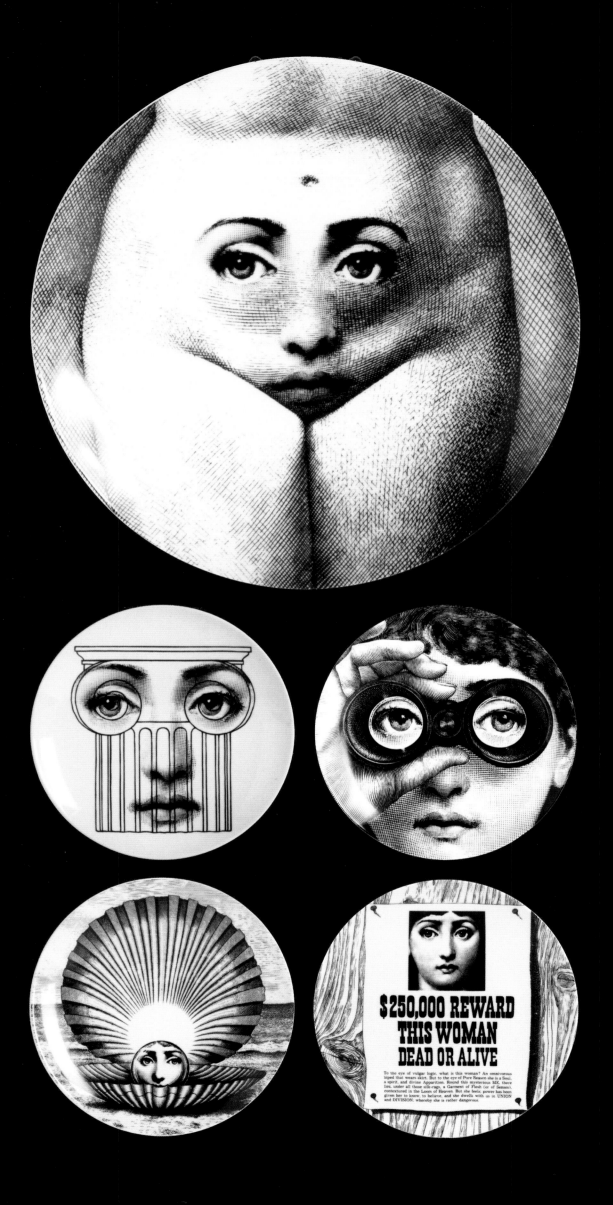

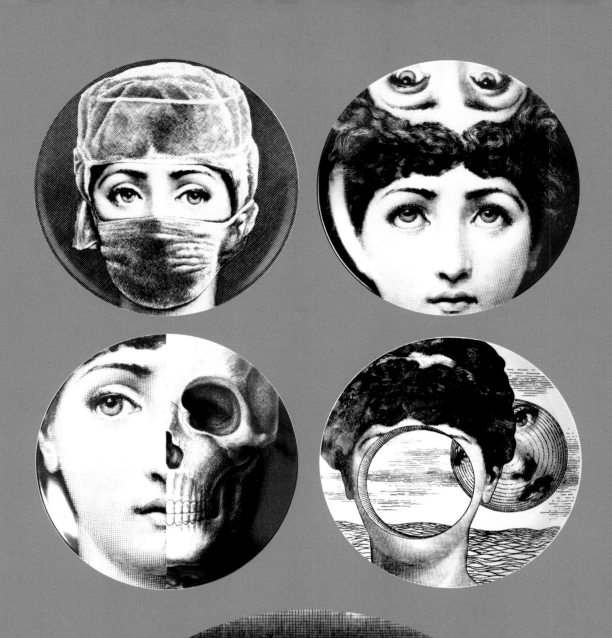

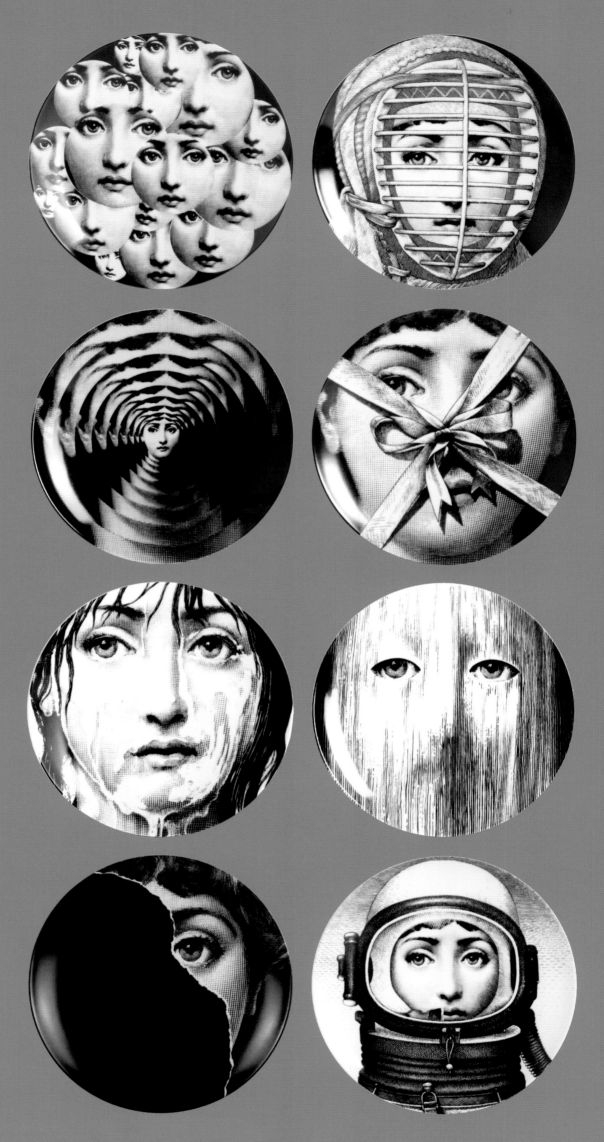

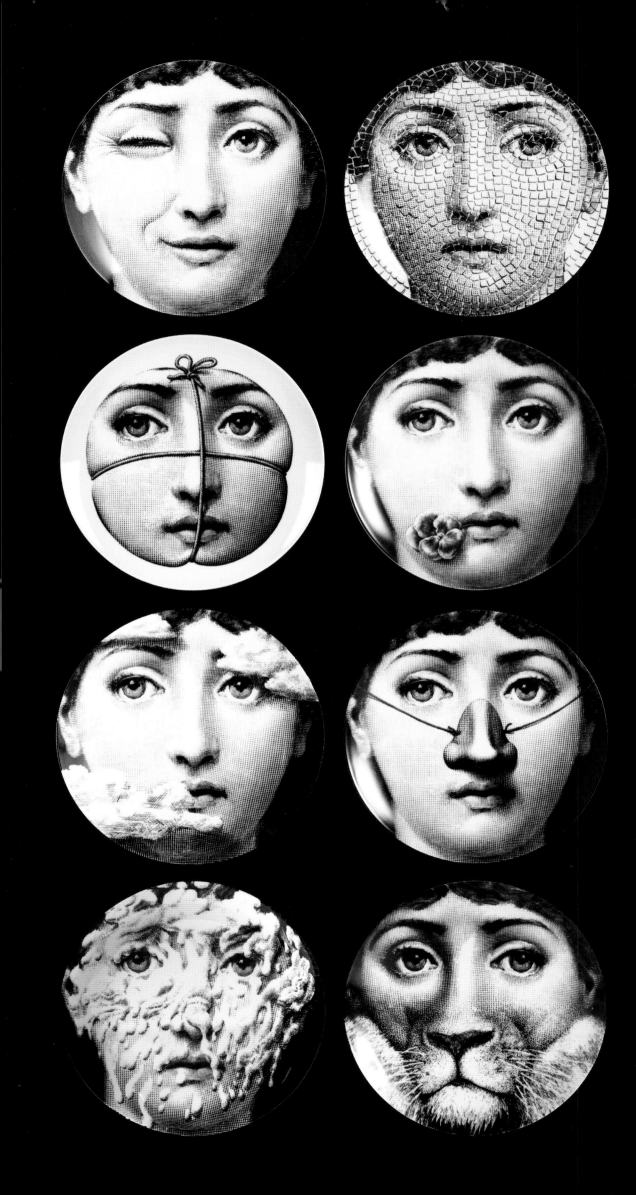

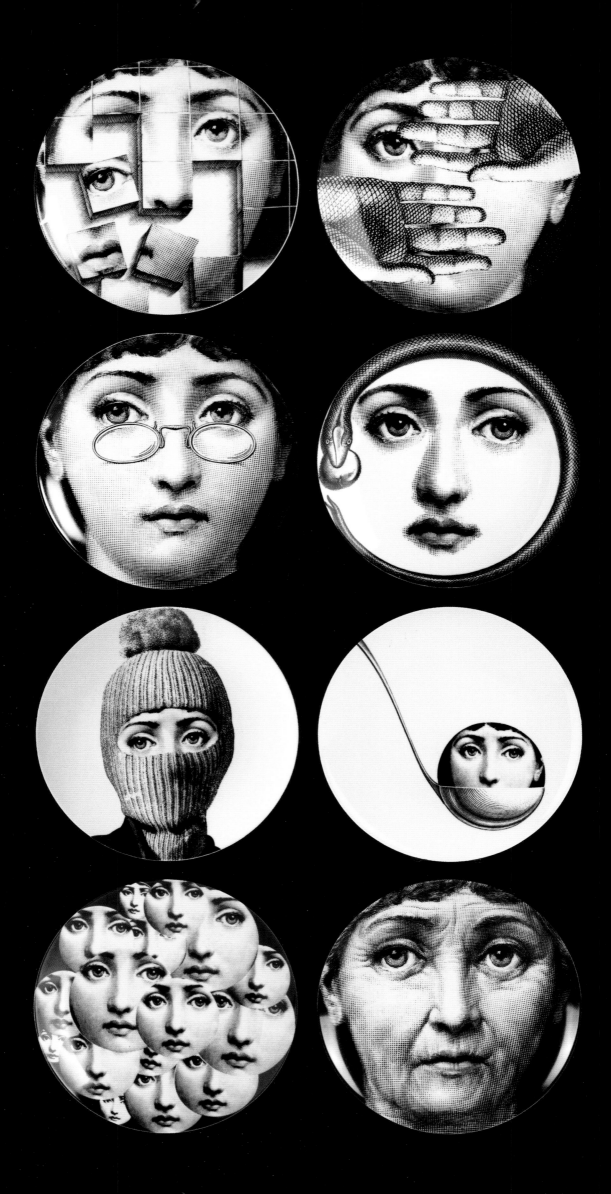

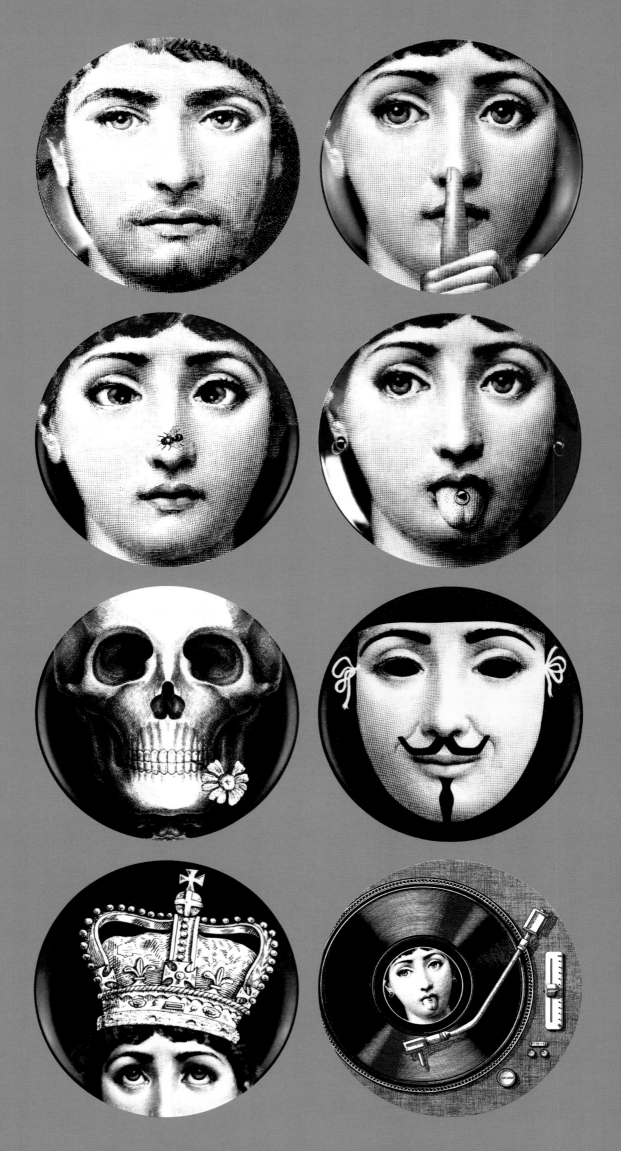

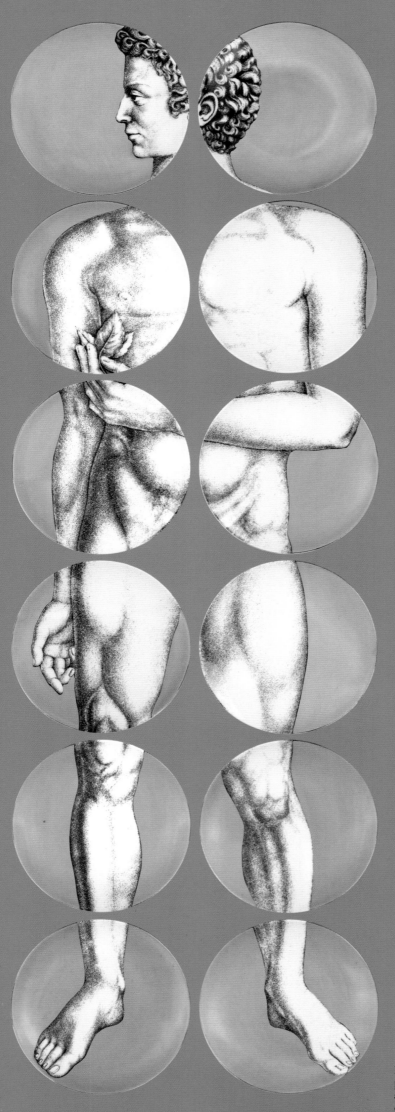

Adamo (Adam) plate set
1950s
Lithograph on porcelain,
with hand-painted gold
Diam. 26 cm

Pp. 209-244
Book of fourteen original pen
drawings for *La Folie Pratique*
(Practical Madness) calendar
1947
Ink on paper

These drawings were used by
Piero Fornasetti to make a calendar
printed for his friends in 1947. They are
an example of the artist's penchant for
developments on a simple pen- or
pencil-drawn line.

LA FOLIE PRATIQUE

DESSINS A LA
PLUME
DE
PIERO
FORNASETTI
A
DEITINGEN
1945

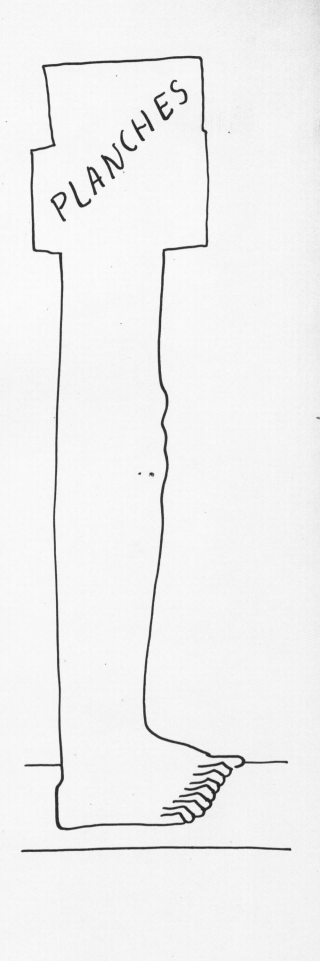

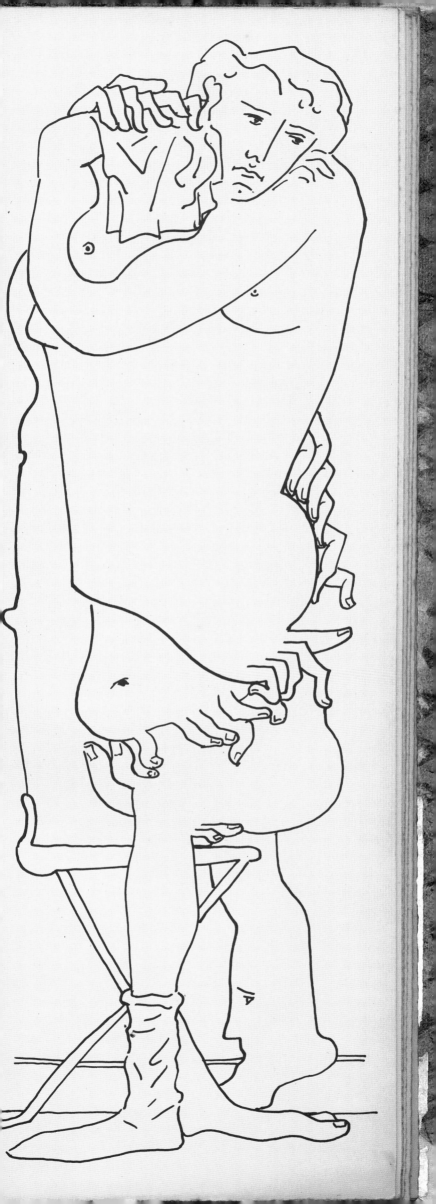

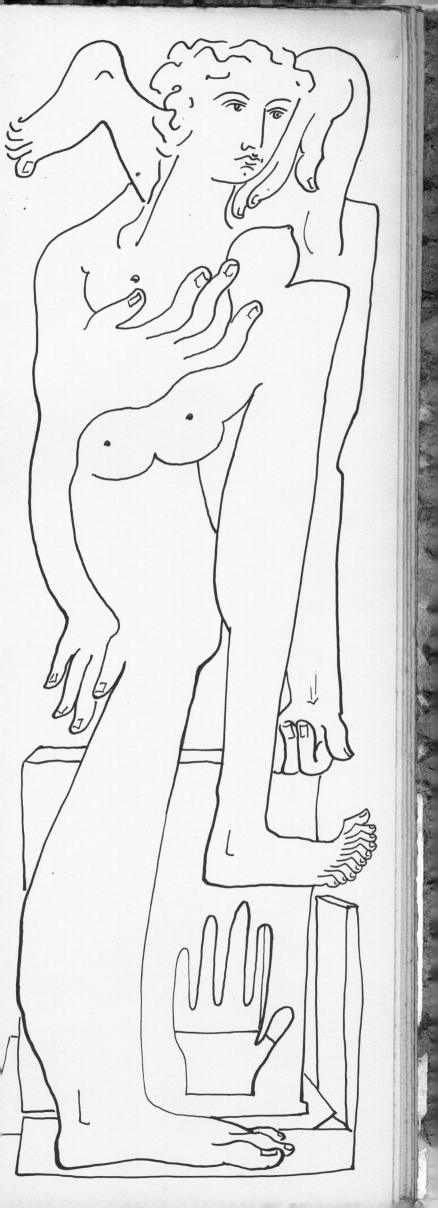

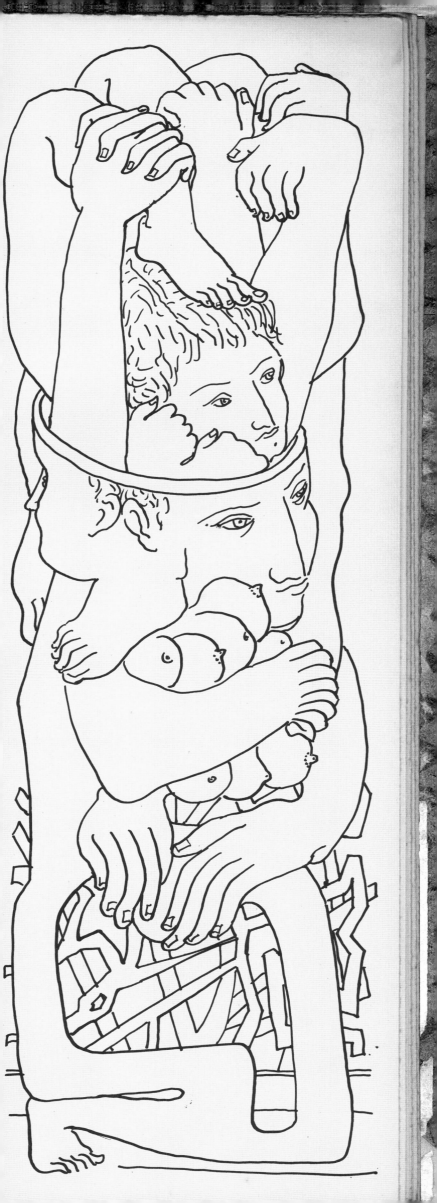

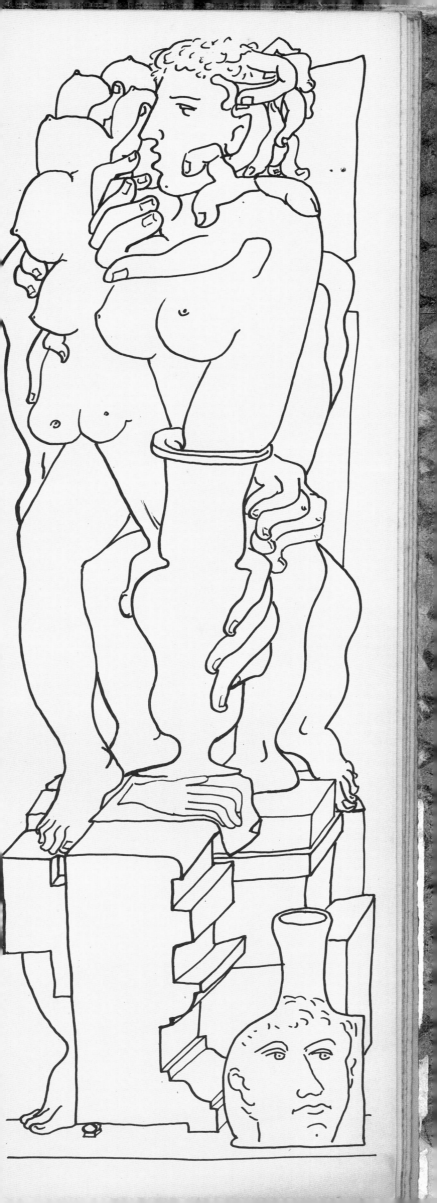

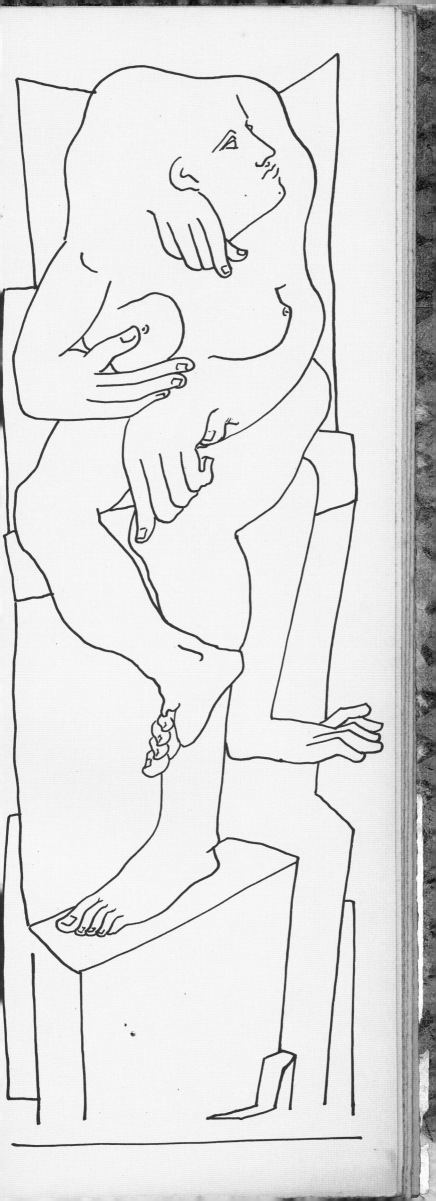

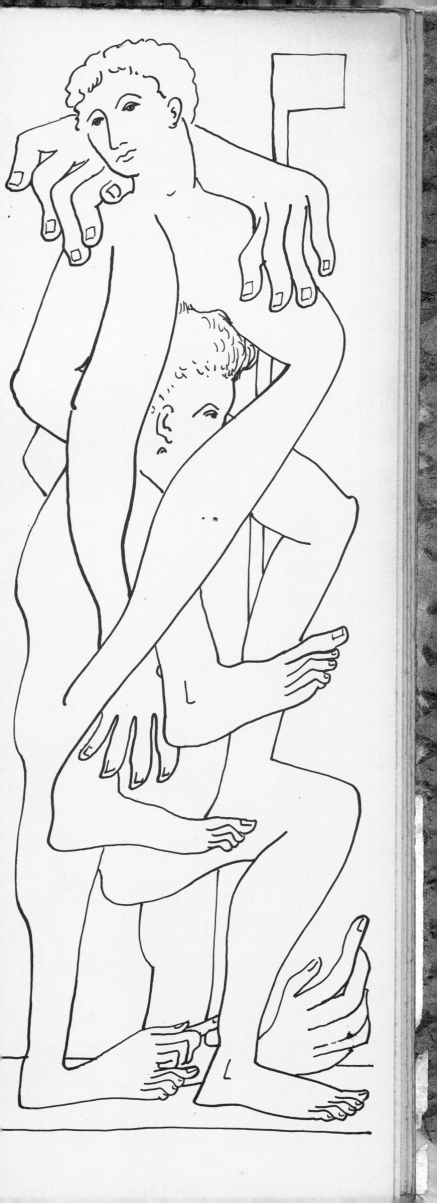

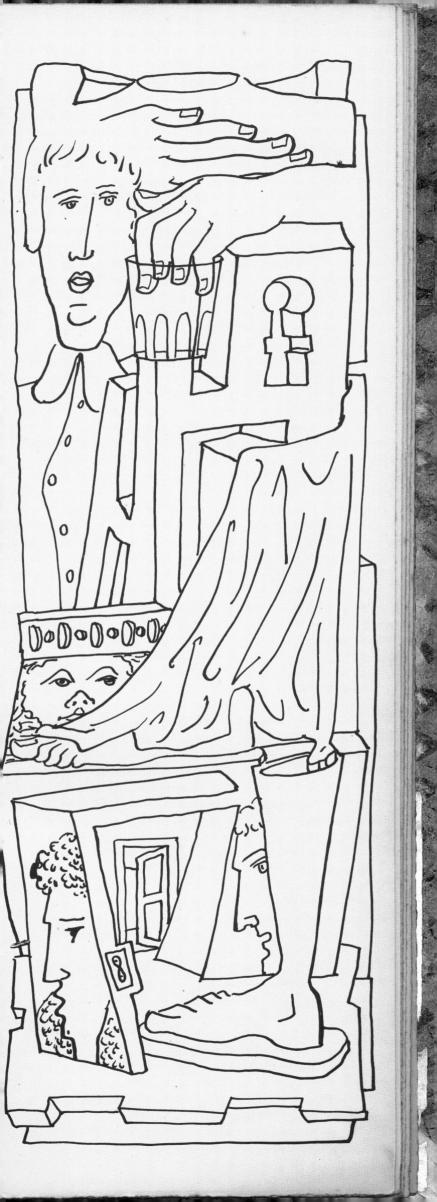

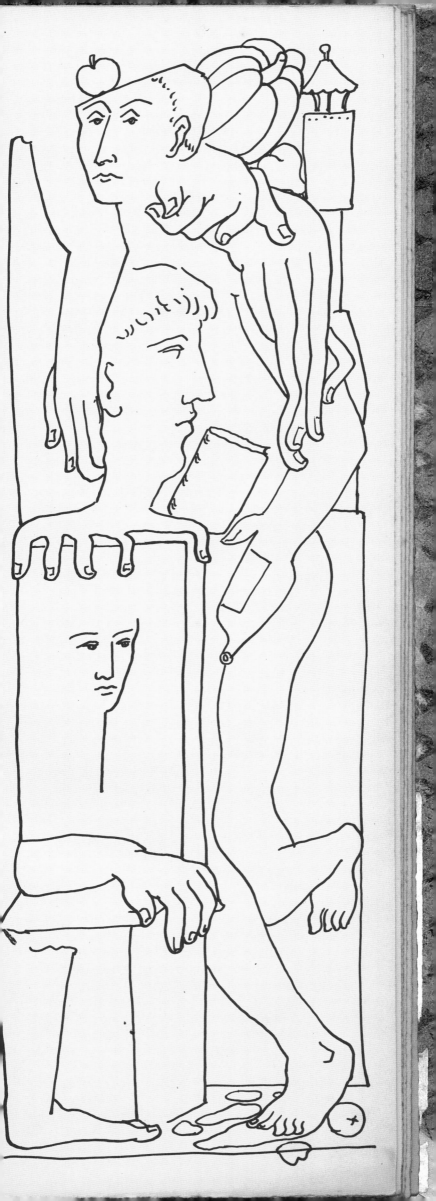

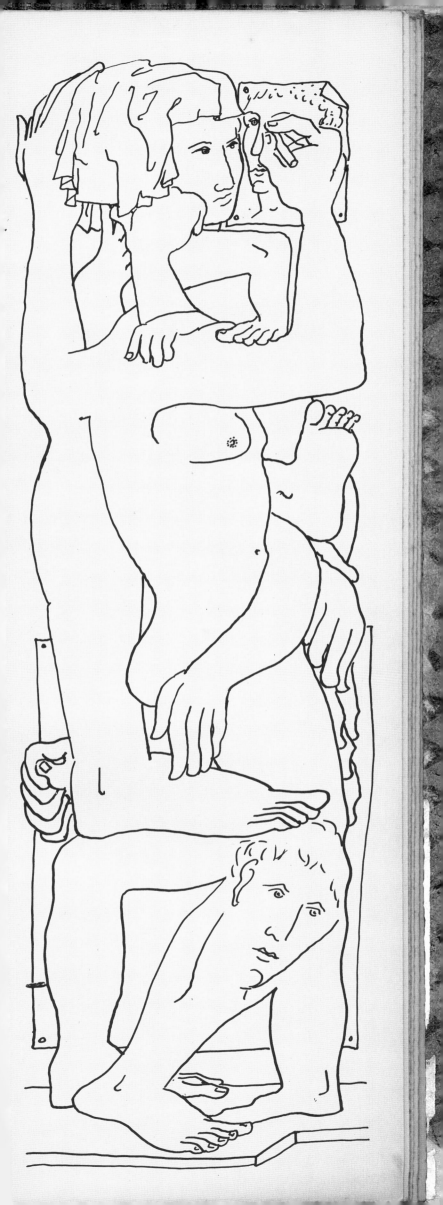

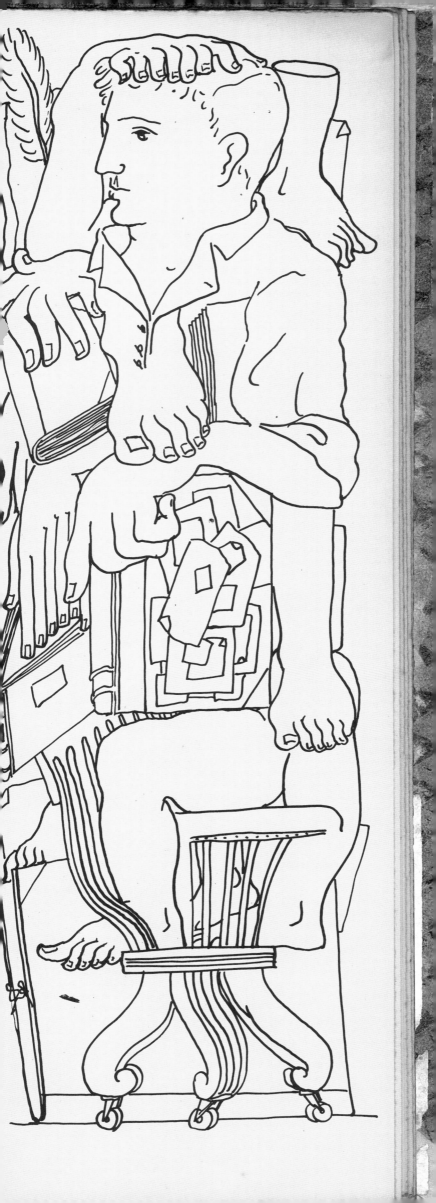

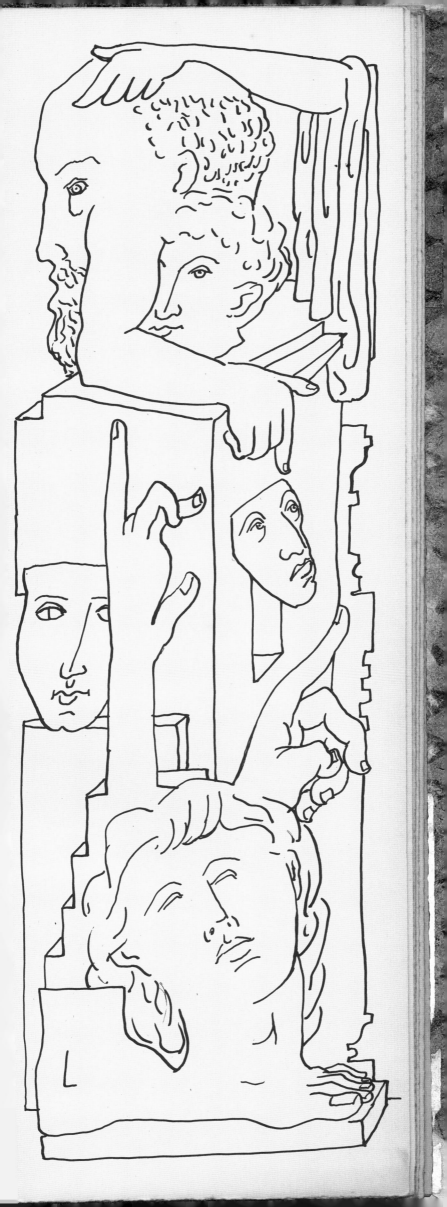

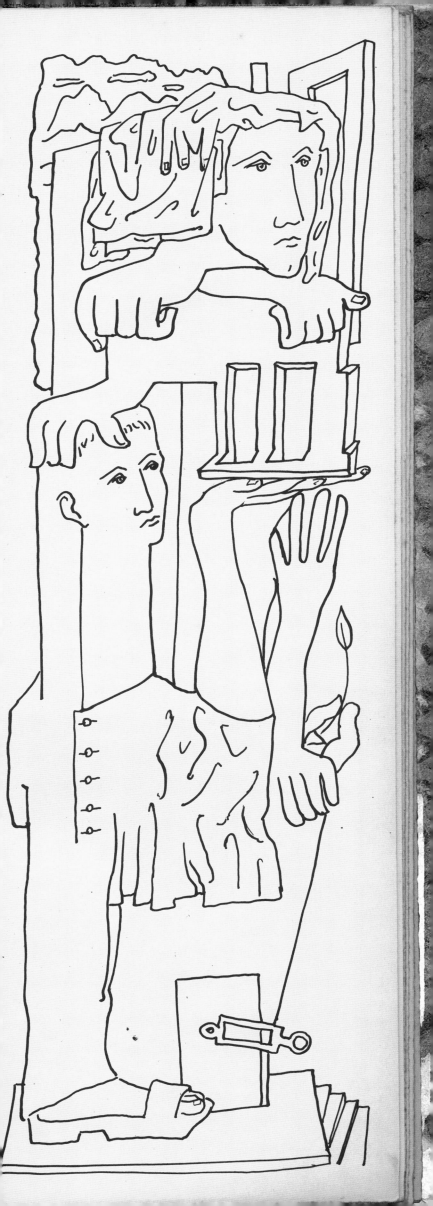

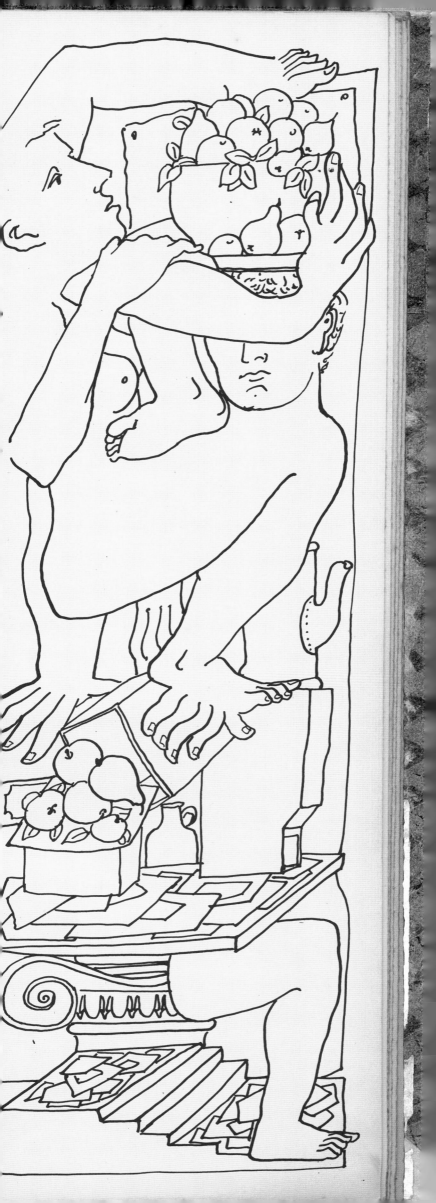

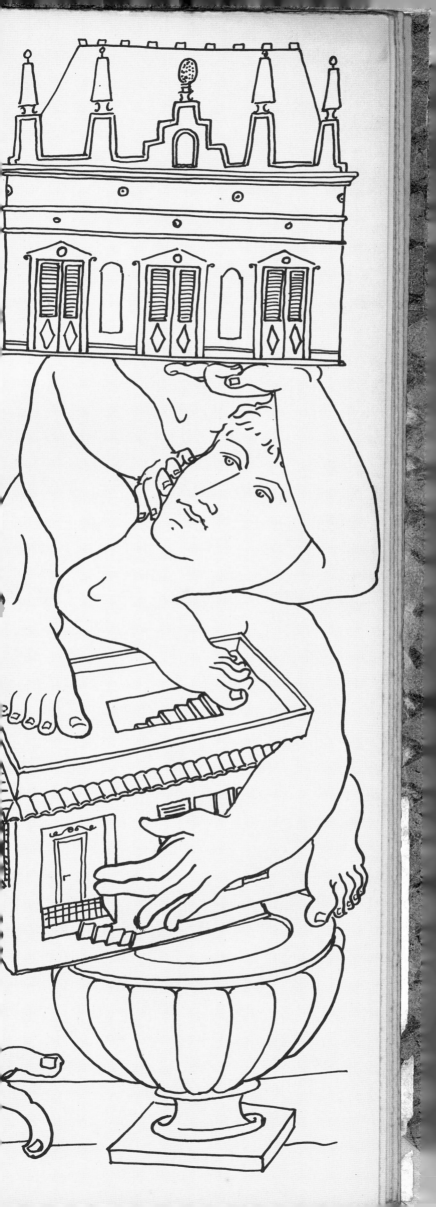

FIN

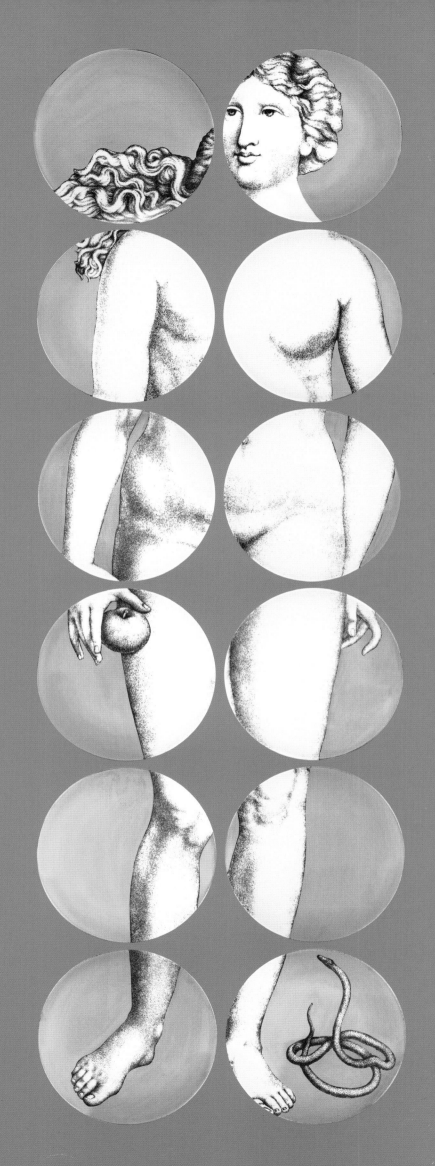

Eva (Eve) plate set
(Eve) plate set
1950s
Lithograph on porcelain
with hand-painted gold
Diam. 26 cm

THE COLLECTING GAME

Showcase window displaying Piero Fornasetti's
Biedermeier glass collection

There is more than an affinity between the
aesthetic principle of 'Theme and Variations'
and the practice of a collector. In both cases
the object is fixed – a face; an object or a class
of objects – and inexhaustible: in the incessant
mutation of variations, or the inventory of tiny
singularities that distinguish and differentiate
objects in a collection. One may wonder which
of these obsessions, in Piero Fornasetti's case,
takes precedence. A born hoarder, he declared
himself to be fascinated by this strange afflic-
tion and totally sympathetic to fellow sufferers.
He always lived surrounded by glasses, books
and printed matter of every kind, and dreamed,
as he once admitted in a television interview,
of the ultimate challenge: putting together a
collection of collectors.

Fornasetti's studio
with shelves containing books,
tools, bottles
1930s

Display case in the shape
of an obelisk filled with a collection
of crystal prisms and polyhedrons,
Fornasetti's house, Milan
1950

Piero Fornasetti's
collection of playing cards

Collection of masks
in Piero Fornasetti's painting studio

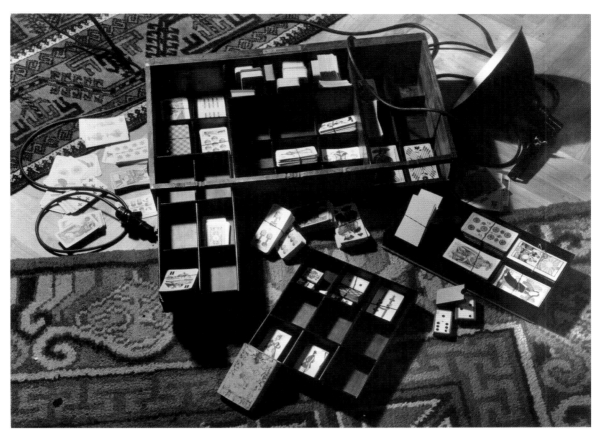

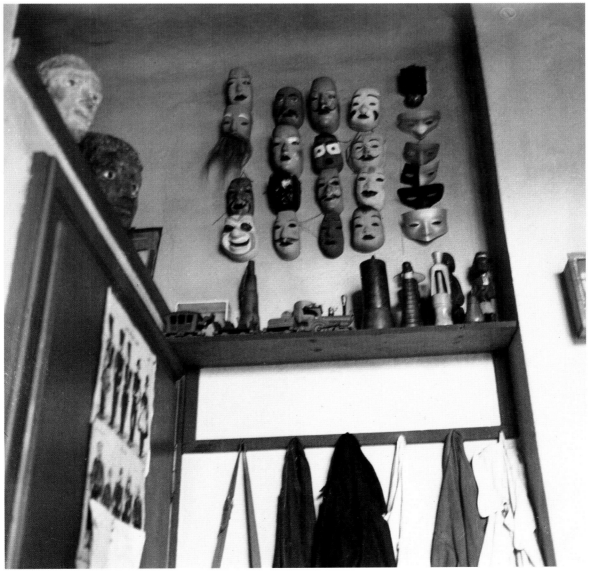

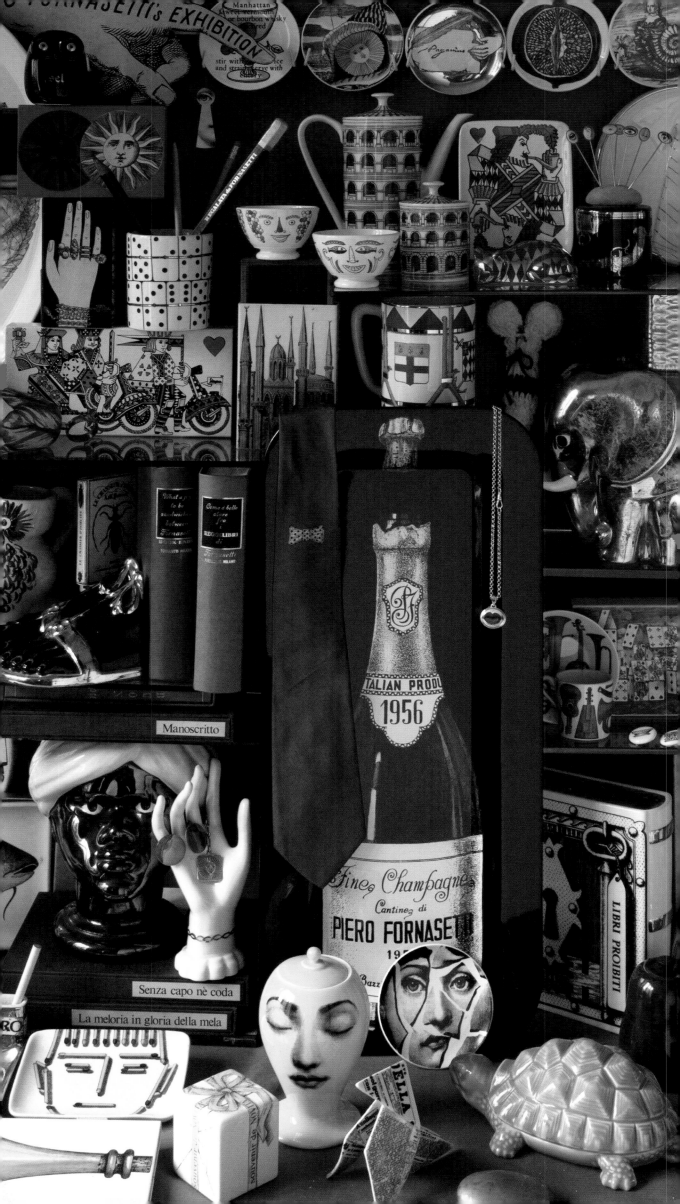

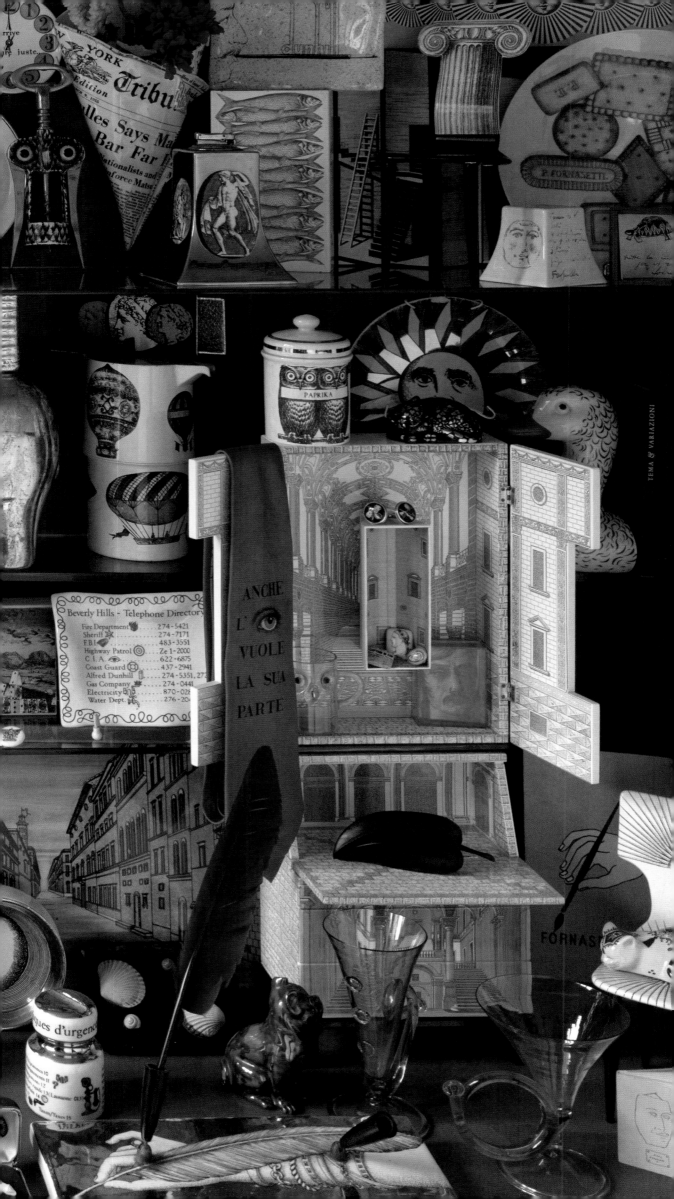

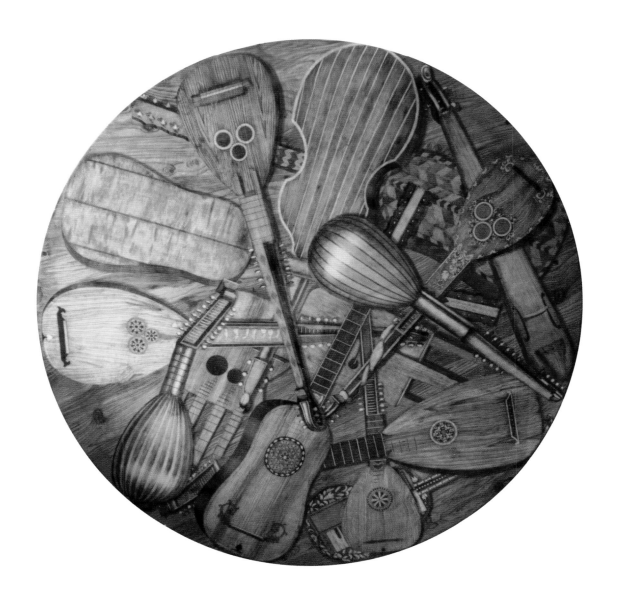

p. 250-251
Fornasetti's cabinet of curiosities:
some pieces from the Fornasetti
archive
1950s–1990s
Photograph by Marco Covi

Strumenti musicali
(Musical instruments) table
1950s
Lithograph on wood
with painting by hand
Diam. 170 cm

Cabinet designed by Gio Ponti,
hand-painted by Piero Fornasetti
and produced by Fontana Arte
One-off piece exhibited
at the 7th Milan Triennale
Hand-painted curved glass,
gold and silver leaf
46 × 11 × 171 cm
Courtesy Luca Preti, Milan

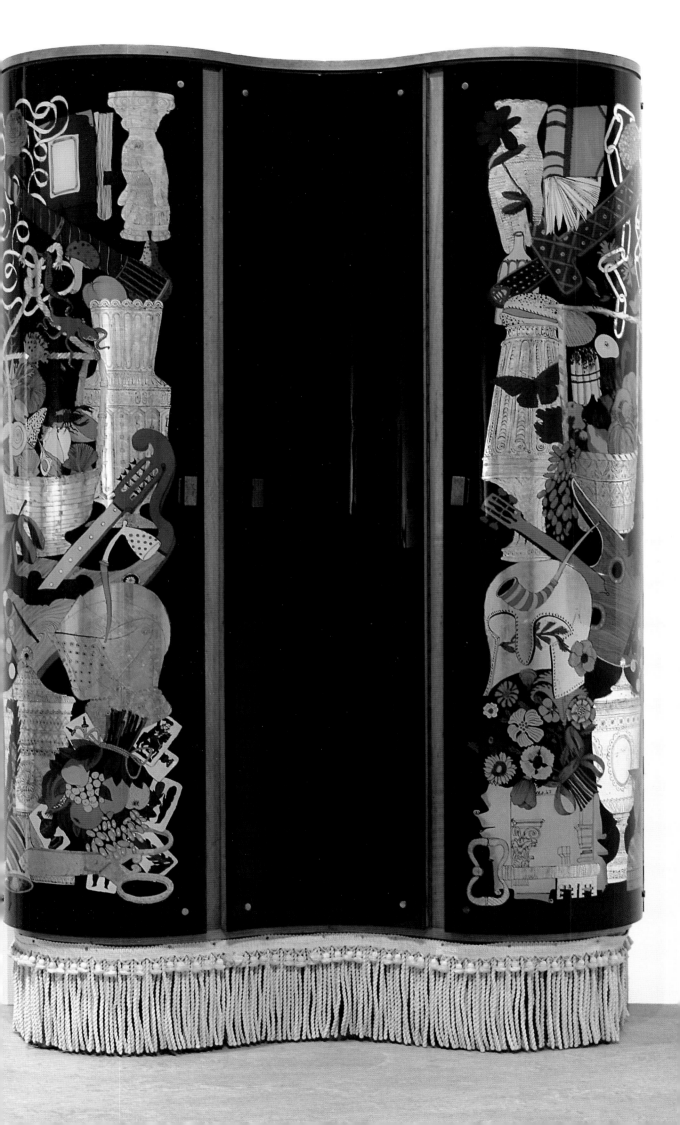

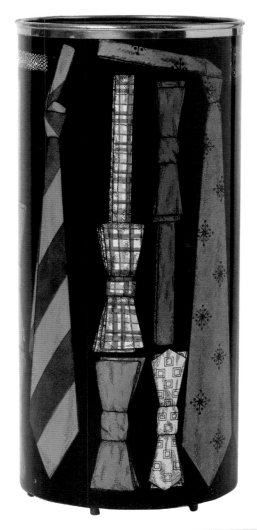

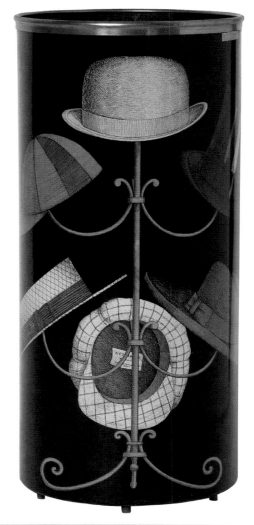

Cravatte (Ties) umbrella stand
1950s and 1960s
Lithograph on metal
with painting by hand
Diam. 26 × 57 cm

Cappelli (Hats) umbrella stand
1950s and 1960s
Lithograph on metal
with painting by hand
Diam. 26 × 57 cm

Conchiglie (Seashells) mirror
Late 1960s
Seashells fixed to a lacquered
wood and aluminium frame
49 × 49 cm

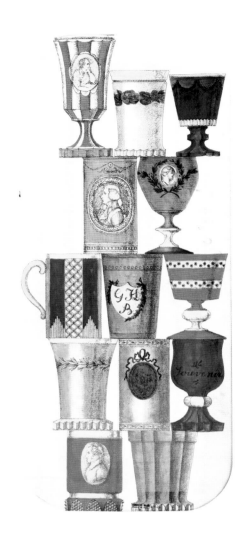
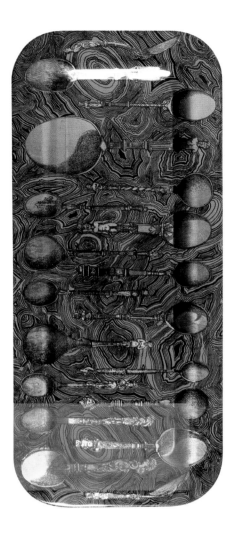

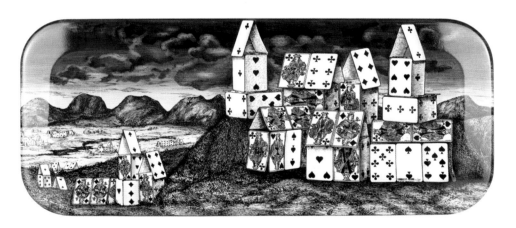

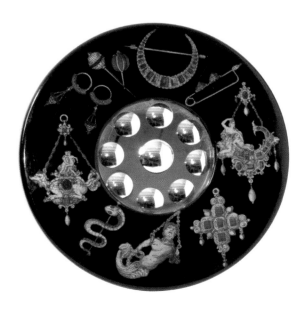

BEFORE
AND AFTER

Abbaglio (Dazzle) table lamp
Reinvention by Barnaba Fornasetti
1996
Silkscreen on glass
33 × 20 × 50 cm

Fiori nella notte (Flowers of the night)
chest of drawers
1950s
Lithograph on wood with painting by hand
100 × 56 × 86 cm

Mirror
1960s
Brass and glass
Diam. 60 cm

Corallo wallpaper
Reinvention by Barnaba Fornasetti,
Cole & Son
2009

Rarely does one see a body of work as singular and obsessive as that of Fornasetti, and destined more than any other to expire with its originator. Besides, and in contrast with the classical era when, from the Audrans to the Senés, the Saint-Aubins to the Jacobs, families of artists and craftsmen followed in each others' footsteps, families of decorative artists seldom pass on their vocation – with notable exceptions (Line Vautrin and her daughter Marie-Laure, Robert Goossens and his children Martine and Patrick). Piero Fornasetti was not an easy character, and for his son Barnaba there came a moment when breaking out of the family circle became a necessity. In spite of everything, they reunited in the 1980s when the business faced with urgent problems. It fell to Barnaba to restore the firm's balance and future prospects in harmony with the scale and vision as originally intended. He succeeded brilliantly, when one considers the journey taken and the renown that the name Fornasetti now enjoys. His task now is to assure the destiny of a business whose archive is so rich, as he says, that it could feed itself: a sort of enormous piece of bachelor machinery that would go on reproducing games of application and transference, these games that are the principal elements of Fornasetti's œuvre.

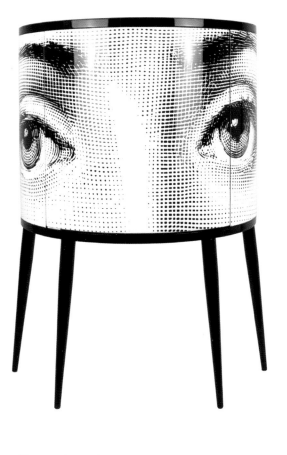

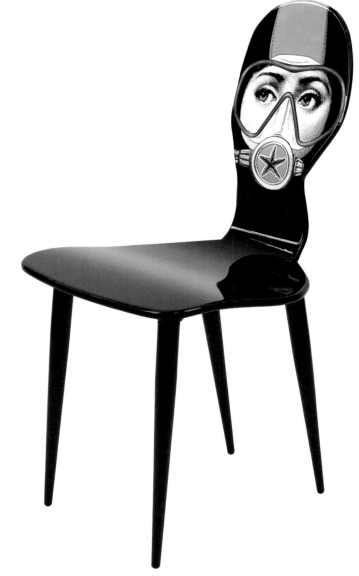

Tergonomico stool
Reinvention by Barnaba Fornasetti
2006
Silkscreen on wood
Diam. 38 × 46 cm

Occhi (Eyes) console
Reinvention by Barnaba Fornasetti
1998
Silkscreen on wood
65 × 32 × 97 cm

Silvia Sub chair
Reinvention by Barnaba Fornasetti
2014
Silkscreen on wood with painting by hand
40 × 40 × 90 cm

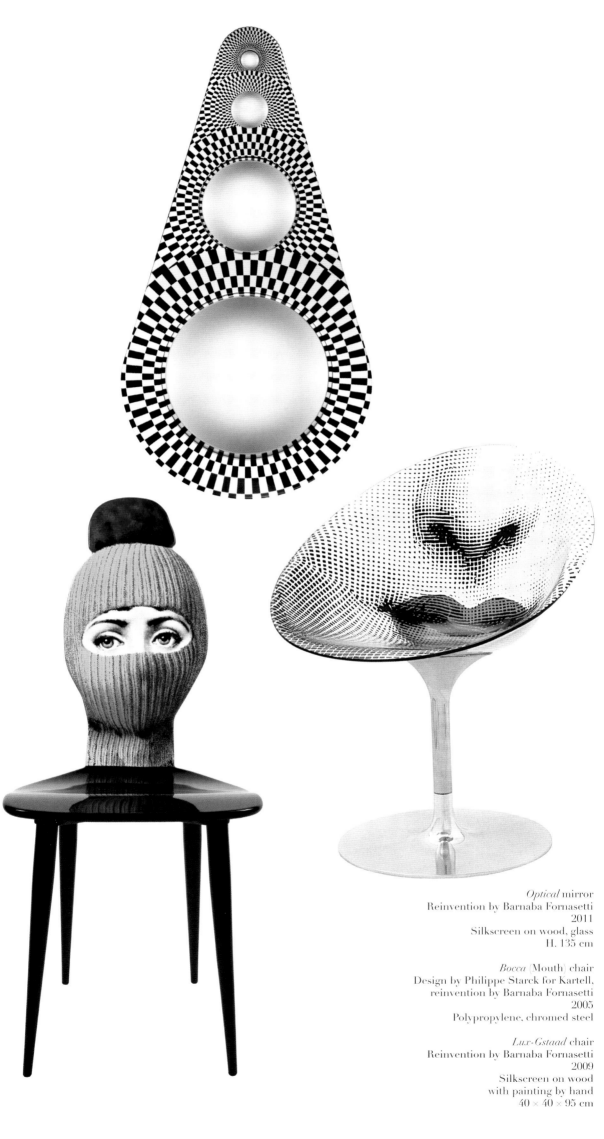

Optical mirror
Reinvention by Barnaba Fornasetti
2011
Silkscreen on wood, glass
H. 135 cm

Bocca (Mouth) chair
Design by Philippe Starck for Kartell,
reinvention by Barnaba Fornasetti
2005
Polypropylene, chromed steel

Lux-Gstaad chair
Reinvention by Barnaba Fornasetti
2009
Silkscreen on wood
with painting by hand
40 × 40 × 95 cm

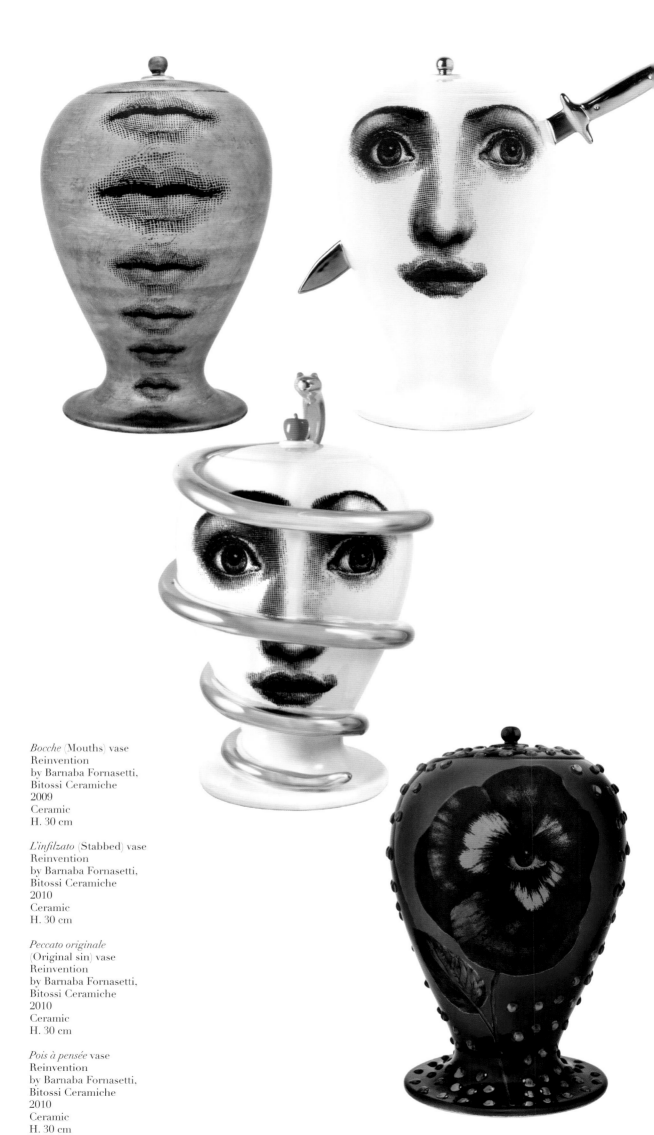

Bocche (Mouths) vase
Reinvention
by Barnaba Fornasetti,
Bitossi Ceramiche
2009
Ceramic
H. 30 cm

L'infilzato (Stabbed) vase
Reinvention
by Barnaba Fornasetti,
Bitossi Ceramiche
2010
Ceramic
H. 30 cm

Peccato originale
(Original sin) vase
Reinvention
by Barnaba Fornasetti,
Bitossi Ceramiche
2010
Ceramic
H. 30 cm

Pois à pensée vase
Reinvention
by Barnaba Fornasetti,
Bitossi Ceramiche
2010
Ceramic
H. 30 cm

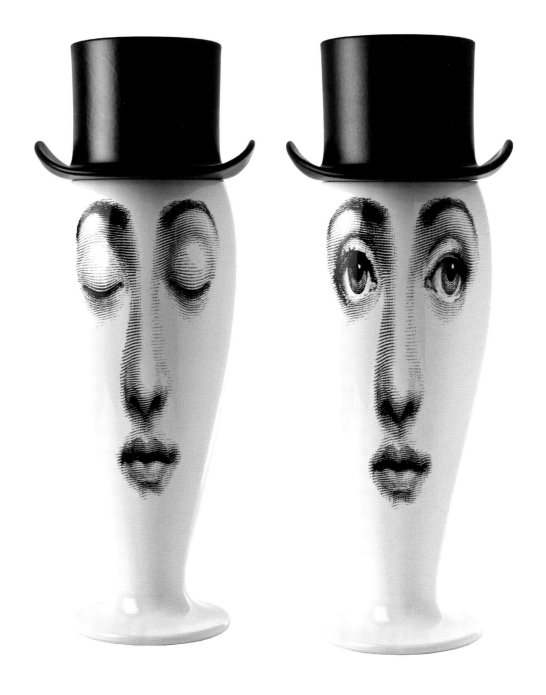

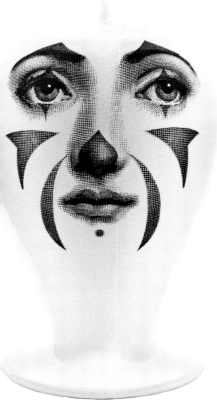

Smilzo Cilindro
vase
Reinvention
by Barnaba Fornasetti,
Bitossi Ceramiche
2011
Ceramic
H. 70 cm

Pagliaccio (Clown) vase
Reinvention
by Barnaba Fornasetti,
Bitossi Ceramiche
2011
Ceramic
H. 30 cm

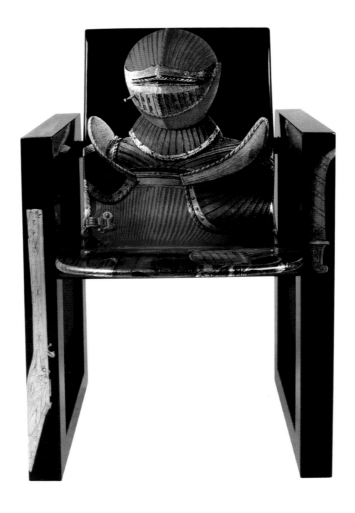

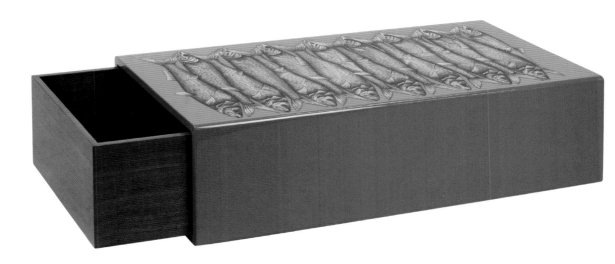

Sergente Armistizio chair
Reinvention by Barnaba Fornasetti
2011
Silkscreen and silver leaf on wood
with painting by hand

Sardine (Sardines) blanket chest
Reinvention by Barnaba Fornasetti
1999
Silkscreen and silver leaf on wood
with painting by hand
100 × 50 × 28 cm

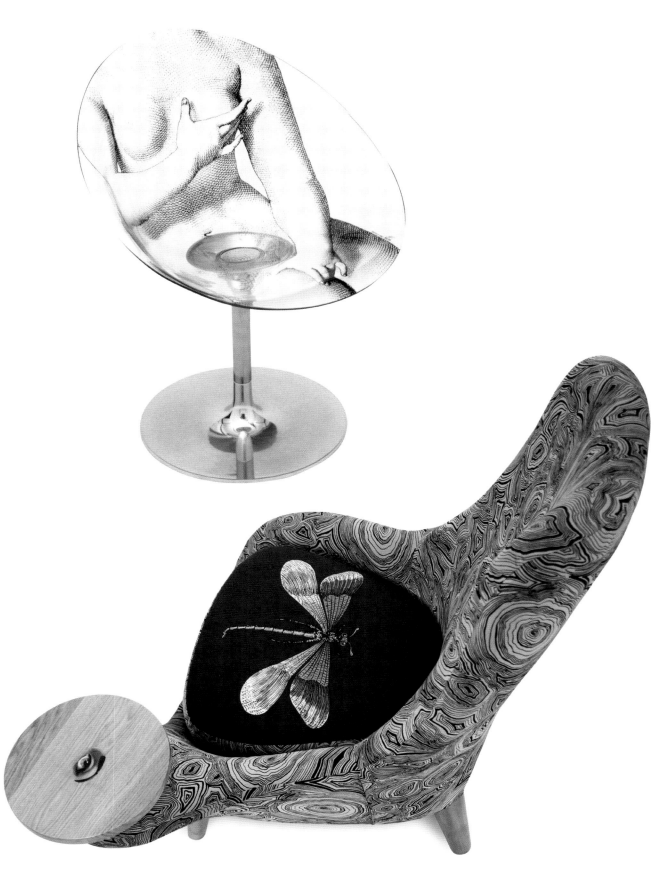

Venere chair
Design by Philippe Starck for Kartell,
decoration reinvented by Barnaba Fornasetti
2005
Polypropylene, chromed steel

Baciamano–Entomologia
(Handkissing–entomology) armchair
2014
Jacquard fabric, silkscreen on wood
with painting by hand
Design by Nigel Coates,
decoration reinvented by Barnaba Fornasetti
127 × 124 × 114 cm

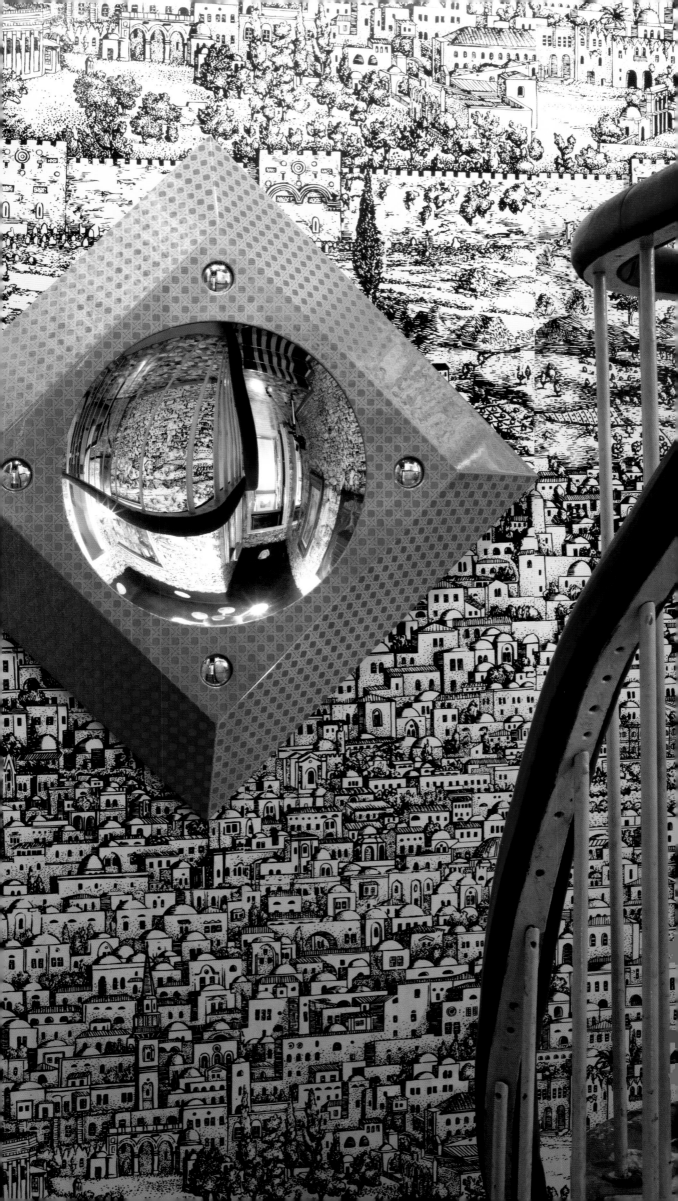

SLOW DESIGN

Barnaba Fornasetti

Hortensia.

My first collaboration with my father began when I was no more than three years old, when I brought in from the garden a hortensia leaf with a daisy on top, which my father turned into the design for a platter… I only ever lived in the world of Fornasetti: the whole house was filled with the spirit of his designs, his tastes, his collections. I was well aware that when my friends came over to play they found the atmosphere a little strange and the whole place eccentric, but I never knew anything else, all of this seemed to me a relief from ordinary everyday life.

Genealogy.

There was something rather singular about our family history. My grandfather had more or less planned out the development of future generations, and each member of the family had an allotted role. Thus Piero was destined to become a businessman, and he managed to redirect this duty to my uncle, so that he could pursue his artistic vocation. That meant he was reluctant to raise any objection when I told him I wanted to be a car designer. I always had a little passion for car design and I liked to think of myself as a new Pininfarina, designing products for mass consumption, but in the end I changed tack.

My father inherited from his father a stubborn character; he could be hard and authoritarian, and when I was a rebellious adolescent he epitomised for me the establishment in all its glory. It was the 1970s and I saw myself fitting in perfectly with the climate of liberation and revolt that characterized the

p. 264
Canneté mirror
Reinvention by Barnaba Fornasetti
2011
Silkscreen on wood
80 × 80 cm

Gerusalemme (Jerusalem) wallpaper
Reinvention by Barnaba Fornasetti, Cole & Son
2000s

decade. I was always on the side of complete non-violence, but like everyone I joined demonstrations and marches, and I found myself at the heart of groups considered extremist – which was how I ended up in San Vittore prison for sedition in 1969, on the day there was a general revolt by the prisoners. That was a great crisis moment for my father who knew I was perfectly incapable of anything like that, and the crimes we were accused of were perfectly imaginary – that in fact we were being manipulated by politicians without our knowing it. Despite my father's respectable bourgeois appearance, he was deeply disgusted by this state of affairs and didn't hesitate to support us for a moment.

Businessman.

Thanks to him, I ended up getting a job with Ken Scott, an American designer whose glory days were in the 1960s and '70s when he made some exuberant flower-power prints for the fashion world. I worked for him for two or three years, doing a bit of everything: I drew designs on fabrics, or on panels for a catwalk show at the Piper Club in Rome, for instance.

Then I went to Tuscany where I set up a small business rebuilding and restoring old houses. That experience was very enriching for me because I learned to solve my first management problems, as much in the world of fabrication of products as in my relationships with clients or with a team of artisans.

It was equally a way of showing my father that I wasn't just a dreamer or a likeable dilettante, but that I was capable of managing myself and even of creating a real business. Working with him then seemed out of the question, because he was so centred on himself, that I would have been completely stifled and wouldn't have been able to find the smallest amount of room for self-expression. What's more, I would have had to bow to the demands of the boss, the same demands that had driven him to the wall…

Handing over.

The situation is probably partly explained by his difficult character. At the end of the 1980s the shop and the atelier entered a dramatic period. Piero's furniture and other objects were no longer as successful as before, and his perfectionism, together with his blind trust in people who were not always the most reliable, drove him to the brink. It was at that point that he turned to me for help to save the situation. Those years were testing times: first I had to audit the accounts and create licences; then I had to eliminate undesirable partnerships. I also started a new company, so as not to have to manage the liabilities of the preceding years. Above all I needed to rationalize activities somewhat: Piero wasn't in the habit of asking

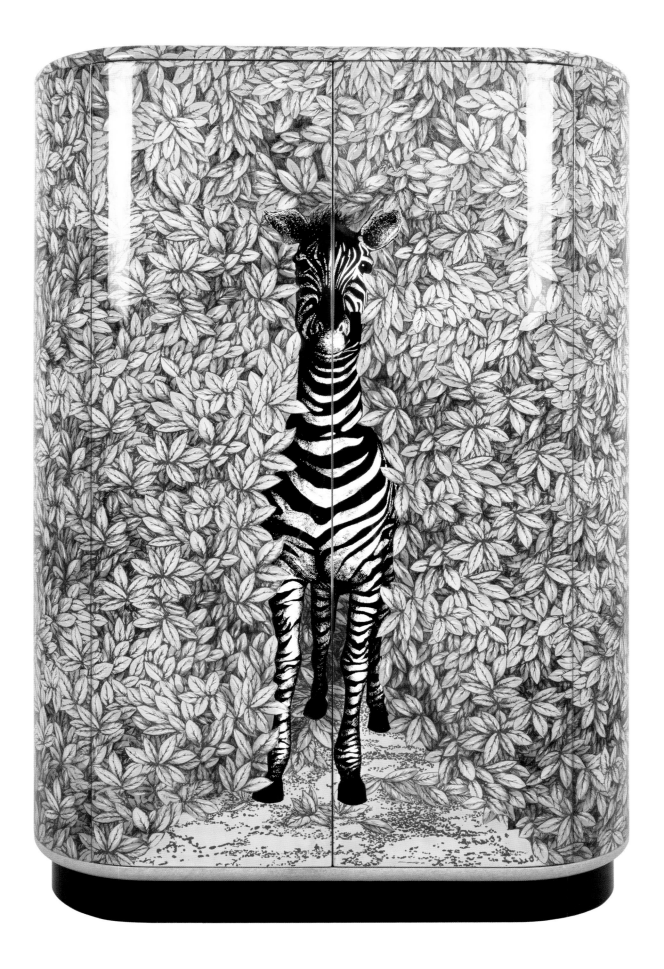

Zebra cabinet
Reinvention by Barnaba Fornasetti
2003
Silkscreen on wood
with painting by hand
92 × 33 × 130 cm

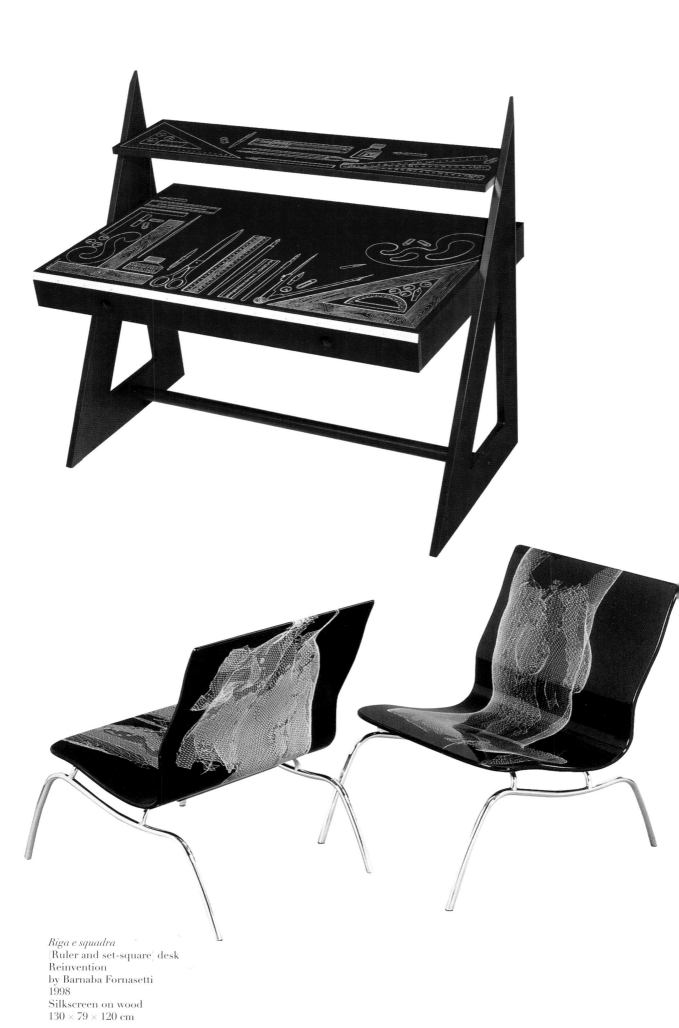

Riga e squadra
(Ruler and set-square) desk
Reinvention
by Barnaba Fornasetti
1998
Silkscreen on wood
130 × 79 × 120 cm

Tête-à-tête chairs, black version
Reinvention by Nigel Coates
and Barnaba Fornasetti
Silkscreen on wood
2002

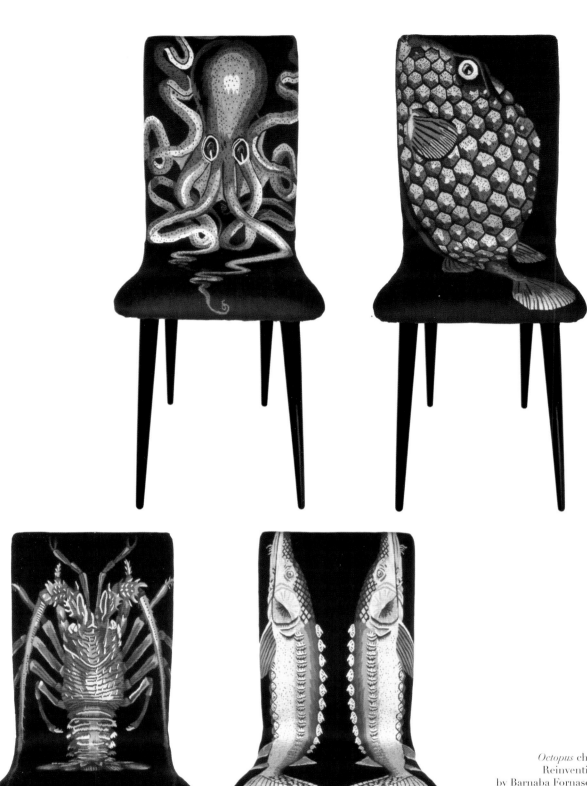

Octopus chair
Reinvention
by Barnaba Fornasetti
2010
Tapestry, silk
40 × 40 × 95 cm

Ostracion chair
Reinvention
by Barnaba Fornasetti
2010
Tapestry, silk
95 × 40 × 40 cm

Palinurus chair
Reinvention
by Barnaba Fornasetti
2010
Tapestry, silk
40 × 40 × 95 cm

Sturio chair
Reinvention
by Barnaba Fornasetti
2010
Tapestry, silk
40 × 40 × 95 cm

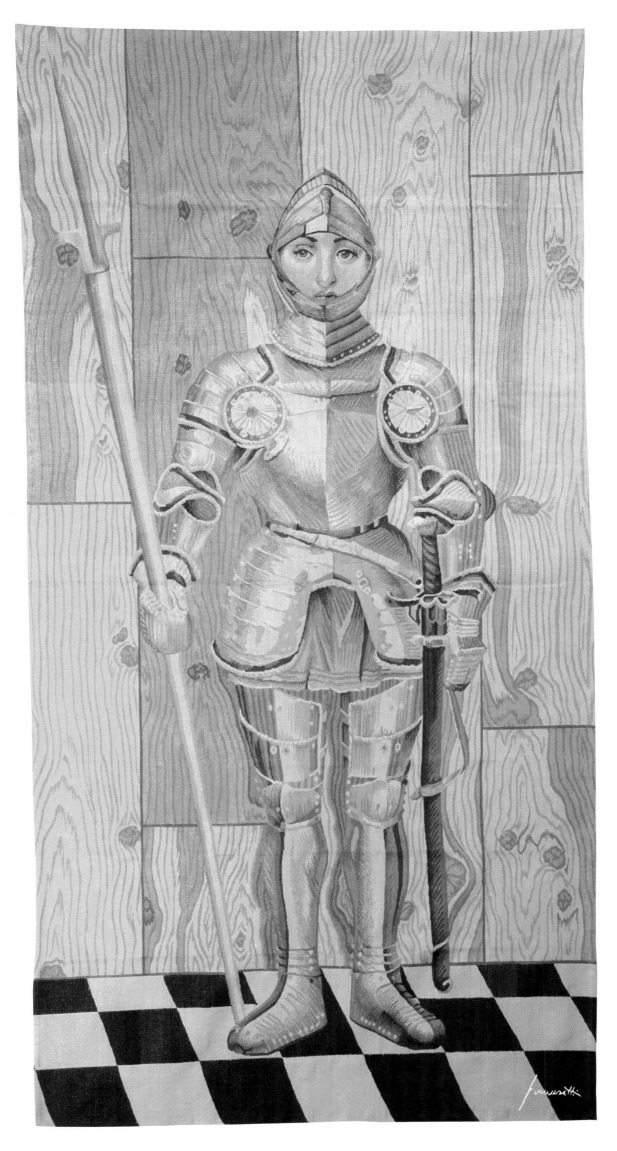

too many questions, when he had an idea – as happened often; he would simply call the workshop, or a craftsman, and ask him to make this or that, without worrying about how much it would cost, or its commercial viability. He liked nothing more than to give a simple description over the phone – some idea of proportions, materials, colours and finishes – and then, when it arrived, to see if the object looked like what he had dreamed of the night before, and if it didn't match his idea to send it back to be redone … I really had to adapt production to a slightly more rigorous method.

Originals.

In the end there was only one artisan left in the workshop, a pensioner from Puglia, who spent his time squabbling with my father, to whom he spoke only one day in two, but who was utterly devoted and had in the course of time acquired a remarkable skill that he was not always prepared to share. I managed to establish a trusting working relationship with him by avoiding the power struggles that Piero always found necessary; and then we began to make an inventory, to classify and restore the archives. That coincided with a re-evaluation of Piero's work, with the opening of a shop called Themes and Variations in London, and the preparation of his first monograph by Thames & Hudson. A new type of visitor began to visit Via Brera, looking for 'original furniture', and I remember my father's outraged reaction: he would say 'Original? But how many "originals" do you want?' For as long as I am able, I will only make originals, and the ones that I first made I have improved as we went along.

Series.

My father never really bothered much with signed, limited, authenticated, inventoried works. Those things had scant importance for him: the objects themselves were what mattered. In the end they were all unique pieces. Once again, in the light of new market demand, I had to re-think things: we had begun to keep an exact register of what we produced year by year; everything was dated and numbered, and we added a maker's mark as well as labels gummed to the inside of the objects themselves.

As he was not the delegating type, and wanted to have a hand in everything, Piero had not collaborated very much with other companies (essentially just for glass and fabrics). This seemed to me to be a dimension worth exploring. Having heard my father express the wish to make objects in porcelain with Rosenthal, we went into partnership with them. I later collaborated with other firms to design ties, waistcoats, scarves (because my father had started out with them), but also lamps,

Tête-à-tête lamp
Reinvention by Barnaba Fornasetti with Nigel Coates
2002
Silkscreen on glass

p. 274-275
Barnaba Fornasetti at the Fornasetti showroom in Milan
Installation for the Salone del Mobile 2013

lampshades, and other small items. And in the end I understood that this had actually been a mistake. This type of production ended up competing with what we already made and affected our credibility. The porcelain objects that we continued to make, piece by piece, in the workshop, could not match what Rosenthal produced in series, in terms of value and price. What was more, Rosenthal's Fornasetti range was sold side by side with more commercially important brands such as Versace, and did not benefit from the necessary attention. We were really shooting ourselves in the foot.

I also investigated using other materials, such as methacrylate, for lamps or a new style of object. But I quickly understood that once again this contradicted the spirit of our handmade pieces, made with particular care in limited editions. There was seemingly something a bit cheap about objects made this way; this often happens – but not always – with plastics or Plexiglas. Perhaps one day someone will be able to show me a really remarkable-quality resin or plastic…

Cylinders.

My father had made his first ceramics using porcelain and white faïence, plates mostly, from various German makers or, later, from Richard et Ginori, the company for whom Gio Ponti had made some of his most famous designs in the 1930s. But the quality or excellence of the ceramics was of no importance to him: it was nothing more than a support for his designs and his imagination. He only used very simple forms – plates, cups, platters, saucers – and he designed them in sets of six or twelve pieces, which fulfilled daily needs. One could say that he had a functionalist side to him, because the furniture and other objects that he made were, as far as he was concerned, for everyday use and should be both practical and comfortable; nothing annoyed him more than a badly designed chair.

The cylinder was another of his favourite forms: it was also the shape he used for his coffee cups, waste paper baskets, and umbrella stands. The origin of the latter is quite amusing: he used to like to ride his bicycle around the outskirts of Milan, which in those days was wasteland, where you would find only a few little factories and light industrial buildings. It was here that he noticed long Masonite cylinders that were used to protect electrical circuits. He searched everywhere looking for what they were, who produced them, where he could get some, and he finally used them, cut into lengths, to make his first series of umbrella stands, which he would later make out of metal.

Applications.

My father's first step was to apply to three-dimensional objects the knowledge that he had gained as a printer. He

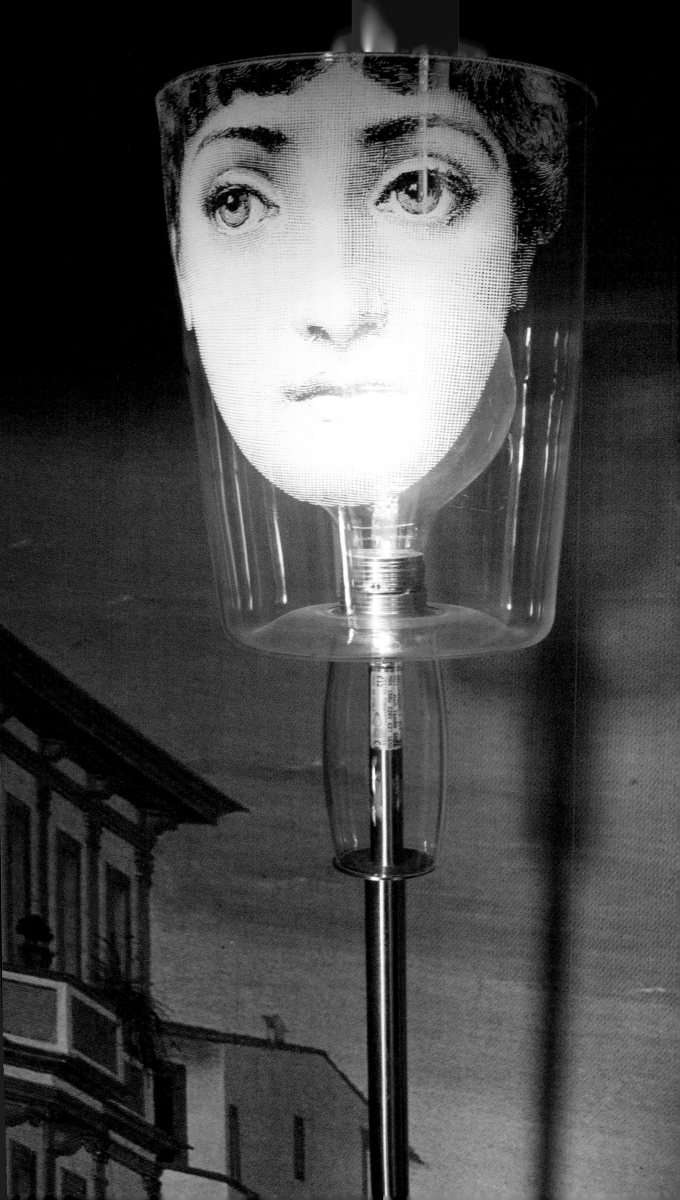

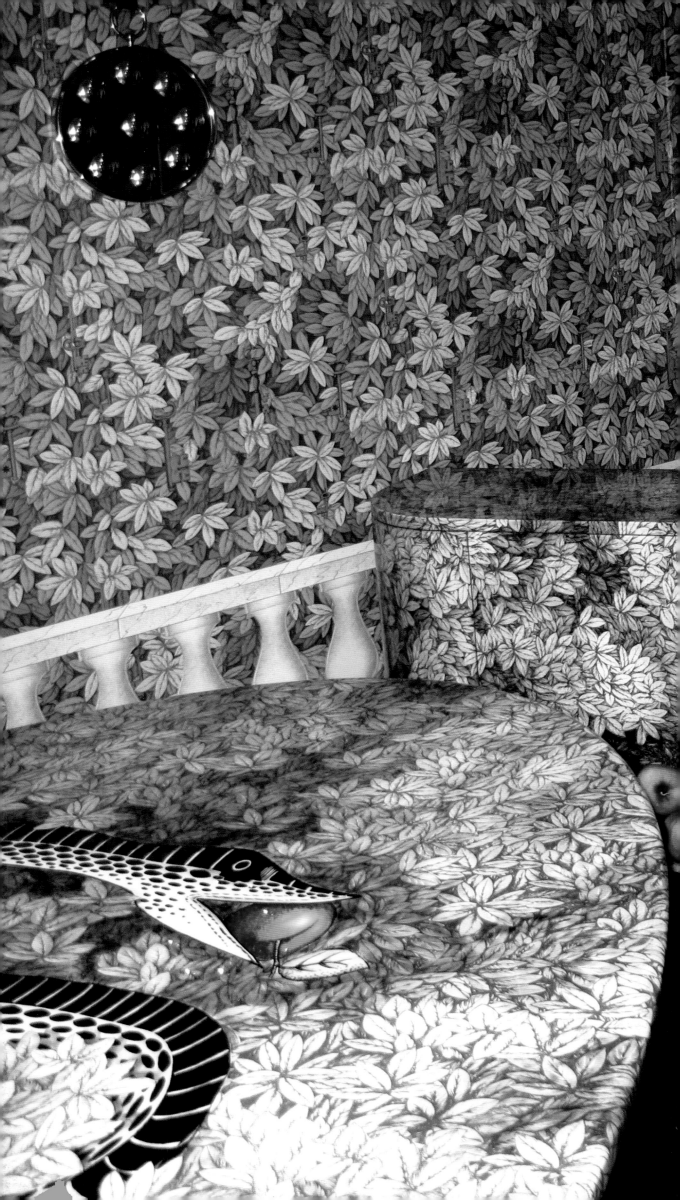

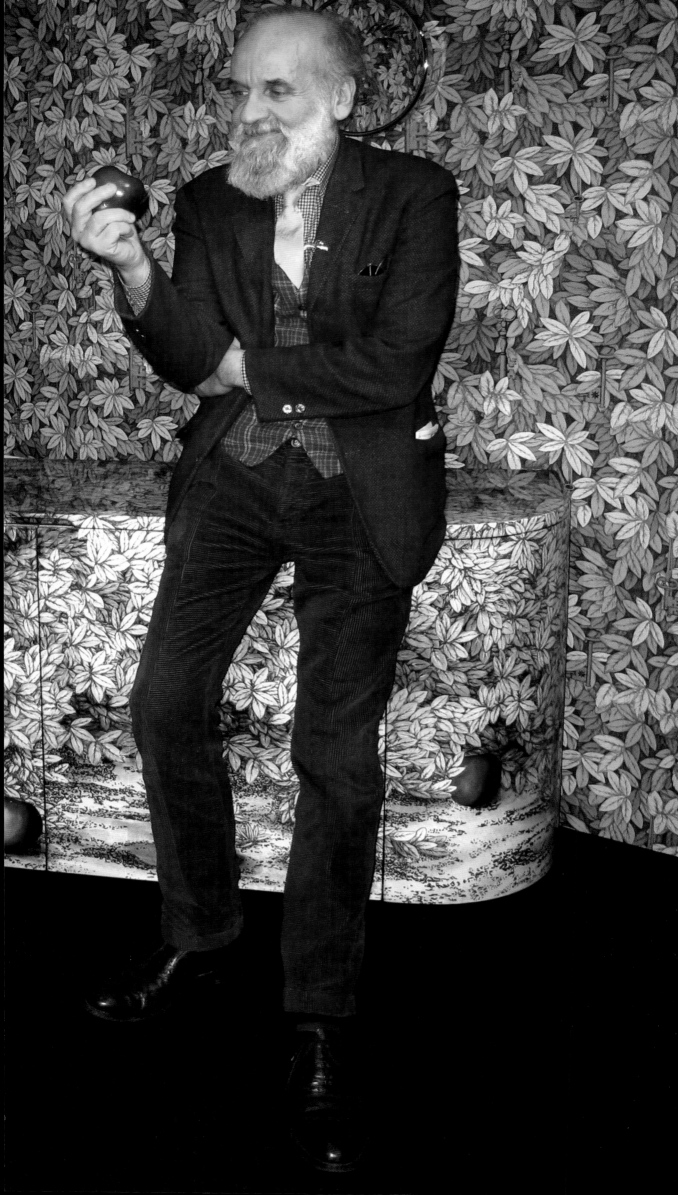

Nuvole (Clouds) sofa
Design by Nigel Coates,
reinvention by Barnaba Fornasetti
2014
Jacquard fabric, wood
212 × 200 × 85 cm

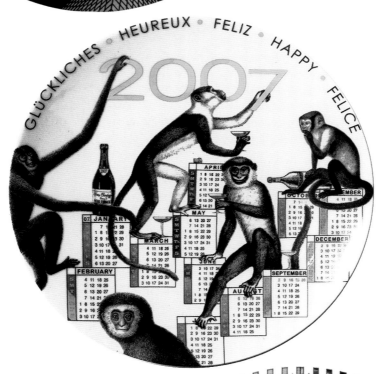

Calendario (Calendar) plate
Reinvention
by Barnaba Fornasetti
2015
Silkscreen on porcelain
Diam. 24 cm

Calendario (Calendar) plate
Reinvention
by Barnaba Fornasetti
2007
Silkscreen on porcelain
Diam. 24 cm

Calendario (Calendar) plate
Reinvention
by Barnaba Fornasetti
2001
Silkscreen on porcelain
Diam. 24 cm

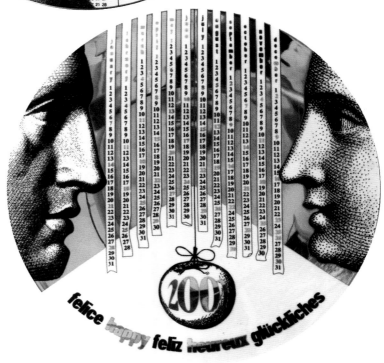

started by making lithographs on scarves (quite an unusual technique for printing on silk); then he discovered a way of transferring the image from dampened paper, on which he had rendered his drawing, that he was then able to apply to all kinds of support, before stabilizing it, colouring it, and applying varnish, polishing it, and so on. Today we mostly use silkscreen, which is a little simpler, but the studio still works more or less as it did in my father's day. I basically try to keep a balance between technological improvements and our own craft knowledge, particularly from the ecological perspective. For example, we no longer use anything but water-soluble colours, and I try to get our suppliers to improve the products we use. That is the case with the company that supplies us with lacquer and varnish: it is a rather substantial business and we don't represent much turnover for them, but one day I wrote to the owner and invited him to come and see what we were doing, which bore no comparison with the industries he was used to working with. We established a special relationship, he follows everything we do and he has put all his research at our disposal. I have to admit that I find it exciting, this perpetual negotiation between the demands of work made by hand and the production and research that is endlessly evolving.

Costs.

The direct consequences of all that is that a piece we make today is always an improvement on previous ones, and that has an effect on its price, which reflects the way it is made, the hours spent on making it or researching it, and so on. To those who say the cost is too high, I usually reply that our pieces are not expensive, but they come at a price. And that requires a certain knowledge and understanding on the part of the seller and the buyer. For me this is a fundamental relationship, in that we can't take on the big luxury conglomerates, and if we want to keep our identity we have to remain a niche business.

Trumó.

From Piero I have inherited the desire to imagine, to invent, to dream – as it were – with my eyes open. And I would have liked to be able, like him, to spend my time dreaming without worrying too much about how it could be done, about the consequences of reality, but I can't; the laws of design make you do the opposite: first you have to make something, and after see how it works, both technically and commercially.

From him, I also inherited a whole repertory, a lexicon of imaginary forms. It's both a constraint and a challenge. I have to reinvent and reinterpret endlessly: to find how to adapt his drawings and projects without denaturing them. Take, for example, what in Italy we call a *trumó* (a sort of dresser or cabinet).

It stands for conviviality, a rite of family social life, a way of life where people would gather for lunch or dinner, and which today has practically disappeared. It was one of the major pieces that my father and Gio Ponti collaborated on in the 1950s. One of my first impulses was to give it a fresh purpose: for example, by very slightly modifying its proportions in 1999 to accommodate to accommodate a television or one of the first home computers (you have to imagine them before today's flat screens and laptops... now the prototype has to be adapted once again).

In the 1980s I also turned it into a cabinet display case, with two doors and interior lighting, where a collection of objects could be shown: I was inspired by Gio Ponti's Pirelli Tower, and the decoration echoed that of an old-fashioned screen, as reflected in the glass façade of the building as it was submerged in a Milanese mist. I called this prototype 'To Piero and Gio'. We still make this historic model, albeit adapted as required, and that is another type of challenge I like very much.

Intangible.

You may find it paradoxical from someone whose father spent his life designing objects, and who left thousands more to be made, but my utopia would be to leave behind all this producing, making series after series, encumbering the world with objects. The things that Piero made, and we after him, are here to stay; they are not consumer goods to be thrown away, they are for keeping, to be passed on from generation to generation. There is already so much furniture and useless stuff on the planet. Why add another model of a chair (even if it's something I have done myself), when most of them are uncomfortable?

Fornasetti doesn't make 'design', but something I would call, for want of a better word, 'decoration': basically it is about transposing images onto a surface, whatever that might be, and that offers infinite possibilities for variation, as far as the kind of support is concerned. In the dull everyday grind, decoration is like a kind of music: it stimulates dreaming and fantasy. And the advantage of the process we use is that it also lends itself to virtual reality: we are trying to exploit all the rich possibilities on our website. More and more, in fact, I tend to add music to moving or virtual images often in the frame of charity work, because it seems fair to me that business should intervene in the reality of the world around us. It's an opportunity for me to be able to exploit this aspect, which Piero certainly couldn't have foreseen. And I appreciate the fact that we can appeal as much today to cultivated amateurs, ready to catch all the references and artistic culture of previous generations, as to young bloggers who, for their part, are sensitive to the humour and the games with collage and mixing-up inherent to the Fornasetti world.

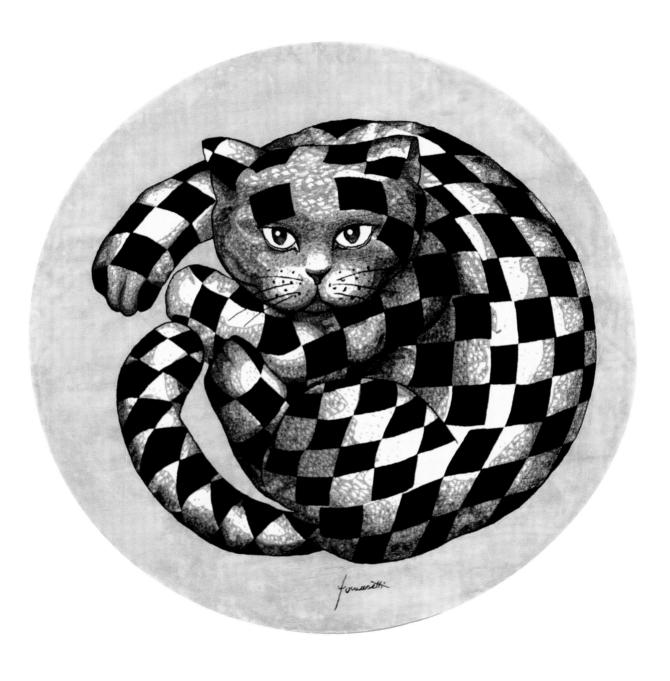

High Fidelity rug
Reinvention
by Barnaba Fornasetti
2007
Hand-knotted wool and silk
Diam. 184 cm

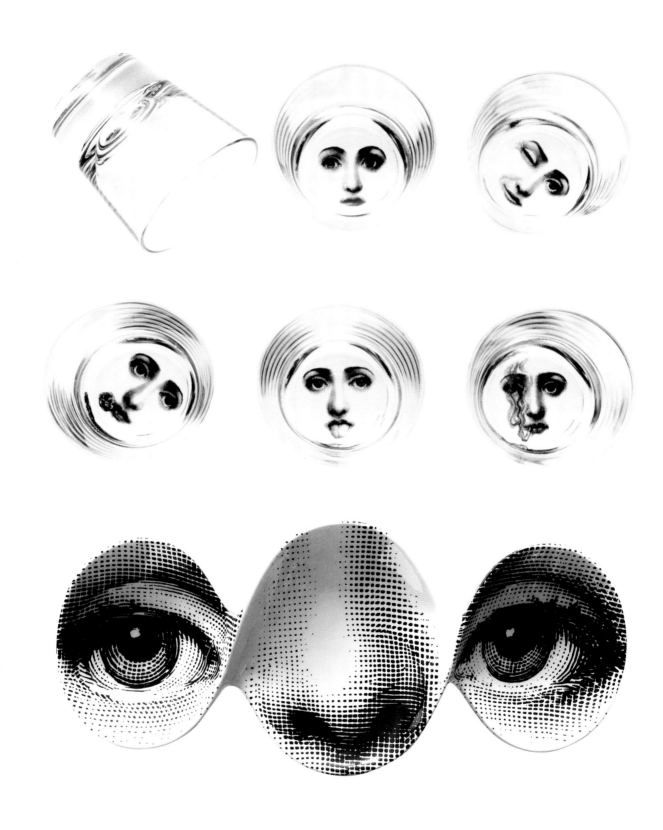

Set of six glasses
from the *Tema e variazioni*
(Theme and Variations) series
Reinvention
by Barnaba Fornasetti
2000
Silkscreen on glass

Occhi-naso (Eyes-nose) snack bowl
Reinvention
by Barnaba Fornasetti
Silkscreen on porcelain

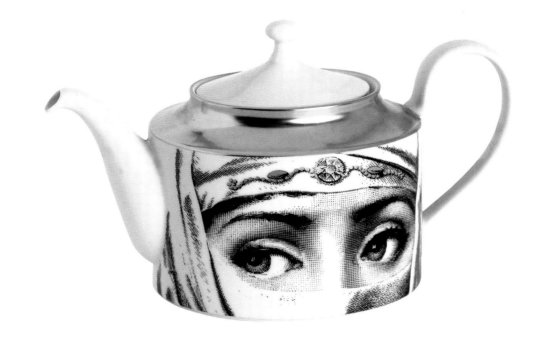

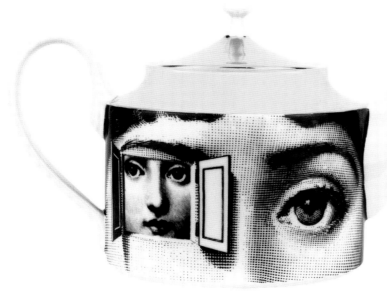

Alta Matematica cup set
Reinvention by Barnaba Fornasetti
2000s
Silkscreen and gold on porcelain

Occhi (Eyes)
teapot from the *Tema e variazioni*
(Theme and Variations) series
N° 116
Reinvention
by Barnaba Fornasetti
1986
Silkscreen and gold on porcelain

Teapot from the *Tema e variazioni*
(Theme and Variations) series
N° 86
Reinvention
by Barnaba Fornasetti
Late 1990s
Silkscreen and gold on porcelain

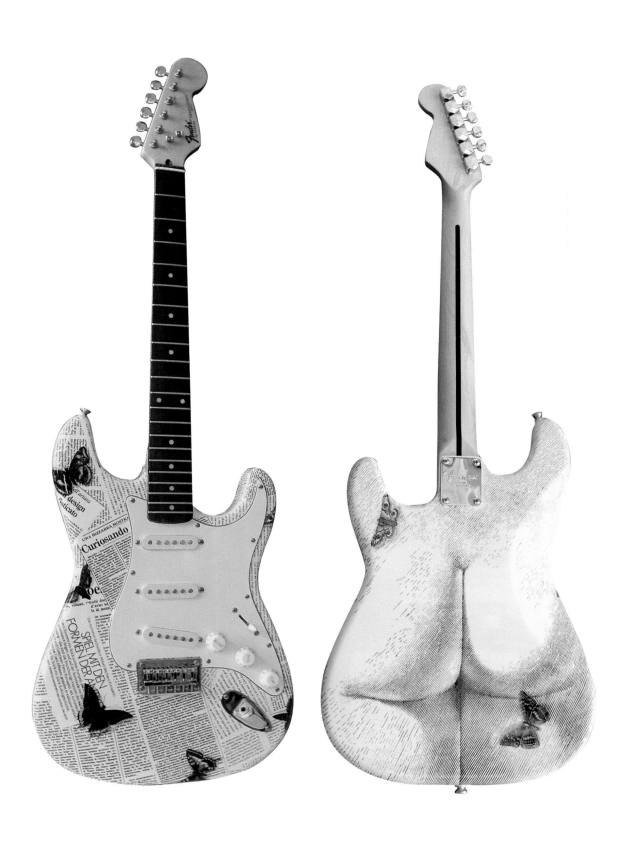

Guitar *Flying on my back*
Fender Stratocaster
Reinvention by Barnaba Fornasetti
2009
Silkscreen on lacquered wood
with painting by hand
32 × 98 cm

Slow design.

I am not, and have never been, obsessed with 'novelty', or these 'new collections' that pop up everywhere in the world of design and are ultimately derived from fashion. A design takes the time it takes: one year, two years, maybe more... What's more, I still manage to find projects in the archives that Piero never realized and that I then adapt for the demands and realities of today. In the end these are timeless, at least outside the bounds of purely commercial time. And I think that answers the need people have for stability and permanence, tired of drowning in a flood of perpetual novelties which all cancel each other out. It's the same motif, or the same ethic, that you can find behind the 'slow food' movement: I would be a strong supporter of 'slow design'.

Future perfect.
I now realize that examples of artistic transmission from father to son are rare. It hasn't always been simple, but I consider myself to have been lucky to inherit this legacy. I have been working for years to consolidate, preserve and expand the Fornasetti world; I can start to think of the future. The artistic reality that Piero made has outlasted that of any number of individuals: it constitutes such a rich archive that it could basically live on for decades. I imagine entrusting it after I am gone not to one person but to a team, a studio, who will know how to exploit its riches and make the spirit live on. Until then, I shall remain the conductor of this little band of virtuoso musicians.

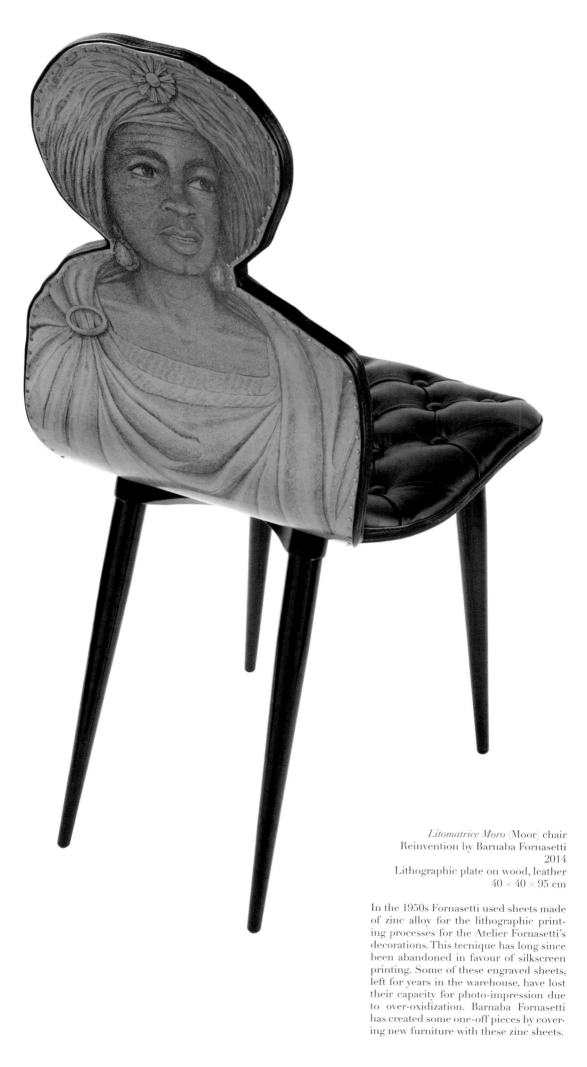

Litomatrice Moro (Moor) chair
Reinvention by Barnaba Fornasetti
2014
Lithographic plate on wood, leather
40 × 40 × 95 cm

In the 1950s Fornasetti used sheets made
of zinc alloy for the lithographic print-
ing processes for the Atelier Fornasetti's
decorations. This tecnique has long since
been abandoned in favour of silkscreen
printing. Some of these engraved sheets,
left for years in the warehouse, have lost
their capacity for photo-impression due
to over-oxidization. Barnaba Fornasetti
has created some one-off pieces by cover-
ing new furniture with these zinc sheets.

SELECT BIBLIOGRAPHY

REFERENCE WORKS

Branzi, Andrea, Mariuccia Casadio, *Fornasetti, The Complete Universe,* New York, Rizzoli, 2010.
——— and Barnaba Fornasetti, *Fornasetti, l'artista alchimista e la bottega fantastica,* Milan, Electa, 2009.
Fitoussi, Brigitte, *Conversation entre Philippe Starck et Barnaba Fornasetti,* Paris, Assouline, 2005.
Mauriès, Patrick, *Fornasetti, Designer of Dreams,* London, Thames & Hudson, 1991.
——— and Ginevra Quadrio Curzio, *Piero Fornasetti. Cento anni di follia pratica,* Milan, Corraini / Triennale Design Museum, 2013.

OTHER BOOKS AND ARTICLES

Aloi, Roberto, *Esempi di arredamento moderno di tutto il mondo, Sale da pranzo,* Milan, Ulrico Hoepli Editore, 1951.
———, *Esempi di arredamento moderno di tutto il mondo, Camere da letto, Armadi, Tolette,* Milan, Ulrico Hoepli Editore, 1951.
———, *L'Arredamento moderno,* Quinta Serie, Milan, Ulrico Hoepli Editore, 1952.
Aria d'Italia, *Espressione di Gio Ponti,* Milan, Daria Guarnati Editore, 1954.
Bangert, Albrecht, *Italian Furniture Design. Ideas Styles Movements,* Munich, Bangert, 1988.
Beauffet, Jacques (ed.), *Design, collection du musée d'Art moderne de Saint-Étienne Métropole,* Saint-Étienne, Cité du design Éditions, 2008.
Bloch-Champfort, Guy, 'L'empreinte de l'homme', *Maison française,* no. 547, April–May 2007, p. 110–111.
Bossaglia, Rossana, 'Fornasetti: between Art Déco and Neo-Deco', *Apollo,* no. 336, February 1990, p. 92–95.
Cahier d'inspirations *Énergies,* Maison&Objet, Paris, SAFI, no. 23, September 2013, p. 58, 60–61.
Cahier d'inspirations *Elsewhere,* Maison&Objet, Paris, SAFI, no. 24, January 2014, p. 86–87.
Centro Studi Triennale, *Ambienti Arredati,* alla 9a Triennale di Milano, Milan, Editoriale Domus, 1954.
Clerici, Fabrizio, 'Piero Fornasetti and his almanachs', *Graphis,* vol. 3, no. 20, 1947, p. 266–270.
Crespi Morbio, Vittoria, *Fornasetti alla Scala,* Turin, U. Allemandi & C., 2007.
Duponchelle, Valérie, 'Los Angeles: le clin d'œil de Fornasetti', *Le Figaro,* 15 May 1998.
Domus – unsigned articles:
'Fazzoletti disegnati da un artista', *Domus,* no. 149, May 1940, p. 48, 50–51.
'Paraventi di Piero Fornasetti', *Domus,* no. 233, volume secundo, 1949, p. 36–37.
'Necessità della fantasia. Paraventi di Piero Fornasetti', *Domus,* no. 236, volume quinto, 1949, p. 34–35.
'Considerazioni su lacuni mobili', *Domus,* no. 243, February 1950, p. 27.
'Opere d'arte sul "Conte Grande"', *Domus,* no. 244, March 1950, p. 18–19.
'Calendari e foulard di Piero Fornasetti', *Domus,* no. 245, April 1950, p. 43.
'Fazzoletti stampati di Piero Fornasetti', *Domus,* no. 246, May 1950, p. 43–46.
'Grand Hotel Duomo a Milano', *Domus,* no. 250, September 1950, p. 22.

'I mobili fantastici alla Triennale', *Domus,* no. 261, September 1951, p. 28–29.
'Interni di una Nuova Nave', *Domus,* no. 267, February 1952, p. 14–15.
'Lavoro e divertimento di Fornasetti', *Domus,* no. 313, December 1955, p. 51–54.
Guido Ballo, 'Sul concetto di "spazio attivo"', *Domus,* no. 428, July 1965, p. 47–59.
Domus – articles by Gio Ponti:
'Una serie di vetri italiani alla VII Triennale', *Domus,* no. 147, March 1940, p. 50.
'Alla VII Triennale', *Domus,* no. 148, April 1940, p. 67.
'Un negozio grafico', *Domus,* no. 246, May 1950, p. 6–9.
'Una sala da pranzo da guardare', *Domus,* no. 252–253, November–December 1950, p. 28–29.
'Particulari di una casa', *Domus,* no. 256, April 1951, p. 31.
'Piero Fornasetti e Gio Ponti', *Domus,* no. 261, September 1951, p. 28–29.
'Printed furniture', *Graphis,* vol. 8, no. 39, January 1952, p. 78–81.
'Ragionamento sulla decorazione pura', *Domus,* no. 266, January 1952, p. 29.
'Una casa di predilezioni', *Domus,* no. 267, February 1952, p. 24–25.
'Una "Casa di Fantasia"', *Domus,* no. 270, May 1952, p. 28–38.
'Fornasetti disintegra la donna e l'uomo', *Domus,* no. 357, August 1959, p. 47–49.
Eidelberg, Martin (ed.), *Le Plaisir de l'objet. Nouveau regard sur les arts décoratifs du XVᵉ siècle,* Montréal, Société historique du Lac Saint-Louis, Paris, Flammarion, 1997.
Febvre-Desportes, M.A., 'Décor à l'italienne, Fornasetti', *Meubles et décors,* no. 700, December 1956, p. 62–63.
Fitoussi, Brigitte, *Objets affectifs. Le nouveau design de la table,* Paris, Hazan, 1993.
Fornasetti, Piero, *Rittrati di ignoti e no (Testo tratto dalle 'Vies immaginaires' di Marcel Schwob),* Milan, All'insegna del pesce d'oro, 1974.
Foster, Anne, 'Un art sans limites', *La Gazette de l'Hôtel Drouot,* no. 40, 14 November 2003, p. 31.
Gaillemin, Jean-Louis (ed.), *Design contre design. Deux siècles de création,* Paris, Réunion des musées nationaux, 2007.
Gex, Bibi, 'Le monde de Piero Fornasetti', *Elle,* no. 3088, 7 March 2005, p. 212–217.
Giovannini, Rolando, *Tile Fashion and design. Vent'anni di progetti e di decorazioni nelle ceramiche d'architettura,* Faenza, Gruppo Editoriale Faenza editrice spa, 2000.

Hanks, David, *Un siècle de design. Le programme Liliane et David M. Stewart pour le design moderne,* Paris, Flammarion, 2010.
Isozaki, Arata (ed.), *Gio Ponti,* Tokyo, The Seibu Museum of Art / Kajima Institute, 1986.
La Pietra, Ugo, *Gio Ponti,* New York, Rizzoli, 1996.
Lovatt-Smith, Lisa, 'Piero Fornasetti. Black and White World', *Blueprint,* no. 33, September 1987, p. 33.
Mauriès, Patrick, 'Le magicien de la via Brera', *Vogue décoration,* no. 35, December 1991–January 1992, p. 69–75.
———, 'Master of ornament', *Blueprint,* no. 331, January 2014, p. 130–146.
Myerson, Jeremy, Sylvia Katz, *Tableware,* London, Conran Design Guides, 1990.
Neumann, Claudia (ed.), *Dictionnaire du design. Italie,* Paris, Éditions du Seuil, 1999.
Ohlmann, Johann, 'La Bottega fantastica: vitrines d'un grand magasin suisse', *Gebrauchsgraphik,* 1967, no. 12, p. 28–37.
Prodhon, Françoise-Claire, 'Fornasetti l'iconoclaste', *AD,* no. 48, April 2005, p. 50.
Ponti, Lisa Licitra, *Gio Ponti. The Complete Work 1923–1978,* London, Thames & Hudson, 1990.
——— and Enrichetta Ritter, *Mobili e interni di archichetti italiani,* Milan, Editoriale Domus, 1952.
Reyssart, Sophie, 'Fornasetti, créateur de monde', *La Gazette de l'Hôtel Drouot,* no. 7, 17 February 2012, p. 142–143.
Scardino, Lucio, 'Cet obscur objet du design. Décors stupéfiants de Piero Fornasetti', *F.M.R.,* no. 11, November–December 1987, p. 89–104.
Sparke, Penny, *Italian Design 1870 to the Present,* London, Thames & Hudson, 1988.
Silvera, Miro, *Piero Fornasetti. Memorie e illusioni,* Parma, Grafiche Step, 1989.
Thébaud, Sylvie, 'Magique Fornasetti', *AD,* no. 64, April 2007, p. 148–155.
Tise-Isoré, Suzanne (ed.), *Un siècle de design. Le programme de Liliane et David M. Stewart pour le design moderne,* Paris, Flammarion, 2010.
Tomio, Luca, Nanda Vigo, *Verso nuovi mondi, Art design 1918/1982,* Milan, Galleria Toselli, Galleria Anna Patrassi, 2008.
Trétiack, Philippe, 'Barnaba Fornasetti, l'esprit de famille', *Elle décoration,* no. 205, December 2011, p. 63–66.
Vedrenne-Careri, Élisabeth, 'Fornasetti et Gio Ponti les petits plats dans les grands', *Beaux-Arts,* no. 93, September 1991, p. 94–97.

PRINCIPAL EXHIBITIONS

1933
Milan, university presentation: first canvases
Milan, 5th Triennale: series of printed
silk scarves
1936
Milan, 6th Triennale: decorative ceramic
frieze, bronze stele celebrating the Italian
campaign in Abyssinia, tea services
1940
Milan, 7th Triennale, 'Textiles, lace,
embroidery' and 'Ceramic, glass
and crystal' sections.
Meets Gio Ponti
1944
Geneva, Foyer des Étudiants, 'Peinture'
1946
The Hague, galerie Boucher,
'Piero Fornasetti'
Milan, Galleria Il Camino, 'Piero Fornasetti'
1947
Milan, 8th Triennale: series of motifs for
ceramics made at the request of Gio Ponti
1951
Milan, Centro di Studi Grafici,
'Piero Fornasetti pittore e grafico'
Milan, 9th Triennale: first exhibition
of *Architettura* furniture, bedroom
by Gio Ponti and Piero Fornasetti
1954
Milan, 10th Triennale
1956
Paris, Galerie Bernheim-Jeune, 'Objets
& meubles décorés de Piero Fornasetti'
1958
Lugano, Interform Arredamenti
d'Interni, 'Exposition de meubles décorés
de Fornasetti'
1959
London, Tea Centre, 'Fornasetti's
Decorative Objects'
Sion, L'Atelier, 'Exposition de meubles
décorés de Fornasetti'
1962
Kaiserslautern, Landesgewerbeamt,
'Piero Fornasetti Möbeln, Keramik,
Porzellan'
Karlsruhe, Landesgewerbeamt,
'Piero Fornasetti'
Lucerne, Uberschlag-Biser,
'Piero Fornasetti'
Stuttgart, Schildknecht, 'Ausstellung
von bemalten Möbeln und
Gebrauchsgegenständen von Fornasetti'
1963
Biel, Kramer Möbel International,
'Première exposition suisse
de Piero Fornasetti Milan'
Düsseldorf, Interior, 'Piero Fornasetti'
1964
Milan, Sala Espressioni, '250 Variazioni'
1966
Chicago, La Colonna Gallery
Dallas, Neiman Marcus, 'Piero Fornasetti'
Los Angeles, Feingarten Galleries
Malmö, Ohlssons
Turin, Galleria Martano
Turin, Torino Esposizioni, 'Il Bagno Oggi'
Zagreb, International exhibition of graphic
design of the PEN Club
Zurich, Galerie Bally

1967
Lille, Opportune, '280 assiettes, thème
et variations d'un visage de femme'
Los Angeles, Limited Editions Gallery,
'Fornasetti Plates'
Turin, 4° Salone internazionale arti
domestiche, 'Invito al collezionismo'
Turin, Torino Esposizioni, 'La casa Oggi'
Turin, Torino Esposizioni,
'La Stanza Metafisica'
1968
Stockholm, Nordiska Kompaniet, 'Italiana'
1970
Paris, Musée des Arts décoratifs, co-curator
of the exhibition 'Bolide design'
1971
London, second Eccentrica exhibition,
'Piero Fornasetti'
1972
Milan, 'Balli e Maschere dal Seicento
al oggi'
1973
Milan, 15th Triennale, 'Mostra Storica'
Milan, 'Il Carnevale dei Pittori'
Padua, Images 70, 'Piero Fornasetti'
Turin, Il Fauno 2, 'Ritratti di ignoti e non'
1974
Geneva, Galerie Aurore, 'Piero Fornasetti'
Milan, Centro d'arte Rizzolino, 'Monotipi
dal 1934 al 1946'
Turin, Documenta, 'Piero Fornasetti'
Verona, Galleria d'arte Giorgio Ghelfi,
'Piero Fornasetti'
1977–1980
Milan, Galleria dei Bibliofili, c. 30 exhibitions
1983
Parma, Mercante in Fiera, 'Mobili e oggetti
anni '50'
1985
Verona, Abitare il tempo, 'Genius loci'
1987
Turin, 'Tessuti Italiani degli Anni Cinquanta'
Verona, Abitare il tempo
1988
Barcelone, Galleria Camilla Hamm,
'Piero Fornasetti'
Verona, Abitare il tempo
1989
Montreal, Galerie Leport Trambley,
'Piero Fornasetti'
Parma, Galleria del Teatro,
'Piero Fornasetti: Memorie e illusioni'
Rovereto, Galleria Pancheri, 'Disegni,
oggetti, fantasie e idee'
1990
Milan, Galleria Il Castello, 'Sonetti grafici'
Munich, Wunderhause
Verona, Abitare il tempo
1990
Geneva, Art and Style, 'Fornasetti'
New York, Gallery 280, 'Piero Fornasetti
1913–1988: Furniture and Objects'
Turin, Galleria Nuova Avigdor,
'Sonetti grafici'

1991
London, Victoria & Albert Museum,
'Fornasetti: Designer of Dreams'
London, Themes & Variations Gallery,
'8 + 1 Screens'
Melegnano, Castello Mediceo, 'I paraventi
di Fornasetti'
Paris, L'Éclaireur, 'Fornasetti'
1992
Lignano Sabbiadoro, Sbaiz Spazio Arte,
'Oggetti eccezionali moda e design'
Rome, Palazzo Ruspoli, 'La follia pratica'
1993
Milan, Salon international du meuble,
'I vassoi di Fornasetti'
Florence, Borgo degli Albizi, 'Sogni, segni
e disegni'
1994
Verona, Galleria Zenaro, 'Piero Fornasetti'
1998
New York, Christie's, 'Piero Fornasetti
Italian Design'
Los Angeles, Christie's, 'Important Design:
The Life of Piero Fornasetti'
2002
Paris, Palais-Royal, '69 dessins érotiques'
2003 2004
**Washington, San Francisco, Chicago,
Toronto, Los Angeles**, Italian Institute of
Culture, 'Fornasetti. La follia pratica'
2005
Milan, Galleria Luisa delle Piane,
'Il segreto di Fornasetti'
Paris, L'Éclaireur, 'Le Secret de Fornasetti'
2006
Brussels, galerie 146 Autegarden-Rapin,
'Piero Fornasetti'
London, The Hospital Gallery, 'The Secret
of Fornasetti'
2007
Milan, Galleria Carla Sozzani, 'La cravatta
scioglie il nodo!'
2008
Milan, Galleria Carla Sozzani, 'Fornasetti
rugs by Roubini Rugs'
Milan, Galleria Carla Sozzani,
'Ossessione ionica'
Milan, Galleria Carla Sozzani,
'Tappetti Fornasetti'
2009
Milan, Spazio Fornasetti, 'Fornasetti:
l'artista alchimista e la bottega fantastica'
2011
Beaune, galerie Epokhé, 'Fornasetti'
Berlin, Qubique Furniture Fair, 'Fornasetti'
Milan, Spazio Fornasetti, 'Il riflesso magico'
2013
Milan, Spazio Fornasetti, 'Autoritratto'
Milan, Spazio Fornasetti, 'Sublime tabacco'
Milan, Spazio Fornasetti, 'Il piatto forte'
Milan, Triennale Design Museum,
'Piero Fornasetti, 100 anni di follia pratica'
2014
New York, Whitney Museum,
'The Five Senses'

This book was published to coincide with the exhibition 'Piero Fornasetti. La folie pratique'
at Les Arts Décoratifs, Paris 11 March – 14 June 2015.

This exhibition was co-organized and co-produced by
Les Arts Décoratifs, Paris, Triennale Design Museum and Immaginazione srl/Barnaba Fornasetti, Milan.
The exhibition was made possible with the participation of
Valentino
Yoox
and
Fondazione Vittoriano Bitossi
Cole & Sons
United Parfums

LES ARTS DÉCORATIFS

President
Bruno Roger

Director General
David Caméo

Director of the museums
Olivier Gabet

Director of development
Renata Cortinovis

Director of communication
Pascale de Seze

EXHIBITION

Exhibition curators
Barnaba Fornasetti
Olivier Gabet

Assisted by
Laurence Bartoletti
Yuki Tintori
Chiara Zanesi
Corrado Guerreschi

Head of exhibitions service
Jérôme Recours

Exhibition layout concept
Barnaba Fornasetti

Exhibition layout design
Giulio Albertazzi
Assisted by
Raffaele Arcone

BOOK DESIGN

Laurent Fétis and Sarah Martinon
Studio Fornasetti

ACKNOWLEDGMENTS

We express our gratitude
to the following private collectors
who generously agreed
to lend their works:
Anna Bonera Salvoni
Fabrizio Benintendi
Cinelli
Marva Griffin
Holly Johnson Antiques & Design
Angela Missoni
Herat De Nicola
Luca Preti
Galleria Senzatempo
Gruppo Statuto
Turin Gallery

We would like to thank
all the staff of Immaginazione srl,
in particular:
Alessandra Banfi
Nadia Boni
Simone Colferai
Diego D'Ayala
Gabriele Ferrero
Andrea Foffa
Valeria Manzi
Andrea Nannoni
Roberta Pardi
Mdjop Silla
Annalisa Wappner
Fulvio Marcello Zendrini

Les Arts Décoratifs wishes to thank:
Louise Curtis
Anaïs David
Kevin Lebouvier
Isabelle Mendoza
Marie-Laure Moreau
Juliette Sirinelli

Immaginazione srl extends its thanks to:
F.lli Agostoni
La Compagnia del Sole
Farrow and Ball Limited
Alessandro Fornasetti
Toni Meneguzzo
Cesare Picco
Pomo
Tipografia 25x35
Xilo1934

PHOTO CREDITS

Andrea Boscardin
Alessandra Catella
Marco Covi
Sandro Farabola
Hugh Findlater
Fabrizio Garghetti
Nicoletta Giordano
Howard Gray
Ugo Mulas
Irving Penn
Arianna Sanesi
Alberto Zabban
Chiara Zanesi

First published in the United States of America in 2015 by Rizzoli International Publications, Inc.
300 Park Avenue South, New York, NY 10010
www.rizzoliusa.com

Originally published in French in 2015 by Les Arts Décoratifs,
107 rue de Rivoli, 75001 Paris - France

2015 2016 2017 2018 / 10 9 8 7 6 5 4 3 2 1
ISBN: 978-0-8478-4713-6
Library of Congress Control Number: 2015932837

Printed in Italy

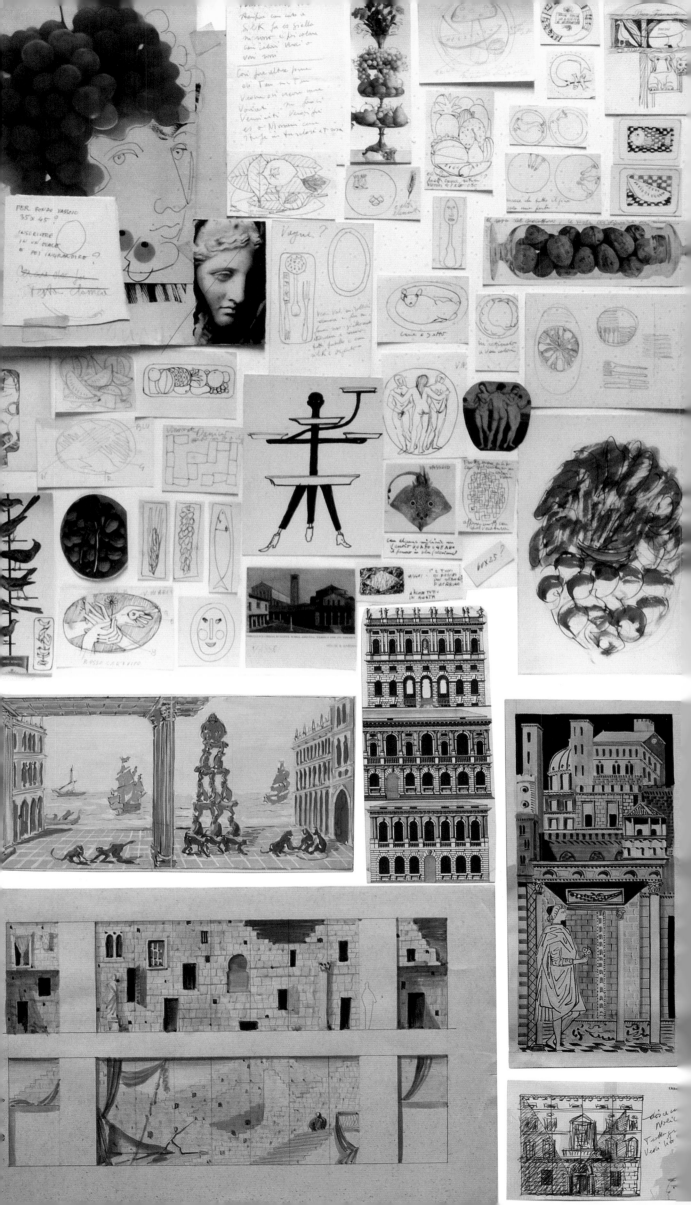